ESSENTIAL DARKROOM TECHNIQUES

ESSENTIAL DARKROOM TECHNIQUES

Jonathan Eastland

CASSELL

AUTHORS ACKNOWLEDGEMENTS

The energetic assistance of the customer services and public relations departments of many
manufacturers of branded goods named in this volume is hereby gratefully acknowledged, as is the
use of specific trade names relating to film, chemicals, materials and hardware. I would like to
mention, in particular, Agfa, Ilford Anitec UK, Kodak, Tetenal, Paterson-Photax, Durst, George
Elliot Ltd and Nova Darkroom Equipment, who have supplied technical information and product
photographs. I am also indebted to Pat Wallace of the Polaroid UK Ltd press office for her
enthusiasm and help in providing samples and information for the chapter on Polaroid products.

This edition first published in the UK 1995 by
Cassell
Wellington House
125 Strand
London WC2R 0BB

All photographs are by the author except where credited.

Distributed in the United States
by Sterling Publishing Co. Inc.
387 Park Avenue South
New York, NY 10016
USA

Distributed in Australia
by Capricorn Link (Australia) Pty Ltd
2/13 Carrington Road
Castle Hill
NSW 2154
Australia

British Library Cataloguing-in-Publication Data
A catalogue record for this book is available from the British Library.

ISBN 0-304-34548-2

Designed by Blackjacks, London
Printed and bound in Singapore

CONTENTS

PREFACE TO THE SECOND EDITION

Some of the predictions I made in the introduction to the first edition of this book concerning the advent of digital imaging are now beginning to have a profound effect on new generations of photographers. The most important of these changes, the introduction of Kodak's Photo-CD, whereby photographic images can be written to disk for recall into ordinary desk-top personal computers, already affects the choice of method by which the final print is made.

I use the word 'print' in this instance to denote the finished hardcopy produced from an original film negative or transparency. Using conventional film, up to 100 processed negatives can be scanned to a CD disk by professionally equipped film-processing laboratories. The disk is returned to the photographer with a set of conventional prints, but the viewing quality of these is no match for the digitally stored disk images which can be viewed via an audiovisual CD player on a standard colour television screen. Viewed on a dedicated colour monitor, results are positively stunning, but hardware such as this costs more than some of the most expensive cameras. The costs involved in transferring film images to disk and the initial cost of CD hardware by which they can be viewed are, however, moderate. If a personal computer is not available, along with the additional hardware for the down-loading of CD images and the software required for image manipulation and output to a near photographic-quality dye sublimation printer, the benefits of CD viewing appear fairly limited.

This area of electronic imaging is currently undergoing a dramatic explosion in terms of equipment and software, but the serious photographer contemplating such a route would be well advised to make a thorough investigation of this not inconsiderable minefield before making any decision. Many innovations are now in the development pipeline and these may ultimately reduce the very high capital costs of items like digital scanners and printers to a more affordable level. But this is unlikely to take place for some years and, until this happens, most users anxious to exploit the exciting potential of the 'electronic darkroom' will, for the moment, prefer the more cost-effective course of having a professional laboratory output disk-stored images to print. Not being able to scan one's own images to disk or output a hardcopy from the computer is akin to owning a conventional enlarger for which no lens is available – at least, at a sensible and reasonable price. And that is the real reason why this book has been revised and republished.

In the years ahead, the two technologies – digital electronic and conventional silver image – will sit side by side, the former having a bigger impact in the professional and industrial sector. In the amateur field, enthusiasts will continue to benefit from the considerable advances still being made in the area of improved film emulsions, paper and chemicals. The introduction of a new format of 35mm film will almost certainly see a whole new breed of autofocus compact cameras and lenses armed with electronic CPUs (central processing units) which automatically transfer exposure and subject colour data to a magnetic backing on the film. Computerized enlargers, similar to the models already marketed by Fuji, will incorporate decoding chips which can read the data stored on the new film type. It will be possible to make perfectly rendered first-generation colour prints without the need to resort to fully processed test strips which may still need yet more filtration adjustment before an acceptable print can be made.

The very nature of this new film may present problems for the home-processing enthusiast until new developing spools are designed. As yet, however, there is no real indication of when the new film or ancillary products will be available. The major film manufacturers have gone to great lengths to give assurances that, whenever the new film does arrive, it will coexist happily with conventional 35mm products.

At the time of writing the original edition of this book almost ten years ago, amateur and professional photography was experiencing a dramatic boom in colour; in particular, in the use of colour negative products. Black-and-white, though still used in some professional quarters, had long ago succumbed to advertisers' demands in the popular and magazine press. Oddly, it was to be some years, at least in the United Kingdom, before the demands for editorial colour were met by quality newspapers.

Today, the bulk of editorial press photography is originated on colour negative materials, reversal materials still largely being employed by photographers working in advertising and in the magazine and book trades. In these areas, reproduced black-and-white images are made largely from electronically converted colour originals; little is actually originated on black-and-white film stock, unless supplied by the photographer.

In spite of the widespread use of colour for colour's sake, black-and-white photography still enjoys a healthy following in the amateur field, encouraged by the mid eighties proliferation of 'fine art' photographers and specialist press attention to the craft. In the United States, where commercial demands are comparable with those of Europe, there has always been a much stronger interest in 'conventional' black-and-white photography. At the present moment, resuscitated techniques and formulae for such long-retired processes as two-bath black-and-white film developers are being enthused over as if they were new discoveries and repackaged by quick-thinking manufacturers. The demand for quality fibre-based printing papers has never been stronger. Add to this a seemingly healthy demand for archival preservation products and one can quickly see that black-and-white photography, far from being in its death throes, is alive and kicking.

My own favourite medium is certainly black-and-white, though of late I must confess to having become more and more fascinated with the potential of colour and its use in making images of ordinary, everyday life. I am sure that the reason for this is that, from my very first Kodak Box Brownie camera, given to me by my paternal grandmother at the age of ten, photographic life for the next three decades has revolved almost entirely around black-and-white. I have only used colour when commercial demands required, and then only in a fairly perfunctory manner. It is only in the last ten years that I have made a concerted effort to grasp some of the basic tenets of colour photography.

In the process, I found there is actually very little written work available to the enthusiast which explores theory and practice beyond a description in fairly elementary terms of the basic values of the spectrum. I am not here referring to processing technique, but to ways in which the mind can be educated to 'see' in colour. I found myself drawn to books on the history of art, in which the working practices of well-known artists were documented, followed by endless visits to galleries and museums to view paintings. Colour is certainly not an easy subject to comprehend, but I can recommend the benefits of time spent studying the work of artists of all periods. What many of these masters of light and shade, tone, contrast and colour differentiation, learned in the process of creating great works with brush and pigment has played a significant part in my more recent appreciation of colour photography.

As this edition of *Essential Darkroom Techniques* goes to press, many new film, chemical and paper products were launched on to the market at the bi-annual international trade Photokina exhibition in Cologne. Those products which I could persuade manufacturers to release to me prior to this exhibition are included in this edition, but it is likely that some of the current products mentioned will

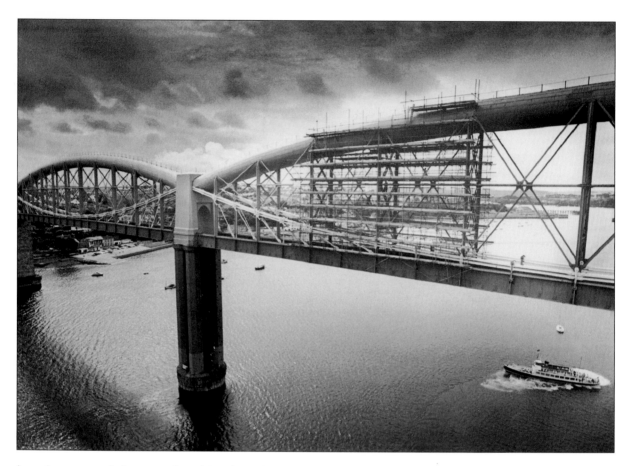

have been upgraded or repackaged by the time publication takes place.

The meticulous student will benefit from studying instruction sheets packaged with all products whether old or new. I still have many sheets dating back to the earliest days of my association with this fascinating hobby and these have proved to be a valuable asset over the years. Just occasionally, I have come across stocks of old chemicals – especially powder types – on the shelves of long established photographic dealers which were perfectly usable with some types of modern film stocks.

As much as the chemistry of photography might be considered scientific in some circles, for the vast majority of practitioners it is a craft, and a hugely satisfying one at that. To

be reasonably successful in producing high-quality prints and slide images, the student need only apply a modicum of freely available knowledge. The bulk of what the beginner needs to know is contained in film pack, chemistry and paper instructions issued by manufacturers. It is only the method of application which can make the difference between poor, average and high-quality results. Plenty of patience, enthusiasm and determination to succeed are the only other ingredients you will need. I hope this volume goes someway to providing the short-cuts to that end.

Jonathan Eastland
Hamble River 1994

Brunel's bridge at Plymouth; a straight print loses much of the intended effect. In this print, sky to the top and left was heavily burned for effect, while the right side of the bridge and sea at bottom was held back. Different contrast grades in the manipulated areas of the print were made possible by Multigrade paper.

DARKROOM DESIGN AND LAYOUT

Everyone has their own idea of the ideal arrangement for a particular room, whether it be the bathroom, bedroom or kitchen. Likewise, no two darkrooms are ever the same. What all should have in common, however, is a demarcation between 'wet' and 'dry' areas. In most homes, one of the biggest problem facing the photographer about to set up a darkroom is not where the real or imaginary divider between 'wet' and 'dry' should be placed, but how much space is available for use as a whole. Strictly speaking, a darkroom is no longer necessary for film processing or for printing. Daylight developing tanks can be easily loaded in a changing bag. Acceptable enlargements can then be made using a daylab.

Print-making in the conventional way requires a more elaborate and light-tight working area. This may be an area set aside in a bathroom, bedroom, garage, outside workshop or stair cupboard, or anywhere where adequate space can be found to set up an enlarger and the minimum of trays, tanks and washing facilities. Excellent quality enlargements have been made in the field using nothing more sophisticated than two plastic buckets and a folding enlarger erected inside a black plastic tent. Slightly more sophisticated, fully framed rectangular tents are available through some mail-order suppliers both in Europe and the United States. Some larger models available through suppliers in America are equipped with wet and dry benches with collapsible frames. The advantage of a darkroom tent is that it only need remain erected for as long as is necessary. When the space is required for another purpose, it can be quickly dismantled and stowed away. The disadvantages are that no permanent water or waste services can be connected and all water for mixing and washing must be imported.

PLANNING THE DARKROOM

The permanent darkroom is more complicated and, if it is to run efficiently, needs almost as much attention to detail in the planning as the field darkroom lacks in facilities. The first requirement is to try to establish as far as possible what the darkroom's primary function will be: whether it will be used for producing mainly colour prints, colour transparencies, black-and-white or all three. Second, it will pay dividends to ruminate on further acquisitions of hardware: a second enlarger, possibly of larger format and requiring significantly more height and baseboard space than the one in current use; automatic high-capacity print dryers; deep tanks; motorized drum processor; steel cabinet; film dryer,

These paper processing tanks are available from Nova Darkroom Equipment and come in a range of sizes suitable for the photographer with limited darkroom space. (By kind permission of Nova Darkroom Equipment.)

and so on. You may decide that none of these items are needed immediately, but if the photographic bug has bitten deeply, rest assured that there will be innumerable additions to the basic inventory from time to time. All of them will need working space, so it is just as well to make some allowance at the outset.

Professional darkrooms need similar consideration. Where the area is to be used by more than one operator, some thought should also be given to the way in which those operators prefer to work. In one example, where a team of so-called specialists were employed to design and build a darkroom for the London base of an international news agency, not one of the photographers or darkroom operators was consulted regarding the location of basic equipment, its size or function or at what height it would be best placed. The result was that the photographers got a spanking new darkroom which rapidly became an ergonomic disaster area.

The only benefit was the huge amount of space allocated to the darkroom. Although in this case it was rather more than was necessary for even peak traffic periods, space should always be a prime consideration. Even the lone freelance with a more or less continuous workload will find that space to move around the working area with relative safety and ease, space on which to dump sheets of negatives as far from 'wet' areas as possible, space to step back to view the easel image in comfort, and space to wander from the wash tank to an enlarger, or light box, or bench on which half a dozen damp dry prints are laid out for inspection, is a great asset. Such areas of space are frequently at a premium, however, and perhaps the most that one can hope for is a spare room which is easily divided into a functional 'wet' and 'dry' area with the least amount of conversion. Studios employing a full-time darkroom technician and assistant will need proportionately larger areas.

Just how much space will be required will also depend largely on the personality and working habits of the individual. Those with a fairly meticulous disposition, who cannot work efficiently at anything unless tools and materi-

als are well ordered, may easily be able to withstand what others might consider an element of claustrophobia. Just how small you can go will depend on the physical size of equipment, how much of it there is and where it must be placed in relation to the operator. One photographer I know works within the confines of a 6x4ft (1.8x1.2m) box in which the centrepiece is a revolving office stool. An enlarger and assorted shelves of paper and smaller equipment line one side of the box, while dishes, an auto-print processor and wash tank are laid out opposite. The back of the door serves as a hanging rack for a home-made film dryer and a safelight. Photographers can sometimes be found in much smaller workplaces but, never having had that experience myself, I would imagine that too little space would severely restrict output, as well as any inclination to attempt much that was serious.

Those of us who prefer what may appear to others as a relatively untidy approach to work often produce our best while buried under a mountain of totally irrelevant material. My own darkrooms have become progressively larger over the years. This has been partly due to an ever expanding inventory of equipment, but mainly because of the sense of satisfaction gained from working comfortably in a large area where confusion can apparently reign supreme without actually encroaching on the work space. I need acres of space around an enlarger baseboard for negatives, dodging utensils, masking frames, pens, notebooks and all the other paraphernalia which seems to accumulate. This confusion is all of my own making and so long as it remains that way I am perfectly content to continue working.

When a stranger invades the darkroom and tries to make order out of chaos, I am then at a loss to know where to begin again. Having a larger darkroom helps. I can keep my mess around my own work-station while others create theirs around a second or third. Surprisingly, the 'wet' area is nearly always fairly orderly, though I must admit that my patience is hardly ever extended to cover the totally unnecessary practice of whitewashing the walls with hypo.

New York, Nikon F2, 200mm Nikkor on Tri-X rated at ISO 400. The film was machine-processed in a Kreonite processor for an effective EI800 which made the negative extremely dense. The skyscraper was burned-in heavily. Agfa Record Rapid, grade 3.

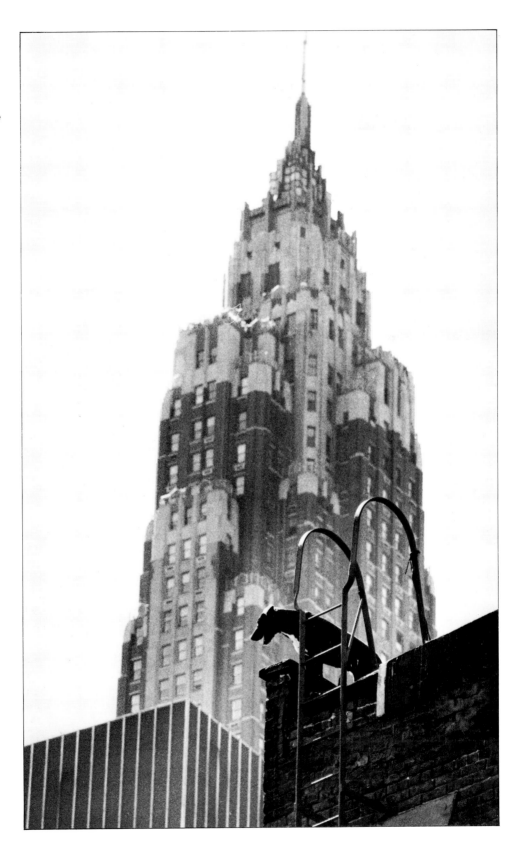

Small darkrooms encourage the photographer to be more disciplined; large ones have the opposite effect, especially when more than one person has simultaneous access. It is essential, therefore, when planning your place of work, to pay attention to the detail of layout.

Traditionally, the following spaces are most commonly allocated for work when a temporary darkroom is considered the most practical solution: utility room, kitchen, or bathroom. When the work area is to be of a permanent nature the following are usually considered: attic, spare room, bedroom, garage, garden shed, or other exterior building. Older houses often have far more in the way of protected space than most modern buildings but, even so, when the temporary darkroom has to be set up, the bathroom almost invariably tops the list. This is something of a mystery to me, especially if materials and equipment are to be stored in the same room after each use. Aside from the immediate advantage of a hot and cold water supply and adequate waste system, bathrooms are not ideally suited to the photographer's needs. Accumulating moisture, condensation and steam produced by other users when the room is not used for processing will soon damage paper supplies and rust equipment which is left unprotected . However, as a very temporary measure until another facility is found, all that is required is some kind of support for an enlarger, a large sheet of heavy-duty black plastic sheeting which can be taped to any window to keep the light out, a safelight and three plastic dishes that will fit easily into the bathtub.

One of my first encounters with a darkroom took place in a friend's house. Clever carpentry had produced an efficient mobile bench which resembled an oversized walk-in wardrobe. I was so impressed that I used the idea, slightly modified, while living in rented accommodation. Provided the mobile bench is custom-made to fit into an existing bathroom and there is space available to store it outside when not in use, the problems encountered with regard to moisture and other potential hazards should be easily overcome.

The most common fault in picture-taking at the film negative stage is camera shake. This may be induced by the camera operator or some other phenomenon. However slight the shake appears to be on the negative, it will always be enhanced when the final print is made. Unless firmly secured, enlargers often suffer from the same malady. Except for office buildings, where the floors are generally constructed from reinforced concrete, both old and new homes tend to be built with wooden floors on wooden joists. Any mobile or portable enlarger bench must be secured as firmly as possible in order to help reduce the possibility of shake being set up through exterior vibrations while prints are being exposed.

The portable cupboard bench poses some problems in this area and, while the emphasis should be on portability to a large extent, none of the solidity of a fixed bench should be sacrificed. If construction is to be in timber, use a minimum of 2in (5cm) square prepared wood for the main frame uprights, working bench chassis and supports for the under shelf. The back can be clad with pegboard, and sides and cupboard door fronts with thin 3-ply or hardboard pinned to light door frames. The actual working surface should be as heavy as possible; a high-density chipboard is ideal, provided it has a plastic laminate working surface and is properly edged to prevent any moisture from penetrating the core; 15mm plywood, also with the upper surface covered, will be suitable. For little extra expense, however, including the time expended in fitting the laminate top, it would be more efficient to have a 'post-formed' top custom-made to fit the proportions of the chassis. Such worktops are basically comprised of chipboard with a rounded leading edge on to which has been heat-sealed a plastic laminate top and bottom. Paying a little extra for a made-to-measure enlarger bench will pay dividends.

As I have already said, attention to detail in the planning of any darkroom is of the utmost importance. Slightly more investment than was originally envisaged in better quality building materials will always benefit the operator in the long term. But if you are working to a strict

budget, there are ways in which funds can be pruned on some items. Because photography is such a popular leisure pursuit, the price of some items of equipment may seem to some to be inordinately high. I would prefer to spend more on essentially functional equipment which, because of its construction, will stand the test of time rather than on some item which is designed to appeal for more aesthetic reasons.

Darkroom safelights are a good example of how industry caters for the amateur market. It is essential, as we shall see later, to have a faultless safelight system, but this can be organized easily and cheaply for most printing requirements and graphic arts materials use with simple wall-mounted light-fittings and a handful of pygmy bulbs. These are the tiny 15 watt lights which are often found on restaurant tables or outdoor Christmas trees. One such light, placed strategically and shrouded by a baffle can be mounted above the mobile bench on an extending arm which is locked into place when the bench comes into use with a bolt and butterfly nut. In larger, permanent darkrooms, pygmy lights can be positioned around the room so that they will throw light over relatively safe areas. Red bulbs are most suitable, but you must ensure that the socket end of the bulb is properly shrouded, as there will usually be a paint defect which allows small amounts of white light to be transmitted.

Other cost-saving utensils include measuring jugs, which are invariably cheaper to purchase from large department stores or specialist plastics outlets which cater for industry and agriculture. Here, too, you will often find items which are more than suitable for use as semi-deep tanks, developing trays and wash tanks. Hardware stores can usually supply ordinary domestic dish-stacking racks of the plastic-coated wire-basket type. These can be hung on clips under the enlarger work surface, and are useful for storing things such as tanks or the dozens of empty film cassettes and spools that some photographers hang on to for no special reason. A useful film-drying hanger can be easily adapted from a wall-mounted kitchen towel holder with several swing arms. When not in use, the arms can be folded down out of the way or swung back against a wall.

So far, I have assumed that most photographers will require a bench large enough to tackle both black-and-white and colour processes, using wet-tray methods. The portable unit described will certainly have enough working space for most techniques. Those photographers who are equipped with auto-drum processors for colour print-making and film-processing may reasonably decide that a smaller portable unit will be more practical in the space available. There is also the question of where such a unit could be stored when not in use. The major disadvantage of any temporary set-up within the living area of a home is that, while the photographer is working, other members of the household are subjected to certain restrictions. 'Bathroom off-limits' is definitely an inconvenience to most people, even when the frequency of black-out is very low. For the photographer, such psychological factors affecting the preparation for a print-making session may diminish enthusiasm. Combine these two considerations and you have a cast-iron case for considering a more permanent working area.

For those interested only in the processing of reversal materials, a darkroom as such is not essential. Provided film can be loaded on to spools in a changing bag or other completely light-tight space, processing can take place in a very small area in daylight. The most common location seems to be the kitchen sink. With today's chemical technology, reversal processing is no more difficult than colour negative or black-and-white and only requires temperatures to be maintained accurately throughout the process.

So let us now turn to more permanent fixtures: the walk-in darkroom with plenty of practically usable space. There are several features here which need special consideration when planning the layout of a proper working area; these are as follows, though not necessarily in order of importance:

1 Decide the ideal 'wet' and 'dry' bench-height from the floor in relation to operator convenience.

2 Decide the ideal 'dry' bench height in relation to maximum elevation of the enlarger and the most convenient easel-height from the floor.

3 Will the 'wet' and 'dry' areas be adjacent to the divider or on the opposite side of the room?

4 Check the convenience of the main services: incoming water, waste, and electrical supply.

5 If there is no existing window opening to the outside, check the construction details of the building for positioning of a suitable ventilation system.

6 Ensure the soundness of the floor joists before importing heavy auto-process equipment, metal-cased dryers, etc.

7 If using attic space, check that the roof is sound; loose tiles and leaks must first be repaired.

8 Make general checks all round for signs of damp, and remedy these if found in any area.

Once you have given some thought to these points, you can begin to sketch out alternative layouts. If you plan to make a fairly substantial investment into building a customised darkroom, try assembling a small cardboard or polystyrene model of your plans. Models of equipment need only be representative blocks; these will give a very good idea of the amount of 'moving' space which will be left when all fittings are in place. It also allows for major and minor detail changes to be made to plans before any building commences. It is essential that, when complete, your darkroom allows you freedom of movement between benches, enlargers, drying cabinets and any shelving which is likely to project into the actual working area.

Commercial darkrooms are invariably fitted with some kind of elaborate light-trap entrance which allows operators to come and go at will without hindrance to anyone who may still be working. Off-the-shelf light-trap doors of the revolving type are available at huge cost and, because of their size, are totally unsuitable for the average home. A little ingenuity, again using a cardboard model, will show that it is possible to have an adequate

light-trap entrance which occupies very little space. This can be done using a double curtain technique, or by having a fixed baffle which is constructed from hardboard on a light wood frame.

It is assumed that anyone considering a permanent set-up will have access to one of the spaces already mentioned. There will be numerous advantages and disadvantages attached to all, and these, along with everything else, must be considered. For example, the attractions of an attic or loft darkroom mainly centre on privacy and seclusion. The same thing applies to a large extent to the basement, but if there is a choice then my preference would almost certainly be below stairs rather than in the roof, unless I had already undertaken major conversion work in the loft.

In older houses, main services are available in the loft, but few have roof spaces which are fully insulated from cold and heat. Any darkroom built into an uninsulated roof space will suffer from an excess of heat in summer and freezing cold in winter. Basements tend to remain at a fairly even temperature all year round, do not require cooling in summer and consume little power for heating in winter. Add to this the close proximity of mains water, waste and power services and that little work needs to be done to make the space light-tight, and you have a good case for using the basement.

Spare rooms on upper floors are usually ideal. Room temperatures can be easily controlled by thermostat where hot air, conventional central heating or air conditioning is installed. In more temperate climates, heating can be arranged where no fixed installation is present using portable electric convector or oil-filled radiators fitted with a time clock. This will help to keep the space at an even temperature and prevent unnecessary power waste.

When the appropriate space has been selected and before any new construction takes place, a thorough check of the state of floors and walls should be made. If plaster-work or floorboards are in need of repair, this should be carried out immediately with

Suggested layout for a small darkroom; keep it simple so that the available space can be utilized for worktop areas. Entrances from white light need special sealing.

Key:
A) Sink
B) Nova Darkroom print processor
C) Bench-top paper processor
D) Power points
E) Fluorescent white light
F) Enlarger
G) Entrance
H) Dark curtain
I) Ventilators to exterior
J) Work-top ('wet' or 'dry')
K) Work-top ('dry')
L) Floor
M) Cupboards/drawers under work-tops as appropriate

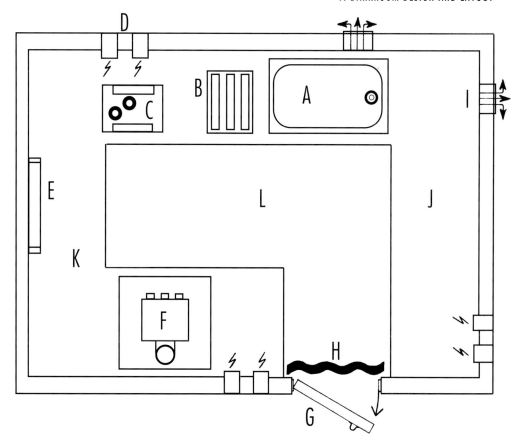

careful attention being paid to any possible sources of dust being properly sealed. In older properties, dust can be a frequent problem in the darkroom unless it is dealt with at the outset. First, remove all traces of the existing floor covering; remove any nails which protrude and secure any loose boards. Replace those which look as if they may be rotten. This is always the best time, too, to inspect underfloor wiring. If it is at all suspect, have a qualified electrician do the work. This solves two potential problems: one is the risk of electrical fire caused by circuit failure; the other is the necessity or temptation to install the darkroom wiring circuit yourself without really knowing what you are doing, and then having to satisfy an insurance company inspector that the work you are planning to carry out meets specific insurance provisions. It is usually worth checking both house-cover policy and house-contents policy to ensure that, if you do do the work yourself, cover remains in force.

Once you are satisfied that the floor is stable and any work which needed doing under

it has been completed, the task of sealing can begin. Use sheets of hardboard pinned or stapled in place over the whole floor area. Alternatively, spend more funds on high-density chipboard. This material is a better insulator and, if thick enough, will provide a solid work base. A proprietary vinyl floor covering should be used next, although there is no reason why some other material, such as cork tiles or industrial waterproof short-pile carpet should not be used. A degree of comfort in any darkroom is essential, especially when there is a likelihood of long hours being spent standing. In this case, a cushion-floor type vinyl floor covering is to be preferred. When measuring the area to be covered, make an allowance for a few extra inches all the way around the room perimeter. The covering can then be folded upward and stapled to skirting boards. This will help facilitate the cleaning of the floor and will also prevent dust finding its way upward from under the floor. Seal the edges of the vinyl where it is stapled to the skirting board with waterproof carpet or gaffer tape.

It is essential that all dust sources are eliminated at the outset. Attic/loft and basements will cause more problems in this area than most others if not efficiently dealt with at the outset. One basement darkroom I worked in for a number of years had a flagstone floor laid over bare earth. It had been a wine cellar before my occupation and, while most of the seams between each flag had been filled with cement and the floor painted with an industrial sealant, it caused never-ending problems. Had I put down a layer of concrete over the flagstones and then sealed it, I doubt it would have been such a source of inconvenience for so long.

THE WORKING LAYOUT

Now that most of the groundwork has been done, you can begin to think about the most practical and convenient layout. Remember that you are the prime operator. If anyone else is invited to work in your darkroom, it will be as a guest only. All detail should therefore be aimed at providing you with facilities which suit your own needs and not those of others.

There are several schools of thought regarding darkroom design, very few of which could ever be described as being 'the best' or 'better than'. Much will depend on the amount of space available, whether you are left- or right-handed, whether you prefer to stand or sit when working, and so on. It is assumed, however, that the work to be produced will be of an exacting standard and will cover all aspects of photo-processing technique.

The layout illustrated here can be adapted without too much difficulty for use by disabled people. Where possible, darkroom sites should be situated on lower-floor levels and proper provision made for access by wheelchair if necessary. This will mean that the entrance and/or exit will have to be wider than normal and ramps may be needed where a step up or down is sited. Bench heights must be naturally accessible by anyone seated and should not be so deep that the back cannot be reached from a sitting position. Most off-the-shelf enlargers are designed for use by people who are not incapacitated. Operation by wheelchair-bound photographers may prove difficult if the equipment is placed on a side bench. To overcome this problem, the enlarger should be mounted on its own custom-adapted table and placed as near to the centre of the darkroom space as is practicable. Assuming there is adequate aisle space to allow ease of movement, the disabled operator should now be able to operate all the controls by moving around the equipment. Because most modern enlargers are of lightweight construction it will be an added advantage to have both table and enlarger baseboard fixed in position, so that the equipment remains secure in the event of accidental collision.

Electrical switchboards and all electrical appliances must be properly grounded and placed well away from 'wet' areas. Operating switches should be placed within easy reach of the chairbound person, and all ceiling-hung lights will be more practically operative if fitted with ceiling-mounted pull-cords. Still on the subject of power, it is worth elaborating further on alternative installations. Mains power to the darkroom should be independent of the main household domestic supply. There are good reasons for this. One is that, if the darkroom supply is connected to the domestic ring main, there is always the possibility that a user other than yourself may overload the system and blow a main fuse. If you know that some equipment in the darkroom is liable to draw a lot of power at any time, the chances of the system being overloaded during hours of peak consumption will be higher. To avoid such disasters, a direct feed line from the incoming main supply of the house to the darkroom should be fitted to a special darkroom distribution panel; this installation work should be carried out by a qualified electrical engineer. In most households, the electrical supply from the street is fed through a meter to a junction box or a fused switch box. There should be a spare untapped line from which a 30amp cable can be run directly to the darkroom where it should be connected to a trip switch before

feeding directly into another fused switch box. Separate circuits from each fuse are then set up around the various work-stations. If faults develop at a later stage, it should be relatively easy to isolate the trouble. In the event that everything is shorted, all the fuses in the box will blow, but the trip switch will cut off the main feed. The normal domestic supply should not be affected.

There are many different types of electrical fittings available to the home owner and home electrician. It should be emphasized, again, that if you are at all unsure of what is required, consult a competent and fully qualified electrician with a view to having the work done properly. If you feel confident that you can do the work yourself, select only the most suitable fittings for the nature of the work. All cable should be sealed in conduit. Most sockets of the standard three-pin variety are quite unsuitable in the 'wet' bench area due to their vulnerability to water penetration. Legrand Electric Ltd manufacture a range of weatherproof fittings which are widely available throughout Europe through wholesale distributors, but you may be able to obtain a catalogue of their wares by writing direct to their head office in Dunstable, Bedforshire, England.

Some Legrand sockets are fitted with sprung, hinged covers and large rocker switches instead of the fiddly things most of us are used to. These are ideal for use in the darkroom. If power sockets are required near the 'wet' area, make sure that they are secured to a batten on which the power-supply cable is fed through conduit and clamped with the correct fittings. The batten on which sockets are placed in this area should be not less than 30in (75cm) above the bench. Darkrooms with central 'wet' benches should have the power supply connected to any appliance with an overhead cable which leads back to a dry area. *Never* operate switches or sockets with wet hands; keep the hand which is not in use away from wet trays and metal objects in the immediate vicinity.

In an average room space measuring 10x 8ft (3x2.4m), the most convenient layout will have 'wet' and 'dry' benches sited opposite one another. Ideally, bench width should be in the region of 30in (75cm) which will allow a 3ft (1m) aisle between the two. Narrower benches provide inadequate space for practical working around the enlarger when larger-than-average prints are being made, and less space on 'wet' benches for processing trays of proper size. To prevent undue splashing of chemicals, my own arrangement utilizes two trays for developer, stop and fix. The smaller of the two contains the chemical, the larger outer one catches the drips, but can also be used as a warming bath when required. Electrical dish-warmers, if they are used at all, should be manufactured to the highest industrial use specifications.

I have an automatic agitator which is a custom-made unit in which the electrics are housed in a watertight fibreglass box. The mobile top, which also acts as a dish-warmer, is fitted with lugs into which varying sizes of stainless steel trays can be fitted. Only small amounts of liquid are necessary for developing purposes. However, while this machine is of immense help when producing large quantities of prints, I actually find it easier to control temperature and action using the dish water-jacket method described in the previous paragraph. As soon as the temperature of the developer begins to drop significantly, the contents of the outer dish are discarded and fresh warm water added. In summer, there is hardly ever a need for the water-jacket, except when processing colour materials, and in winter, provided the developer solution is no more than lukewarm to the touch, perfectly acceptable results will continue to be obtained.

Other types of 'open' tray print-processing equipment, such as that manufactured by Nova Darkroom Equipment in the United Kingdom are based on the principle of sandwiching narrow trays in a vertical format between thermostatically controlled water jackets. These are ideal where work space is at a premium, but they do not easily permit the kind of hand control many advanced photographers prefer.

Let us return now to the layout plans, and to cardboard cut-outs. Bench height will

Low light levels often pose special problems for photographers working in black-and-white. The light here came from a single overhead daylight source. Retaining detail in the child's visage meant losing it in the background, which helps add depth and space to the picture. HP5 Plus rated at EI 300 and developed in HC110 for 5 minutes.

depend largely on whether the operator prefers to stand or sit, but in any event would not normally exceed 3ft 7in (91-94cm) in height. Check that, at this height, the ceiling height allows full height extension of the enlarger head. Some large format enlargers have an immense range, but need a lot of height above the column to achieve maximum enlargement. I have a 5x7in (13x18cm) format MPP which, when fully extended, stands well over 6ft (1.8m) above bench height. The smaller the format, the less operating height required, but it is always worth checking dimensions before going ahead with bench construction.

You could use an alternative layout, in which more space is assumed and the central feature of the work area is a 'wet' bench with an integral sink unit and running water. Many larger professional darkrooms are laid out in this fashion and to my mind, if space is available, it provides one of the most comfortable working layouts.

All 'dry' areas are kept to the sides of the room and a central, ceiling-hung safelight provides more than adequate illumination over the main working area. For professionals working alone there are added bonuses over the conventional layout. For example, if you are in the middle of developing prints and the telephone rings, you can continue to attend the print from any side of the bench while answering the call. Other multiple tasks, such as washing and drying, are made easier, and usually the layout allows for more convenient storage space.

HARDWARE AND EQUIPMENT

Special attention should be paid to plumbing, waste services and equipment selected for sink spaces. The services of a professional plumber are advised, even though there are now many different types of PVC push-fit pipe fittings available from do-it-yourself stores. The last thing any photographer wants in the darkroom is a leak from a dripping pipe. Copper should be used for hot-water supplies and joints should be silver-soldered. Acorn-type plastic pipe with special connectors is perfectly suitable for the cold-water supply, easy to fit and does not require any special bending; use compression-joint elbows for corners, etc. Provided the water temperature is not boiling, it is possible to use this material for the hot supply too, but copper is safer.

Brass taps of the garden variety with long spouts are ideal. If you include one which has a threaded spout (on the cold supply) you will find this very useful if you need to attach a length of wandering hose.

One of the most important items will be the sink. Some 'wet' benches are basically just one long trough with a deeper trough housing the waste exit at one end. Trade photographic magazines which specialize in professional equipment frequently carry advertisements for darkroom sinks. These are made from polypropylene or fibreglass. Some manufacturers offer a customising service. The humble kitchen sink, unless of stone porcelain or high-grade stainless steel (18-8), is virtually useless. Inferior grade steel stains easily and, if constantly splashed with hypo (fixer), will soon begin to corrode. This is not to say that it is completely out of place in a darkroom. I've managed with one for years. However, it is worth hunting around for a sink large enough to take at least a 12x10in print; even better if you can find a flush-mounting stainless bowl that can be let into a fibreglass base.

Polypropylene is commonly found in industry and is used for a variety of products including storage bins and trays. Farmers and dairy producers use them and will know where such products can be obtained if you cannot find a local distributor. Lists of plastics manufacturers are to be found in the telephone directory and they are worth investigating before committing funds elsewhere. Brass and stainless waste fittings are available from builders' merchants; a hole-cutter of the right size on the end of an electric drill and a little silicone sealant is all that is required to make a perfectly usable darkroom sink.

Much of the furniture, such as base units, shelving and so on, may be custom-made using materials already described in Chapter 1. Free-standing floor units are quite suitable, if they are to be used only as cupboards. 'Dry' benches should be firmly secured to the wall, using battens and firm uprights screwed to the floor. Some kitchen wall-cupboards are inexpensive and can be fitted above the ends of a dry bench to provide clean storage space for stocks of paper, spare bulbs and anything else you want to keep out of harm's way.

A lot of money is often spent unnecessarily on items of equipment which cannot possibly have any effect on the final print quality. A fairly long list of essential items follows, with brief details as to preferred type. If trade names are included, it is because I have found these particular products to be robust, accurate and functional. The enlarger is dealt with separately in Chapter 3.

SAFELIGHTS

Efficient safelights are essential in any darkroom. Not only must accidental fogging of sensitized materials be prevented at all times,

but the operator must be able to see clearly around the main working areas without suffering the slightest eye strain. Safelights come in all shapes and sizes, from the small 5x7in wall-hanging type, which facilitates easy filter change, to huge overhead sodium types and plug-in globes of varying colour. Ordinary coloured lightbulbs used by the thousand along the promenades of seaside resorts are invariably of too great a wattage (power) to be considered 'safe': 15 watts is the safe maximum for smaller work areas. They can be fitted directly to a suitable wall-mounted socket or used in photographic safelights. This type of bulb, known as a 'pygmy', is available through most electrical wholesalers and, provided they are fitted with a black baffle at the base to cut out the small amount of white light which escapes through the unpainted portion of the bulb, make ideal safelights for most black-and-white and lithographic film processes. I have used these lights in tandem with conventional safelights in my own darkrooms for many years with no adverse effect and vastly improved working vision. It should be emphasized, however, that it is important for every photographer to check thoroughly the safelight level before any serious work is begun in a new darkroom.

All safelights should be placed a minimum of 5ft (1.5m) from any area where sensitized materials are likely to be left exposed, such as the 'wet' bench area and in the immediate proximity of the enlarger. Once you have placed all lights strategically, carry out this simple test.

SAFELIGHT COIN TEST

Turn all safelights on. Take two sheets of black-and-white printing paper of approximate grade 0; with emulsion face uppermost, place one sheet on the enlarger baseboard, the other in a clean, empty developing tray in the 'wet' bench area. Take several coins and place three or four over each sheet of paper. Leave the darkroom for one hour. On returning, tear off a small corner from the sheet of paper left under the enlarger. The missing corner is a marker to tell you which area of the darkroom it came from. Mix a small amount of fresh developer and process both sheets of paper for

double the recommended time. Stop and fix normally. Rinse both prints for a few seconds, drain and turn on normal room lighting. If your safelights are really 'safe', the base white of the processed paper should be as white as its own reverse side. Check this by simply folding a third of the paper over so that you can see both the reverse and emulsion side simultaneously. If the emulsion looks at all grey, even vaguely dirty white, thoroughly check the emulsion side for evidence of coin shapes. If you can see them clearly, you have a safelight problem which must be solved before any further work can be carried out. If both sheets of paper are pure white, without any trace of coin shapes or visible tone differential, work can proceed. If you are in any doubt about the whiteness of the paper base after processing, take both sheets of paper into daylight for a further check.

Irregular and darker patches on the paper usually indicate that something other than safelights are at fault. Check all window seals and any existing outer wall ventilation bricks or cavities. Stray light entering from the latter is not always immediately visible to the naked eye; turn off all lights, including safelights, and just stand in the room for two or three minutes until your eyes become accustomed to the darkness. If there is any stray light entering the room, your eyes will soon spot the reason why. When you have remedied the fault, try the coin test again.

SAFELIGHT COLOUR

Safelight colour will be determined by the type of material being handled and predicted work. Dark green is the colour commonly associated with the development of panchromatic film, but not as an inspection lamp. It gives a very low level of illumination, barely sufficient to enable the operator to see anything. It is much better if you start out by learning how to do everything in complete darkness by touch. Use the glow of the green to see whether sheet film being dish developed is properly fixed.

Do not use the lamp for inspection of film undergoing development. Pan film is sensitive to all colours of light.

Tri-X rated as ISO 400 and developed in D-76 diluted 1+1. Lens was a 105mm Nikkor used wide open with available window light. Continuous but slow agitation in daylight tank. Paper, Kentmere Bromide, grade 3.

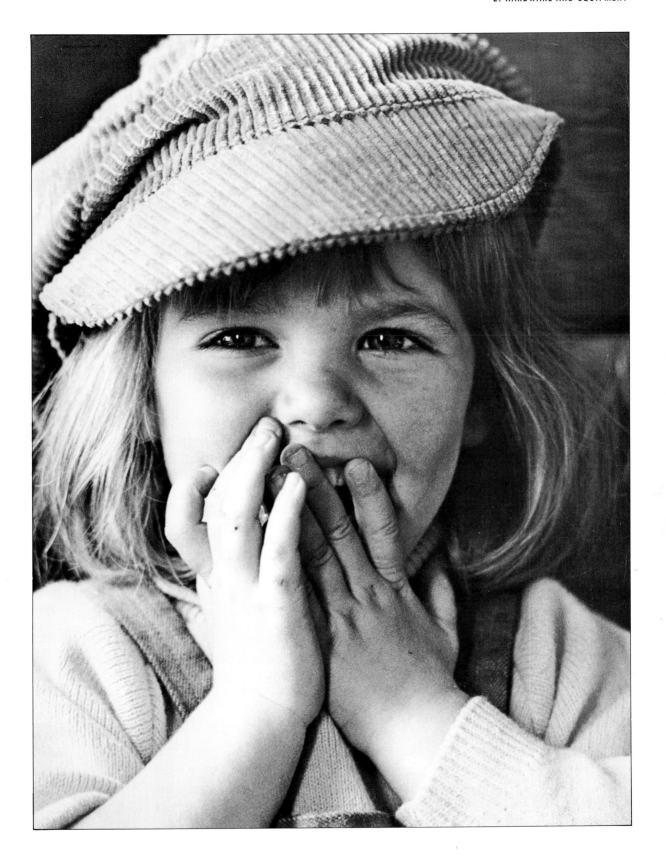

Ships. Printed from a 35mm negative shot on OM1 with Zuiko 180mm f2.8 on HP5 through orange filter. ISO 320 and developed in HC110. Printed on Agfa Record Rapid grade 3. It was burned-in at the top, edges and bottom.

Light amber and red can be used for general illumination, when ordinary fibre-based bromide and resin-coated black-and-white papers are processed. Red can also be used when processing orthochromatic film such as that used in the graphic arts trades. If you are at all interested in producing line negatives on lith film for special effects, a very effective method of processing this film is to use a transparent tray for the developer. Development of the film takes place over a sheet of flashed opal glass or plastic substitute, through which a dark-red safelight is shone from a distance of some 4ft (1.2 m). Reduce the intensity of the light if you have to bring it closer to the developer dish.

Dark amber is used for the processing of colour paper, print film, Kodak Panalure paper (used for making black-and-white prints from colour negative materials) and some positive reversal printing papers.

Always check the paper manufacturer's instructions regarding safelight usage before opening the packaging. Nearly all manufacturers of sensitized materials quote the Wratten safelight filter type by number when specifying safe operating levels. Wratten filters are an exclusive Kodak registered trade name; a typical designation on a black-and-white paper packet would read: 'Open only in darkroom. Use Kodak Wratten Filter Series OC', or '. . . Series 2', and so on. Working photographers refer to most lights used in the darkroom as being yellow, red or green. Do not use coloured domestic bulbs without a neutral density screen or baffle which are either yellow or green in colour. Only red can be considered safe for some of the processes already described.

HARDWARE ITEMS

Most of the following items can be obtained from a local hardware store:

- Industrial rubber gloves, for the mixing of some DIY powder chemicals.
- Overalls or apron, for protection against chemical staining of clothing.

- Cotton tea towels (four at least; rotate two at a time); very useful for wiping utensils, benches, etc.
- Floor mop, of the 'squeegee' sponge type with a lever. Essential.
- Plastic buckets (two); one for the floor and spilled chemicals, the other to be kept solely for mixing of powder chemicals.
- Plastic funnel, large, for the transfer of chemicals, etc. after use/mixing; the funnel can also be used in conjunction with paper coffee-filters, obtainable from food stores; this arrangement is ideal for filtering sediment and emulsion particles from used chemicals before re-use.
- Waste bin and liners; choose the largest bin that can be reasonably housed, since small ones fill too quickly and spill over, creating messy crystallized chemicals which eventually add to the dust problem.
- Kitchen stool; very useful if long sessions are spent under the enlarger.
- Graduated mixing vessels, in 1- and 2-litre sizes available from hardware, catering and some department stores. Graduations should be in fl oz as well as cc and ml.
- Stirring rods (minimum of two required); some people prefer glass, but I use chopsticks made of tough plastic.

DARKROOM ACCESSORIES

The next list of items is best purchased through a photographic dealer. The darkroom accessory market is certainly a minefield for the unwary, but the following items are well worth their expense.

TIMERS
Smiths darkroom timer; a varied range is available, but I have found that the mechanical wind-up type, rated in seconds and minutes from 1 to 60, is the most reliable and durable. Simply set the time required, press a large lever on the side of the timer and away it goes. When time is up, the bell rings in a short, sharp burst. Most mechanical clocks and timers are unaffected by chemical contamination. My experience with modern electronic

types has been less than satisfactory. The Stag twin-range mechanical timer with in/out power transfer and on/off switch: I have had one of these switched timers in my darkroom for some fifteen years. They can be adapted for a number of uses but, as an enlarger timer, the Stag is hard to beat for reliability and accuracy. Professional electronic time switches with built-in exposure measuring devices are available from a variety of sources. The section on printing (Chapter 7) gives details of how to judge exposure to within half a second of accuracy.

THERMOMETERS

Alcohol types are sufficiently accurate to within half a degree. Eastman Kodak in the United States make a range of specialist colour, black-and-white and process (graphic arts materials) thermometers. Electronic Temperature Instruments supplied me with one of their first photographic digital thermometers. The unit is small enough to fit in the palm of a hand and is powered by a small 9 volt dry cell. A wandering lead with probe attached records the temperature of liquids which is then displayed in liquid crystal figures. After years of using an ordinary alcohol stick type, I found the digital read-out faster and much more accurate. It also enabled me to conduct other procedures while reading the instrument from a distance – something I could not do with the ordinary type. There is, however, a price to pay for this convenience. Sadly, I am now temporarily without the unit, having dropped it twice into developer. All attempts to revive it by drying in the hot-air cabinet have failed. Its only fault seemed to be that the wandering probe lead was not really long enough for this kind of work. Ideally, the instrument should have hung on a wall bracket so that the only mobile component, the lead and probe, could be placed in whatever container was in use anywhere on the bench.

DEVELOPING TANKS

One of the best small tanks I ever owned was a Rondinax daylight loading and developing tank. As these tanks can often be found

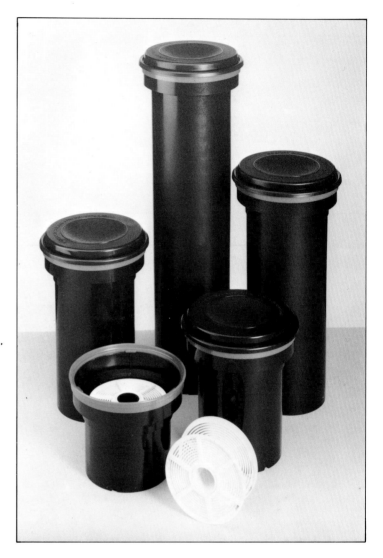

second-hand, the following procedures will be of some interest. The film cassette is inserted into a small chamber in the top of a light-tight bakelite box which contains a 35mm plastic spool and cutter. After cutting off the film leader, the film end is clipped to a rubberised canvas tail fixed to the centre of the translucent film spool. With the lid in place, the knob on the outside of the tank is wound slowly to feed the film on to the spool. When tension prevents further winding, the film end is cut, using the internal knife blade. The film is now ready for processing. A similar Rondinax tank for daylight loading and processing of medium-format film was also manufactured. These tanks are a boon to the

Black plastic tanks and nylon reels from Paterson Products. Tanks can be used for film and paper processing.

*Paterson Products
archival print-washer
tank and basket.*

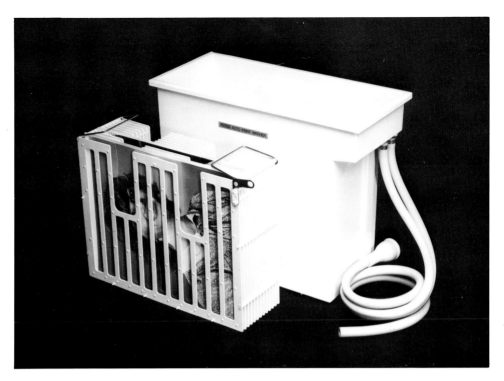

photographer who has no safe place to load ordinary tanks, as well as to the reversal enthusiast who has no need of enlargers and a fully equipped darkroom. One other benefit is that these tanks use very little chemistry and rely on constant turning of the film spool knob to give a 'lick and dip' development.

Popular tanks for the miniature- and medium-format user are made by Paterson. Colleagues who use them regularly tell me they are very good, but I could never get the hang of loading the spools without some mishap.

I find the stainless steel variety preferable. One great advantage is that, unlike the nylon spools used in plastic tanks which must be thoroughly dried, steel spools allow film to be loaded or removed and loaded again while the spool is still wet. Photographers who do not use these tanks tell me that steel spools are difficult to load, so it does seem that the type used is very much a matter of personal preference; the present author has never had one serious mishap with a stainless spool or tank. The loading procedure is an acquired knack, which will come after about an hour's practice, using a gash piece of film loaded into an old

cassette. Loading medium-format film requires the same knack, but is very easy once this is acquired. Brooks, Nikkor and Kinderman tanks and spools are among the better stainless steel products. They are manufactured in sizes to take from one 35mm/120 to up to 8x35mm or 4x120.

Sheet film is preferably developed in tanks using cutfilm hangers. Kodak make a very good range and Combi make a range of sheet film developing tanks marketed under the trade name of Combi-Plan. Cylindrical tanks such as those marketed by Paterson and Jobo can also be used to process sheet film in adjustable nylon spools.

WATER FILTER

An in-line filter in the main darkroom water supply is to be preferred but, if this is not possible for any reason, a filter of the charcoal or micronyl type which can be placed between a tap and a wandering hose is ideal. Water filters help to eliminate many of the problems associated with negatives which become contaminated by hard water, by rust and other foreign matter, which often finds its way into liquid processing chemicals. All solutions

should be filtered before bottling and on re-use, as explained earlier.

FILM-DRYING CABINET

Investing huge funds in camera equipment and not in the darkroom is something of a contradiction, both in terms of respect for one's own ability and for the quality of the final result. Dust, scratch-marks and, worse, film-drying marks are the bane of any self-respecting photographer's life and yet, certainly in the amateur field, very little is available to encourage the concerned enthusiast to eliminate most of the causes of poor-quality prints.

'Hang the film on a line' is an often quoted instruction in much writing on film processing. In fact, if you want prints to be as free as possible of any contamination, they must be dried in an almost sterile compartment. If you value your negatives and want them to remain in excellent condition for as long as possible, use special film-handling gloves which will help prevent fingerprint marking and scratching. The investment required for a commercial film-drying cabinet is quite high. Nevertheless, if you can afford one, it will prove an invaluable piece of equipment. Readers with a little carpentry experience should not find it difficult to build a cabinet, using thin sheets of plywood for the main carcass of an upright box, whose depth measurement is large enough to enable an oblong slot to be cut at the bottom for the insertion of a small fan heater. Ventilation holes should be cut in the top of the box to allow air to escape. A basic plan for this is illustrated on page 28.

A cheaper alternative to the commercial drying cabinet is a wall-mounted hot-air clothes dryer. The unit houses a high-powered fan-blower, a switch for 'high' and 'low' heat settings and a time-switch to operate. A zipped translucent bag is hung by poppers around the machine. Film can be hung from the folding clothes rack. I use such a machine in my own darkroom with complete satisfaction. The air-intake grill can be fitted with coarse foam filters to keep out dust. It will dry a dozen or more full-length 35mm

Marrutt RC35 film-drying cabinet. Ideal for a small darkroom. (By kind permission of Creative Advertising).

films in a few minutes at very little cost. It is also extremely useful for drying resin-coated papers (the techniques for which are described in Chapter 5).

PRINT DRYER

There are many different makes of resin-coated printing papers, which vary considerably in quality and price. One of the most noticeable defects in cheaper papers is the low quality of the finish when the paper has been dried after processing. Some, for example, never seem to stay flat once they have been dried. Buckling of the polyethylene base is a common fault, often caused by an excess of washing and overheating in drying. Delamination of the corners is another fault

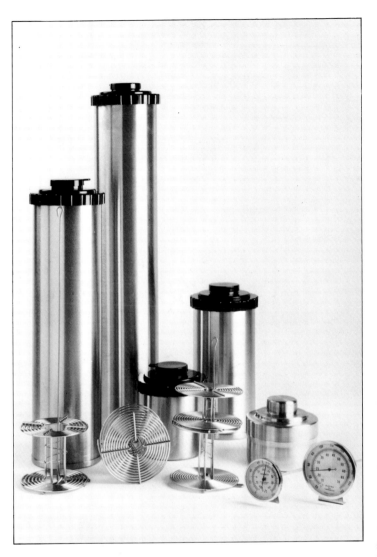

Brooks stainless steel tanks. (By kind permission of Pelling & Cross.)

room than conventional dryers. The electric flat-bed dryer is still one of the most commonly used items of equipment for gloss-finish fibre papers, but is absolutely useless for drying resin-coated paper.

Rotary glazing machines are few and far between. Commercial processors having switched almost entirely to resin-coated papers. The market for rotaries is now confined to a very small sector of the amateur field. Photopia used to market a small rotary glazer for fibre prints, but even these are no longer available, except occasionally on the second-hand market. If you have room for one of these machines and are a fibre paper enthusiast, then certainly acquire one if the opportunity arises. A highly polished drum in good condition will glaze a gloss-fibre print and give it a finish that will make even the best-quality resin-coated print look dull by comparison. The Kodak 15in (38cm) Velox dryer is an ideal size for most smaller darkrooms.

Resin-coated paper users have a greater choice of print dryers, and all at widely contrasting price levels. The Ilfospeed RC dryer uses sponge-covered rollers and infra-red heat lamps to dry the print. The machine is fast, producing a wet-to-dry print in seconds rather than minutes. The price of one of these machines is relatively high compared with that of a hot-air tray/shelf blower type, of which there are many different types available. The cheapest hot-air dryer consists of several plastic-covered wire shelves, rather like vegetable racks, which are inserted into a metal box, at one end of which is installed a dryer of similar specification to an ordinary room-heater. These machines are available from a number of retail and mail-order outlets specializing mainly in equipment for the amateur market. Such dryers are quite adequate when only a few prints at a time are required. Each print needs to be turned every few seconds so that it dries evenly; to do this comfortably no more than two 10x8in prints should be inserted at a time. The main problem with all these machines is that the hot air does not circulate evenly and, worse, prints take a very long time to dry, unless they have been properly 'squeegeed' first. One remedy for this is to

with similar causes, so there are good reasons for the buying the best quality you can afford.

How best to dry resin-coated papers is a problem which has beset amateurs ever since the material was introduced. Ordinary fibre-based papers caused fewer problems, partly, I suspect, because long use has enabled photographers to develop satisfactory solutions. The 'sandwich' technique, using layers of blotting paper, though protracted, gives extremely flat and stable prints, especially with matt, semi-matt, lustre and satin-finish papers, and the blotting paper does not damage the paper surface. Fine-screen fibreglass drying screens are also available and can be used for fibre or resin-coated papers, but they take up more

acquire an air-blower model, which incorporates its own roller 'squeegee'. Another is to adapt an old washing-machine mangle (with composition rubber rollers) so that it can be mounted close to the wash tank. As prints are removed from the wash, they are then passed one by one through the rollers. A sheet of plastic-laminated board placed vertically at an angle to one side or at the back of the sink makes a useful platform on which wet prints can be wiped with a length of 'squeegee' blade. This is certainly a cheaper remedy.

My own method utilizes the base and part of the roller system from an obsolete stabilization print processor. These machines work on the 'lick and dip' principle. By removing the two sets of dip rollers and by adjusting the position of the remaining sets, a very efficient motorised 'squeegee' enables large quantities of prints to be put through to the film-drying

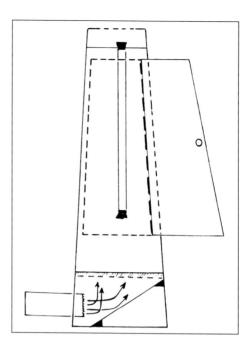

Plans for a home-made full-length film dryer using thin plywood faced with melamine and 1-2kw fan heater.

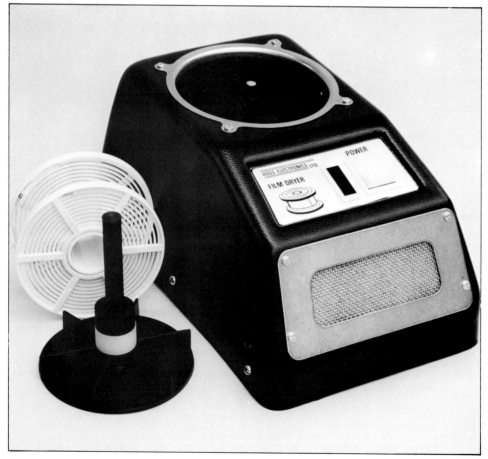

Single spool film dryer made by Ross Electronics Ltd, and distributed by John Boxall (Photographers) of Cuffley, Hertfordshire. Drying time is between 20 and 30 minutes.

Bench-top modular print processor – the Durst Printo – can be purchased in parts as additional processes become necessary. This model is assembled for 3-bath processing and has an integral print dryer fitted at right.

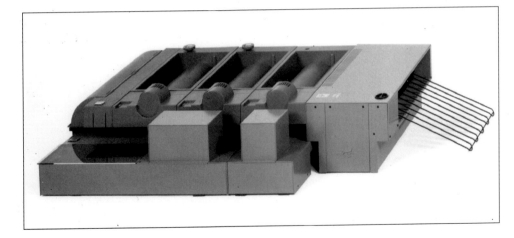

Durst film dryer with enclosing soft PVC cover, similar to the one described in the text. (Both by kind permission of Durst UK Ltd.)

cabinet. Prints are hung by one corner, using rubber-edged clips obtainable from a hair-dressing supplier. Because the down draught from the blower circulates the air more efficiently, up to twenty 10x8in prints can be dried in a matter of minutes, giving a very high gloss finish, without any tendency to curl because of over-heating.

MISCELLANEOUS ITEMS

By now the darkroom inventory will be almost complete. There are numerous miscellaneous items not discussed at length which will still be essential and these are listed as follows:

- Film hanger clips; these should be weighted and in stainless steel; use hairdresser's perming clips, mentioned above, for hanging prints and films in home-made dryers.
- Polythene storage bottles (at least 4.5 litre capacity) for liquid chemical storage. Glass 'winchesters' used by pharmacists are ideal if chemicals cannot be dark-stored.
- Filing cabinet; this should be of a suitable size for storing negatives.
- Negative files: the loose-leaf glassine type for miniature and medium format negatives, if these are not stored singly in glassine envelopes.

- 📷 Scissors: Wilkinson straight-edge type for various tasks; both short and long are useful.
- 📷 Print tongs, for handling prints in open trays; use rubber gloves if preferred.
- 📷 Dust blower: the compressed air type, or large, soft dusting brush or anti-static brush or all three. A lens cleaning cloth is also useful. Do not use paper tissue of any description if you value negatives and lenses!
- 📷 Rotary cutter, for print trimming.
- 📷 Dry-mounting press, or domestic iron together with a supply of mounting tissue; sheets of self-adhesive paper can be used, or contact adhesive available from graphic arts suppliers. A supply of mounting card, available from art shops, and a mount cutter will also be needed.
- 📷 Dodgers: various shapes of dodging aids for the purpose of 'burning-in' and 'holding- back' certain portions of prints are essential. Experience will show which shapes are the most useful. Many

professional printers use their hands only, and it would be as well to start learning how to accomplish this technique at the beginning of your printing career. In my experience, the only really useful aid, apart from hands and fingers, is a 4in square piece of black card with a circular hole cut in the middle. It helps if the hole, which will vary in size from approximately ¼in (6mm) in diameter to a little under ½in (12mm), has a furred edge. It may be necessary from time to time to cut out shapes from black card which can be utilized as customised dodger masks which fit the subject.

- 📷 Spotting brushes and inks, surgical scalpel: all for retouching prints.
- 📷 Stanley knife or craft knife, fitted with a retractable blade, for general-purpose use.

Not all of the items listed above are essential for general printing but, if you hope to produce good-quality work, you will find that everything has a specific use and that skimping will only make life tiresome. As time passes, your inventory is bound to increase, not just because of new developments which take place from time to time, but because inevitably there will be some items not listed here which you may find essential for certain types of work. And it is always pleasant to acquire the odd luxury item, even if its use is only occasional.

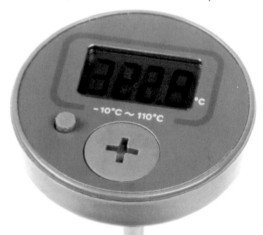

Probe-type thermometer (far left), which drops into Durst Printo modules, and a Durst paper safe (left), available in single units, can be added to as necessary. The safe modules are interlocking. (Both by kind permission of Durst UK Ltd.)

THE ENLARGER

Some photographers know instinctively what format, type and marque of camera equipment they want to buy, without having to spend hours mulling over reports or advertising propaganda. A great many others are prepared to investigate the market thoroughly before making a decision. Rather less attention seems to be given to the one piece of darkroom equipment which will show whether the camera and lens you chose is any good or not. One only has to look at the plethora of enlargers on the market to decide that whoever was responsible for the design work probably was not a photographer or a practising darkroom technician.

The vast majority of amateur units available through retail outlets are mass-produced, are too light and rely on cheap and sometimes badly finished components, the consequence of which is that most photographers have not much hope of producing finished work which is truly representative of their camera's worth. Happily, this sweeping generalization does not apply to every marque, but there are many machines on the market which are neither worth their price nor fit for serious use. If the same consideration given by photographers to their choice of camera were given to enlargers and their lenses, I am sure that the general quality of work would improve.

CHOOSING AN ENLARGER

When choosing an enlarger, various points have to be taken into consideration; the most important of these are discussed below.

BUDGET
If you are planning to invest in new equipment, weigh up whether the extra price you will pay as against the cost of a second-hand

item is going to be worth the guarantee and the packaging. Diligent searching and inspection of used goods will often turn up just what you want, perhaps for a lot less than the cost of new equipment. This obviously does not apply to everything and there are some items of equipment which I would not give a thought to purchasing in used condition. However, if you have time and enthusiasm to chase advertisers, there are some good bargains to be had.

OPERATION
Simplicity, ease and accuracy in operation are the three main requirements of an enlarger. To achieve these the manufacturer must work to fine tolerances. A good enlarger is the result of precision engineering, coupled with an understanding of operational requirements. Focus adjustment can be achieved in several ways. Coarse focus (image magnification) is adjusted by raising the enlarger head up and down the main column. Various devices are used to achieve this end, including rack-and-pinion, spring-loaded collar with recoiling-spring steel band or counterbalance wire and weight and brute-force friction collar on column. Fortunately, not many of the latter type are now made, but there are plenty of the former types in various guises.

The key is to select the smoothest mechanism requiring the minimum effort to move the heaviest head. Fine focus is usually adjusted at the lens panel, either by helicoid bellows adjustment, using a friction wheel on steel extension bars (older types) or by rack-and-pinion. The mechanism to achieve fine focus should be as smooth as that of a camera lens, requiring the minimum amount of effort by the user. Any enlarger that requires much more than fingertip effort to control is simply not worth the trouble, no

matter how complex the computer it employs to calculate exposures.

LIGHT SOURCE

There are three main types of light source used in enlargers. These are, respectively, 'diffused', 'condenser' and 'cold cathode'. The first two utilize conventional tungsten or halogen light sources, which are then either diffused through a sheet of flashed opal glass (white plastic in many cheaper models), or the light rays are gathered by optical condensers to provide an even spread of light over the negative. General purpose enlargers, capable of handling negative sizes from the larger medium formats down to miniature, often have only one set of condensers to carry out this operation. To achieve correct magnification of the image, differing focal-length lenses are inserted in the lens panel. The printed image from smaller formats invariably suffers. The flashed opal diffused illumination is preferred by some photographers because it has the apparent effect of reducing visible film grain in the print. Diffuser-type enlargers are often difficult to focus correctly and apparent print sharpness is sometimes inferior. They are not good if your negatives are slightly shaken or unsharp for any reason, but useful for high-key and portrait work, where subtle and flattering results are required.

Cold cathode light sources provide even illumination across the negative, without the use of condensers, resulting in enlargers considerably smaller in size, format for format, than those utilizing conventional tungsten sources. Cold cathode enlargers are, however, mainly available only for formats of 5x4in or larger. The light source is constructed of thin opal glass tubes, moulded into a square or rectangular grid. Some enlargers of this type are fitted with mercury-vapour filled tubes, while others utilize light-corrected fluorescent tubes. Cold cathode sources are not always compatible with colour printing materials and often have a peculiar effect on some variable contrast black-and-white papers. There are listed fluorescent specialists who can make colour corrected light tubes to size. Custom-made tubes are usually expensive. Cold cath-

ode advantages are few, the main one being that the lamp house does not get very hot, which allows some larger format negatives to be printed using glassless negative carriers. The main disadvantage is that the nature of the light makes the baseboard image difficult to focus when negatives are dense.

Many enlargers on the market today use low voltage DC lamps in conjunction with sophisticated electronic circuitry and a reflex system of mirrors and single convex condenser lenses to project the light source. This enables manufacturers to design smaller, more compact machines. The penalty is that they are often lighter and therefore do not have the rigidity of older 'heavy metal' lamphouse models. It is therefore essential to ensure that your enlarger will be mounted on a firm and solid base which cannot be subject to vibration.

Durst was one of the first manufacturers to introduce the reflex lamphouse over two decades ago. Some of their modern enlargers are illustrated on these pages. For the average amateur, their range represents excellent value. One of the best enlargers made in recent years in the United Kingdom were those manufactured by MPP (Micro Precision Products). Sadly, the company ceased manufacture some time ago, but their range included three superb models for large and medium-format work, as well as a general purpose machine which easily converted from a medium-format enlarger to one capable of taking miniature negatives by the simple changeover of condensers, negative carrier and lens. Nearly all of the black-and-white and colour prints made for this book were produced on MPP equipment.

FOCUS

Two methods of focusing are available: automatic and manual. In the first mode, the enlarger is set up at a predetermined level of magnification and accurately focused. Thereafter, the head of the enlarger can be racked up and down the column to any level of magnification and the negative will stay in focus at any stage. For 35mm work, the Leica V35 is probably the most sophisticated autofocus machine available.

Gem 67 enlarger fitted with variable contrast filter head suitable for printing variable-contrast black-and-white papers. (By kind permission of George Elliot & Sons Ltd.)

Focus on most manual enlargers is adjusted using a single rack-and-pinion wheel device which moves the lens panel as required to give the sharpest baseboard image. Sharpness of the image can be checked using a grain magnifier while simultaneously operating the fine focus control. The latter method is slower in operation, although once you are used to a particular enlarger and use it frequently, I doubt that the operational time difference between the two methods would be very noticeable. I know that when I am using an automatic I spend more time checking and re-checking the focus than I would when using my own manual machines.

NEGATIVE CARRIER

Just as film flatness in the camera is of critical importance to negative sharpness, the degree of flatness of the negative at the enlargement stage will have a profound effect on print sharpness. The choice of carrier type in enlargers is twofold: glassless or glass sandwich. Both have drawbacks in some respects. In the case of the latter, the negative is positioned in a carrier comprised of two sheets of optical glass flats . This provides four extra sides of medium through which the light must be projected and on to which all kinds of foreign matter may cling. Dust can turn up anywhere, causing problems for the concerned print-maker and costing hours of time in its removal and the retouching of prints affected by it.

Glass carriers are preferred for larger formats where, if no heat shield is present in the enlarger, heat generated by tungsten source illumination will cause minute buckling of the negative. This phenomena is particularly noticeable when using medium or large format negatives which have a very thin base. Any undue warping of the negative will make it difficult for the printer to focus the image evenly across the print easel. Because of its physical size in relation to larger formats, miniature film tends to be more stable and less affected by heat.

Larger formats, on the other hand, require less magnification to achieve larger print sizes and, therefore, any dust or foreign matter

accumulated on a glass carrier will be less noticeable in the resulting print than on a same size print made from a smaller negative enlarged through glass.

One other phenomenon which may occur in the use of glass carriers, particularly if the glass is non-optical in quality, is Newton's Rings. These appear on the baseboard as a series of concentric coloured rings which can appear on the print. It is the result of the glass carrier sandwich being forced apart by the slightest pressure exerted, usually on the top plate, when a negative buckles under excess heat. The change in shape of the negative is sufficient to cause uneven contact with one or other or both glass plates, resulting in an unsightly mark on the print, which may at first appear to have the characteristics of a water-

Range of enlarging easels. (By kind permission of Pelling & Cross.)

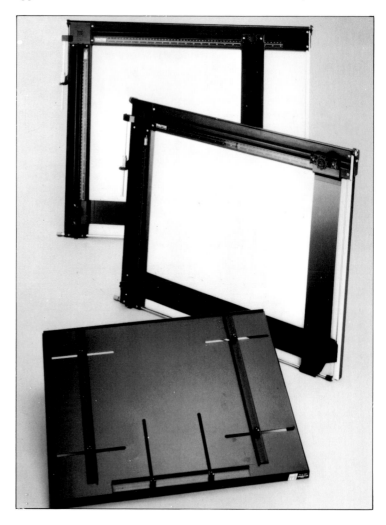

mark on the negative produced in the film-drying process.

Anti-Newton's Rings glass, such as that used in projection quality transparency mounts, can be used in some enlargers which are fitted with diffuser type light sources. However, the etching is usually too coarse, resulting in a mottled print effect. The correct material for enlarging purposes is very finely etched, like the fine, clear matt screen in a single lens reflex camera. Newton's Rings can be eliminated by ensuring that your enlarger is fitted with a heat shield glass above the condensers or between condensers and negative stage. It should not be in contact with the negative and should be sufficiently distanced not to cause further problems with the focusing of dust particles.

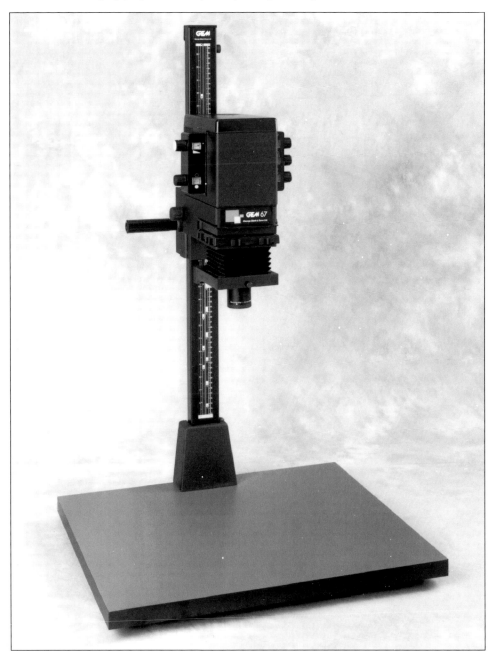

Gem 6x7 enlarger with colour filtration module head fitted. (By kind permission of George Elliot & Sons Ltd.)

When all the evidence is weighed, there is a fairly strong case against glass carriers, especially for the small and medium format user. With larger formats, they are more or less essential. Most auto-focus enlargers are fitted with glass carriers as a matter of course, as are many enlargers on the amateur market. In practice, there is no question in my mind: glassless carriers are to be preferred every time.

DISTORTION CONTROL

If you own a camera with 'movements' (one which has a rising, tilting, horizontally movable front lens panel and similar film plane movements), you will know just how useful this can be in helping to produce distortion-free negatives of some subjects. Such movements are particularly useful in architectural, product and close-up photography. Special lenses are available for both miniature and medium-format cameras, but they are expensive and, unless you have a regular use for them, are not normally considered essential items of equipment. An enlarger equipped with swings and tilts at the negative and lens panel stage can very often be used on those odd occasions when it is necessary to correct, say, obvious vertical distortions of buildings taken on a camera without the means to remedy the fault.

Distortion correction using the enlarger is not an alternative to correction made at the time of the original exposure in the field, and the degree of success in making adequate corrections in the darkroom will depend largely on the versatility of the equipment. The enlarger lens panel, negative carrier and easel should all be capable of independent movements, not only in one direction in an arc moving from left to right, but also back and forth when the equipment is used facing the operator in its normal bench-mounted position. If this is not possible, some means of rotating the negative is necessary. This is a feature sometimes found in large-format enlargers and some more expensive professional small-format equipment. Those without can only be made to produce correct results with difficulty.

Durst Magico 35mm enlarger (above) suitable for the novice student and Durst M370 colour and M370 BW enlargers (left) suitable for more advanced work. (Both by kind permission of Durst UK Ltd.)

However, it should be emphasized that it is not essential that any enlarger be fitted with any of these refinements if some small degree of correction is to be accomplished. Simply by raising or lowering one end of the print easel, moderate distortion can be significantly reduced. A pile of books or block of wood supports the attitude of the easel in this fairly primitive but traditional method (see page 104).

MAGNIFICATION

To quantify image magnification numerically the following formula is used:

$$\frac{\text{Lens to paper distance}}{\text{Lens to negative distance}}$$

In purely lay terms, the maximum magnification possible by any enlarger, when used in its normal bench-mounted mode, will depend entirely on the height of the column when measured from the baseboard. Nearly all enlargers are capable of being used in different modes; the head can be swung through 180 degrees to allow floor projection to take place. Some have heads which can be swung through 90 degrees to allow horizontal projection and some are equipped with columns which are extendable. In the normal course of events, magnification figures for off-the-shelf enlargers vary between 8 and 19, for 35mm formats, to 6 and 19 for medium formats. These figures apply to enlargers manufactured for specific negative formats. The figures for general purpose machines will vary according to column height, negative format and focal length of lens used.

COLOUR HEAD

There are several advantages to having an enlarger fitted with a filter drawer or integral dial-in

This Durst enlarging lens offers a fast 2.8 maximum aperture, suitable for printing very dense negatives with shortish exposure times. The lens is made to a Zeiss design. (By kind permission of Durst UK Ltd.)

dichroic filter head. For colour work, colour balance filters are essential in both negative and reversal printing. They are also very useful when using the enlarger to make duplicate positive film transparencies and also for variable-contrast black-and-white paper printing. If you specialize mainly in black-and-white work and like the 'Poly-contrast' or 'Multigrade' papers available, a dial-in filter facility gives the operator more subtle control than a standard filter pack used in conjunction with a filter drawer.

The advantage of a colour filter head is that some manufacturers incorporate electronic circuitry in the head which enables the printer to assess the correct colour balance and exposure for every print, regardless of size. With such facilities, work can progress at a fairly rapid rate, though I am none too certain that working blind in this fashion actually teaches the uninitiated very much about the techniques of colour printing. The manual insertion of separate filters and inevitable calculations with regard to test exposures does have benefits in this respect.

The only significant advantage of enlargers fitted with a filter drawer are in the cost department, and it may well be that funds saved in this area can be added to the cost of a really high-class enlarging lens.

LENSES

You will need lenses of differing focal length for different negative formats. There is really very little to say about the lens, except that, aside from the general features of the enlarger already mentioned, it is the single most important feature of any enlarger.

A lens of adequate quality will only produce adequate quality prints. Fast, wide aperture lenses are not important or practically very useful unless the negatives you produce are constantly over-developed or over-exposed, or both, in which case an extra stop may help in viewing the projected image; it will do little for print quality. With normal negatives, the print exposure time becomes so short as to be impracticable for generous management.

FUNDAMENTALS OF BLACK-AND-WHITE PHOTOGRAPHY

The successful origination of prints from negatives in black-and-white or colour work, and from reversal materials (transparency), will depend always on the quality of the intermediary. The quality of the negative is defined in broad terms as being 'normal', 'dense' or 'thin'.

A *normal* negative is one in which the subject-matter has been rendered sharply in a range of tones exactly matching the tonal values of each colour of the subject. Such a negative will have adequate density in the highlight (dark) areas and visible detail in the shadow (light) portions, with clear distinctions of the range between these brightest and darkest areas, permitting a relatively short exposure to paper in order to obtain a clear, bright and fully developed print within a specified time.

Dense negatives are the result of over-exposure and/or over-development, and are easily identified by their lack of contrast and delineation of tonal values. They yield flat, greyish prints in which there is no apparent sharpness and in which film grain is more evident than from an equivalent 'normal' negative.

Thin negatives are identified by their overall translucency and inability to produce sharply-defined, bright, clear prints with a full range of tones from the purest white through to black. The cause is invariably one of under-exposure and/or under-development. The most common cause is under-exposure.

FILM AND FILM EXPOSURE

Understanding the fundamentals of film exposure is of paramount importance to any photographer who hopes to produce consistently good results from the darkroom. Problems with over- and under-development can sometimes be rectified, but if too little exposure in the origination has caused certain elements of the subject-matter to remain unrecorded on film, there is very little that anyone can do to remedy the fault.

Three common methods of assessing exposure in the field are:

- Use of a hand-held light meter
- Use of in-camera meter
- Use of film manufacturers' recommended exposures.

The latter are to be found on a sheet of instructions packed with each film, or indicated by simple symbols on the packet.

By following the detailed instructions in the film pack, anyone should be able to make adequate exposures. However, without some kind of understanding as to how light affects film and how variation in exposure can be utilized to produce constantly predictable results, the photographer may spend much of the time working blindly. As we shall see in due course, exposure variation is not enough in itself. Varied development techniques, as well as the use of different developers coupled with exposure techniques, should all be mastered, and the results of each experiment indelibly printed in the mind for future reference.

If this sounds at all complex, let me assure the reader that it is not. Exposure and development variations follow established guidelines which are flexible enough to allow for individual experimentation. Once the basic knowledge has been mastered, the only limitations on what can and what cannot be achieved will depend largely on the ingenuity and imagination of the photographer.

Firstly, let us consider the mechanical aspects of photography and print-making in

their simplest terms in relation to the one phenomenon which makes the process possible – light. The human eye is capable of absorbing a brightness range – the difference expressed as a ratio between the brightest (highlight) part of the object and the darkest (shadow)) – of as much as 10,000:1. Most black-and-white panchromatic film is limited to a brightness range of 1,000:1, while average ISO 100 colour reversal films are limited to about half that figure. The photographic print has an even lower capacity, as little as 10:1, and a maximum of 100:1. The reader will see immediately that an enormous gulf exists between what the eye can easily differentiate in tonal terms and the capabilities of film and paper.

The photographer should never lose sight of the fact that the brain sorts information (in this instance) subjectively; it reacts to instantaneous change by whichever set of emotions and senses are stirred into action at any given time. These are themselves affected by subtle, almost undetectable changes in the levels of ambient light. For example, in examining a scene in which large expanses of lighter objects predominate, the brain may be deceived into thinking that a black coat in the scene is the darkest object. Look longer at the coat and it will be seen that even this has areas of darker tone in the shadow areas. The camera, exposure meter, film and paper, on the other hand, are all ingredients of a mechanical recording process which is therefore only capable of producing a limited representation of reality.

FILM TYPES

A huge array of film types from different manufacturers is available to the photographer. Familiarisation with as many different brand types as possible will allow the photographer to select types which are the most suitable for specific tasks and eventually to concentrate on two or three emulsion types for most work.

In black-and-white, panchromatic is the most commonly used emulsion. Pan(chromatic) type films are sensitive to all colours of the spectrum and to ultra-violet light. Each subject colour is recorded on the film as a grey tone and

its density will depend largely on the brilliance of light reflected by the colour of the subject. Unexposed and exposed but unprocessed film should be handled in total darkness.

Another type of emulsion is orthochromatic, which is insensitive to red light and can therefore be handled under a red safelight. It is sensitive to blue, green, yellow and ultra-violet light. Red-coloured subjects photographed using this material appear dark, while blue subjects appear lighter. Ortho film is mainly available in sheet form. Agfa make it in 35mm format. Ortho film is ideal for document copying and can be used effectively for some industrial subjects or those which lend themselves to a graphic 'soot and whitewash' interpretation.

Infrared film is a panchromatic emulsion in which sensitivity to red has been extended into the invisible, electro-magnetic spectrum where infrared radiation from the subject-matter is used to expose the film. Subjects which do not emit sufficient quantities of infrared radiation may be photographed using a dark-red filter or infrared filters in conjunction with normal light sources, such as flash, tungsten and daylight. The following filters are useful in obtaining accurate results with infrared film: Wratten 15, 29 and 88a (orange, dark red and black).

Infrared photography is used extensively for forensic and scientific purposes, notably the photography of important historical documents, paintings and other works, more usually to help establish fraud and to uncover works and details normally hidden to ordinary vision.

Chromogenic black-and-white film, unlike ordinary panchromatic and other silver halide emulsions which produce the image through the action of light on the halides which is then converted to metallic silver in development, produces a dye image through the use of colour couplers in the same way as colour negative films. In development, the couplers are activated by chemical residues from developed silver. The more exposure to light, the more silver is produced, with more chemical residue and thus more dye. A bleach-fix bath after development simultaneously removes the residue of silver and stabilizes the image.

Chromogenic films have exposure latitude and fine-grain characteristics. Ilford's XP2, for example, has a high ISO rating (400), but exhibits grain characteristics more often associated with conventionally developed fine-grain panchromatic films. Chromogenic film also has a much greater brightness range than panchromatic film. Film normally rated at ISO 400 can be exposed for values of as little as 50 and as much as 1600 ISO on the same film without recourse to extended or curtailed development techniques. An advantage for the photographer more usually engaged in producing colour negative material is that the same chemical process (C-41) can be used for processing black-and-white chromogenic stock.

FILM SPEED

Each film pack should contain both directions for correct exposure, given certain lighting conditions, and instructions for development, using tested formulae. In-camera exposure will vary according to film speed, which is ascertained according to its light sensitivity. Film speed is designated with the universally accepted numerical ISO measurement, which to a very large extent has replaced the earlier ASA and BS measurements. The German DIN equivalent is still used in conjunction with ISO. The nominal speed of each film is usually marked on the cassette as well as on the packaging.

Film is normally categorized as slow, medium or fast. The lower the ISO figure the slower the film, the higher the faster, and so on. In very simple terms, this information will give the photographer some idea of each film's exposure range, of practicable shutter speeds and lens aperture settings for given lighting conditions. To the more knowledgeable photographer, ISO figures will also be indicative of other film characteristics, including ability to delineate fine subject detail, acutance, contrast, grain characteristic and tonal (brightness) range.

DEFINITION

The ability to delineate fine subject detail, commonly called definition, is dependent on two main factors. One is the grain structure of the film. Minute particles of silver salts, comprised of a mixture of halogens (silver bromide, silver chloride, silver iodide and silver nitrate), are scattered over the supporting gelatin base of the film. Grain structure and density is varied in manufacture to provide the basic slow, medium and fast characteristics: fine-smooth and coarse-grained emulsions. All of these characteristics are subject to further change during the course of exposure and development.

Acutance is the measurement of film sharpness, but can normally only be accurately

It is more difficult to achieve impact with colour. In this picture, use is made of a mainly monochromatic colour range and combined with an unusual viewpoint. This, and the photograph on the next page, are effective in colour but would lose much of their impact printed in black-and-white.

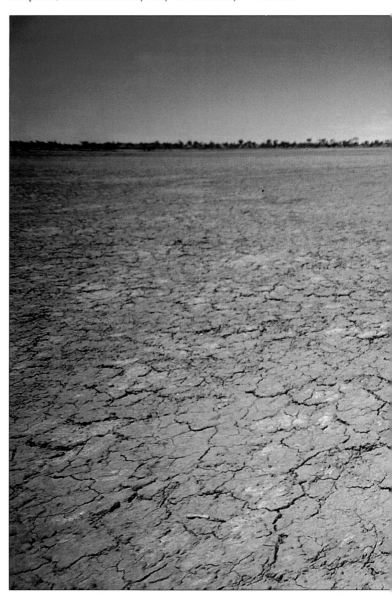

measured under a microscope using a densito-meter. In practice, the term 'high acutance' is given where the demarcation line between light and dark subject tones is very narrow. When film is exposed there is a tendency for extraneous light to be scattered over the emulsion surface, which causes a slight fluffing of the tonal separation zone. Its effect is less noticeable in finer-grained film than in high-speed, coarse-grained emulsions (see page 111). Grain pattern and acutance are both subject to over- and under-exposure, as well as over- and under-development. Both are also subject to physical change if unsuitable developers are employed to realize the image.

Grain structure in the final print is nearly always the most noticeable phenomenon, apart from that of overall sharpness. A fine-grained film will not necessarily yield sharp pictures as a matter of course. It will, however, show more subject detail where the zone of sharpness is apparent. Coarse-grained, high-speed films are capable of acute apparent sharpness, but format for format are less capable of high resolution than slower speed emulsions.

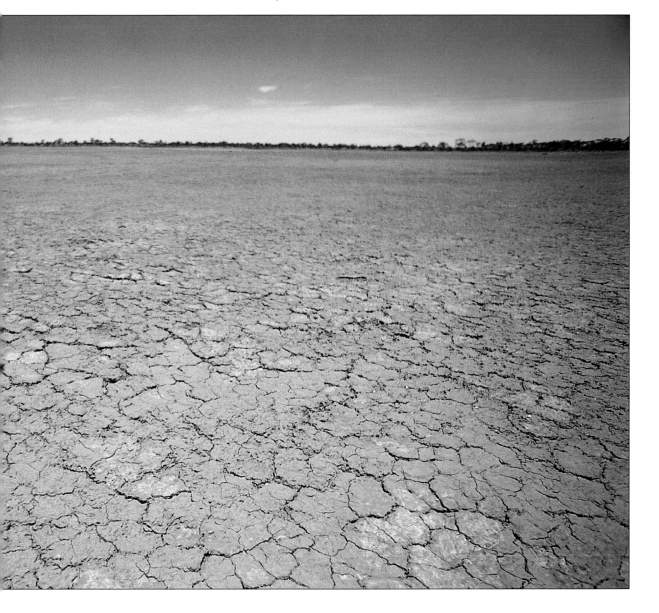

In black-and-white work, the varying effect of granular structure has long been used by photographers for special effect. In recent years, the characteristics of coarse-grained colour emulsions have been exploited to create the 'Pointillist' effect favoured by some artists at the turn of the century. Certain high-contrast film developers, high-speed print and lith film developers can be used to increase the apparent effect of grain in most emulsions, but are particularly successful in conjunction with fast emulsions.

The ability of film to produce sharply defined images is dependent on several factors. Grain structure is one. Thickness of the supporting film base is another; the thinner the better. Accurate exposure and accurate development using the time and temperature method is equally important. Film contrast and tonal range are other factors.

Slow-speed film is generally recognized to be capable of high definition, but not necessarily of acute sharpness. Slow-speed, fine-grain film has high contrast which effectively compresses tonal range. The opposite is true of high-speed, coarse-grained emulsions. When matched to suitable subject-matter under 'ideal' lighting conditions, both types will produce sharply-defined images. But sharpness is a subjective phenomenon and there will often be instances where apparent sharpness may be more effectively reproduced using low-contrast emulsions in conjunction with high-contrast printing papers. The greater the contrast between tonal values and the fewer values contained, the greater the effect of sharpness.

BRIGHTNESS RANGE

Let us return now to the ability of film to record a given range of brightness; the reader should now begin to understand that some emulsions are capable of recording an

Bright contrasting colours heighten the neutral colour of the building. In black-and-white, much of the effect of the red and blue would be lost, thus reducing the intended effect.

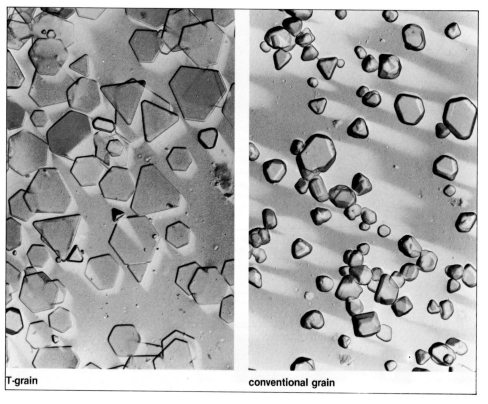

T-grain conventional grain

When magnified nearly 6,000 times with a scanning electron microscope, silver halide grains such as those used in Eastman Kodak Company's Kodacolor VR 1000 film (left) appear flat and table-shaped. These contrast to the pebble-like silver halide grains found in conventional photographic film (right). The new 'T' grains maximise the absorption of light, resulting in a more sensitive 'faster' film. (Photo by kind permission of Kodak Ltd.)

extended tonal range, while others effectively diminish it. Most black-and-white panchromatic film is capable of recording a brightness range of 1000:1, but in practice the range is often very much reduced.

The brightness range of the subject to be photographed is measured by a light meter (see Chapter 6) and expressed as a range of 'f' stops (for a given shutter speed) or 'Exposure Values' (EV).

If the brightness range exceeds the capability of the film in use and/or the print range, some tonal rendition must be sacrificed. This means that some detail normally visible to the naked eye in the darkest or brightest regions of the object or scene to be photographed will be rendered as black or dark-grey or white or light-grey in the final print. With this information, the photographer can now be more selective in terms of which tones are more important.

By varying exposure and development technique in tandem with different emulsion speed, the photographer is given more precise control over the rendition of images on film and paper. Details of zonal processing controls are given in Chapter 6.

CONTRAST

To appreciate fully how both density and contrast may be controlled during development, how film speed is arrived at and how exposure can be calculated to give a desired result, the working photographer should be equipped with at least a basic understanding of the theory used in the laboratory evaluation of film.

SENSITOMETRY

Laboratory investigation into the sensitivity of emulsions is known as sensitometry, and is mainly concerned with investigating the effect of exposure and development. The results of experimentation are plotted using logarithmic values of exposure (log E) against density levels to form a graph in the shape of an inclined and stretched letter 'S'. Thereafter, this is called a characteristic curve, and from it relevant infor-

Fine grain and vaseline used on a filter during exposure have both been used here to enhance the effect of solitude; HP5 rated at 650 ISO and developed in HC110. Print on bromide grade 3 paper.

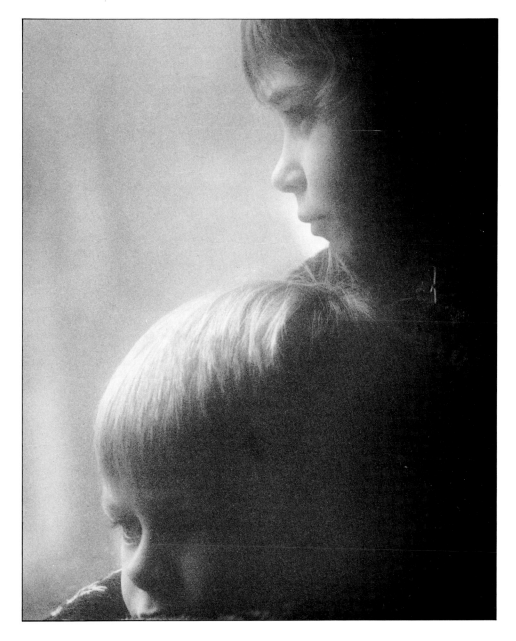

mation regarding contrast, actual film speed and rate of development may be gleaned. The configuration of the 'S' curve is important. It has a 'heel' which slopes sharply into a straight line portion before tailing off at the 'shoulder' into a reverse curve. It is the 'straight line portion' and gradient which are of most interest to the photographer, although there is also information on the demarcation line between fog level and zero-exposure density contained in the 'heel' portion of the graph.

The gradient, or slope, of the straight line section is expressed using the Greek letter 'γ' (*gamma*), and this is found by establishing a point (a) on the exposure base where film density is measured as I. At the point (b) on the exposure base, where an imaginary line drawn from log E vertically to intersect the straight line portion of the graph corresponds with E = (a) + I, a new density reading is taken. The density readings at (a) and (a) + I are subtracted from one another; the result is

the 'γ' figure which indicates the contrast range of the emulsion.

The contemporary photographer, equipped with sophisticated state-of-the-art electronic cameras in which exposure metering is almost foolproof, may wonder why any of this knowledge regarding 'curves' and sensitometry is necessary. There are a number of reasons. The first has to do with statements made in earlier paragraphs regarding mechanical recording devices which cannot think for themselves. Even the computer used to produce the text for this book had to be given constant instruction with regard to the layout and construction of sentences. It could only replace mis-spelled words on command. A modern camera needs the same kind of attention if it is to produce the result required by

the operator; otherwise, when it is operated using settings for average conditions, it will produce only average results.

This may seem like a contradiction of manufacturers' claims that certain cameras only need to be pointed in the right direction to render optimum results on film. A modern, electronic auto-everything instrument will be able to produce perfectly adequate film exposures at the touch of a button. But what it will not do is render the subject-matter in a way which is outside the scope of data for a number of average conditions pre-programmed into the camera microprocessor. Sophisticated cameras with a provision for manual control are no guarantee either that the desired result will be achieved. New settings may be made easily on the basis of

Fine-grain emulsions, such as Ilford's Pan F, are ideal for recording images where detail in the subject is more important than any atmospheric effect created by visible grain in the print.

This picture is typical of the kind of scenes which not only work better in colour, but which are extremely difficult to expose properly when using 35mm format black-and-white, unless the subject is to be used for an entire roll of film. Cluttered scenes, such as this, extend the tonal range of black-and-white emulsions almost to the limit, and some sacrifice must be made in highlight areas in order to retain detail in the shadows. This is where compensated development techniques come into their own.

In practice, knowledge of how the characteristic curve of a particular emulsion can be changed with exposure/processing technique is especially useful to the black-and-white worker. In this shot, the film is almost being asked to achieve the impossible with a real brightness range of approximately 1000:1 being compressed to 100:1 on the negative and considerably less in the print. Meter readings of both darkest and lightest areas were taken and averaged. Exposure selection enabled detail in mid-tones to be retained while unimportant losses occurred at top and bottom end of the range.

the blind leading the blind, but results will be unpredictable and for the most part of no value to either photographer or viewer of the work.

In the laboratory sensitometric test, a sheet of cut film is exposed to a point source light of known intensity at a fixed distance. No camera, lens or enlarger is used – the film is exposed direct to the light source. The sheet of film is exposed in a series of steps in much the same fashion as one would make a print test strip under the enlarger from a negative. The exposure time for each consecutive step should be double that of the preceding one and a unit of time chosen that will give an exact and convenient relationship to its logarithmic value. When the exposure sequence is completed, the sheet of film is then cut into four equal strips, each one containing the series of stepped exposures.

The development stage comes next. Using a known developer of working strength and held at a constant temperature, the four strips are immersed and then extracted one by one for fixing at predetermined intervals. When washed and dried in the normal manner, the technician will have four strips of film on which varying exposure has been subjected to varying development times. Using a densitometer, the density of silver deposit at every exposure stage is measured and then plotted against the logarithmic values of exposure.

The resulting characteristic curve will indicate which development time produces the better contrast range where the density of the darkest (highlight) portion of the strip along the straight line section of the graph is just printable – the level of maximum correct exposure – and where the density of the lightest (shadow) is such that it is visibly different to the base translucency of the film. In other words, it will indicate the level of minimum correct exposure for a given development. The piece of film is known as a 'step wedge'. Wedges can be made at home or purchased direct from film manufacturers in varying densities and contrasts.

Who needs a step wedge? In everyday photography, it has little use, unless the discerning photographer aims to maintain a collection of negatives which are of uniform density and contrast. The negatives may depict a range of subject-matter and exposures may have been made over a long period of time, but if exposure and development of film stock is geared to a constant *gamma*, many problems normally associated with printing difficult negatives will be eliminated. In this case, it may be helpful to have access to a variety of step wedges (see also page??).

DENSITY

Density of the negative in ordinary photographic terms is usually applied to the whole negative, rather than to a single portion of it. A negative which is too dense will be almost opaque, allowing insufficient light transmission through any of its parts for practicable print-making. One which is classified as too thin will be so translucent that there are no areas of opacity in the highlight areas and no detail at all in the shadow areas. Both types will be equally difficult to print successfully, even though in the last resort a chemical reducer or intensifier may be used to make either negative more acceptably workable.

ASSESSING FILM SPEED

In practice, standardised exposure meter settings geared to recommended film speed ratings will give an average exposure assessed for the whole scene; this is where the unwitting photographer will rapidly be led astray. The majority of in-camera meters are not equipped to deal with maximum correct or minimum correct exposure, and if the brightness range of a subject exceeds the film developer capability something will have to be sacrificed. Perhaps the most common failing in this area is the landscape or seascape picture in which the blue sky and fluffy white clouds of reality are lost for ever in tonal compression.

A simple and interesting experiment which will establish the correct average film speed (ISO) for a desired tonal range under known lighting conditions can be easily executed with the most basic of facilities. Items required are: camera, film, developing

tank, timer, thermometer, and chemicals for processing.

Load a preferred film, one which you intend to become a basic standard, into the camera. On either the in-camera or a hand-held meter, set the manufacturer's recommended ISO speed rating. Assuming a 36 exposure roll of film, divide the film into six parts of six frames each. Use a note pad to keep a record of the frame numbers and the exposure given to each. One page for each of the six parts is ideal.

Set the camera on a tripod or firm support and frame a previously selected subject. Do not attempt to make close-up or selective meter readings of different parts of the subject. It should be well-lit with side or frontal lighting. Make a note of what you can see in the light and dark parts of the subject; in particular whether the eye can accommodate detail at extreme ends of the brightness range. Set a shutter speed of say $1/125$th of a second and set the corresponding metered 'f' stop. Make an exposure. Consecutive frames in the first sixth should now be exposed at metered values which are higher and lower than the first exposure but which give the same exposure; i.e. the second exposure could be at $1/250$th second at f5.6 if the first was at, say, f8. Then continue with the third, fourth, fifth and sixth exposures until the highest shutter speed is reached. If this is accomplished on exposure 4, 5 will begin with the lowest shutter speed practicable, i.e. 1 second or $1/2$ second or less.

The next six frames should be exposed at ISO-N (Normal) – 1 full stop. Set the camera ISO indexer to the next lower numerical setting to the one previously used. Expose the first frame of the next sixth at the most suitable metered reading, say $1/125$th second at f8. The next two frames should be given + and – one full stop and the next two + and – 2 stops. Place the lens cap over the lens for the sixth frame and expose the frame blank. Repeat this procedure for the next sixth at ISO-N + 2 full stops.

The second stage of this experiment with the remaining $3/6$ths of film require the exposure procedure to be repeated exactly as in the first stage. When complete, take the film into the darkroom. Prepare the developing tank and processing solutions. Ensure that developer, stop bath and fix are all at the same temperature, which should for preference be 20°C (68°F).

It will be helpful to have more than one loading spool and a spare tank, but if this is not available follow this next procedure.

With a pair of scissors cut off the film leader and trim the film end for spool loading. Extinguish all darkroom lights. Take the film cassette in one hand and, with forefinger and thumb of the other, catch a firm hold of the exposed film end. Pull the film firmly but slowly until it is fully extracted but still attached to the cassette spool. Grip the leader end between your teeth, then slide thumb and forefinger down the edges of the film until an approximate midway point is reached. Stop here and carefully bring up the cassette until you can retrieve the leader end with the same hand, keeping thumb and forefinger of the other hand firmly clasped to the film edges. You will have now effectively folded the length of film in half.

Allow the cassette and leader end to fall, while still retaining a firm grip with the other hand on the middle section. Take the scissors and cut the film at the midway point. Take the loose length of film and place the leader between your teeth while rewinding the other length back into the cassette. Leave just enough film exposed from the cassette to facilitate retrieval. Load the loose length on to the developing spool and place it in the tank. If you have two tanks, load the cassette length also. If not, the following developing sequence will have to be repeated.

Begin the developing sequence and start the timer as soon as all developer is poured into the tank. Development time should be that recommended by the manufacturer for the film used. Begin pouring the developer away 10 seconds before the time is up. Stop bath, fix, and then wash for 10 minutes, drain and dry.

The second developing sequence, using fresh developer, can now begin. The development time should be cut by 25 per cent. When

'Fast' films (high ISO No) are necessary when working under low levels of available light. Tri-X rated at EI1600 and developed in full strength D-76 allowed some flexibility in the choice of higher shutter speeds to stop movement. Interestingly, there is very little compression of the brightness range in this scene printed on a grade 2 bromide.

this length of film is washed and dried, you should have two sets of 3x6 frame exposures. Compare them with the notes of metered exposures.

You will see that in the first set of six, which were processed normally, each frame should be of almost identical contrast and density. They may vary slightly, depending on the accuracy of your equipment. These six frames will show that changes in the numerical value of exposure effect no difference in contrast or density when the value is equal to an optimum figure expressed by the metering system. In other words, the same amount of reflected light reached each frame irrespective of the change in exposure combinations and the duration. If it could be assumed that both shutter speeds and aperture functions of the camera were accurate, any further

variation in contrast and density would have been caused by a phenomenon known as reciprocity failure, about which there is more in Chapter 9.

Compare these negatives now with the second batch of six exposed at ISO-N-1, and then again with the third batch. Compare all three batches with the second length of film, which was given significantly less development. Without comparing notes against the exposed frames, try selecting what appears to be an ideal negative of the subject matter. Inspect it closely under a powerful magnifying glass. See if you can detect clear differentiation between tonal values. Is there a highlight within the highlight and is there sufficient printable detail in the deepest shadow areas? All these values should be readily identifiable, even to the untrained eye.

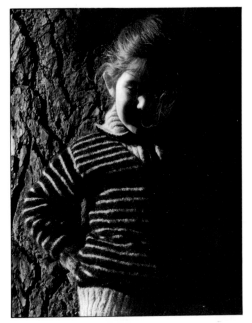

From a nine-negative test to establish acceptable contrast and tonal range, using normal speed rating/exposure and compensated development exposure.

HP5 ISO 400. Hand meter reading of skin tones and highlight areas in jumper F8-11. Normal development.

HP5 ISO 400. TTL reading through 200mm Zuiko lens gave f6.3. Normal development.

HP5 ISO 400. Hand meter reading of shadow area under left arm gave f5.6. Normal development.

HP5 EI320. TTL reading f5.6. Hand metered reading of face f8. Aperture set f5.6, development compensated less 25 per cent. Straight print from negative.

CONTROLLING DENSITY AND CONTRAST BY DEVELOPMENT

There are various other experiments which the photographer can conduct but, in order to obtain full value from any of them, a large-format camera employing cut film is more suitable than the miniature. Cut film allows greater flexibility in developing individual frames, as well as giving a clearer indication of what is happening to the negative. If no large-format equipment is available, a way round the problem is to load short lengths of bulk film into spare 35mm cassettes, enough for, say, three or four exposures on each length. To gain a more precise result, include a standard Kodak grey scale in the picture, as well as a piece of white card about the size of an

enprint (6x4in) on which are written film type and exposure details. Details on the card may read as follows:

HP5 PLUS=320 ISO
EXPOSURE= +2 STOPS

Use a felt-tip marker and ensure that the letters/figures will be large enough to be legible on the negative. To be effective, any test requires a minimum number of negatives which have been over- and under-exposed by 1 and 2 stops, and under- and over-developed by as much as 25 per cent and 50 per cent respectively, as well as normal exposure and development. At the very least, seven negatives will be required, and one of these will have been exposed and developed normally. Ideally, nine are required, to give three of normal exposure at differing levels of development, three of at least one full stop less than normal exposure and three of at least one stop more than normal exposure, processed with percentage reductions and increases as above.

Using a normal grade of paper (gloss finish is best), make nine enlargements from each one of the negatives. There should be sufficient density in the brightest highlight of the thinnest negatives to make printing on a normal grade of paper perfectly possible. Do not attempt to use a different grade of paper, unless the new grade is used for printing all negatives. Development should adhere rigidly to recommended time and temperature technique. Provided exposure is correct for the degree of magnification used, a very useful set of prints will result.

From the first experiment, select the negative containing the best contrast range and make a 10x8in enlargement, again on normal grade paper, or of a grade matching the one used to print the nine negatives, if this was different from normal. When all prints are dried, lay them out for viewing.

It should be understood that these tests are designed to help the photographer establish a range of exposure and development techniques that will give the most desirable print result for personal preference. The effect of tonal rendition and contrast differs according to each photographer's taste. The subject-matter itself is of great importance and in most cases will dictate to a large extent the tonal composition of the final print. In laboratory experiments very little, if any, allowance is made for the aesthetics. Such tests are designed to establish the correct range of values for given circumstances.

LIGHTING

When possible, tests should be carried out using different types of light: tungsten, flash and daylight. Using tungsten and studio flash, the photographer will frequently be afforded more control over lighting and exposure and (because many of the factors involved will be constant) more control over the processed result. With direct on-camera flash out of the studio, and frequently in normal daylight conditions, exposure will be affected by a variety of elements which are beyond normal control.

Here are two examples of flash technique, where full control over lighting and exposure was only possible in the studio shot. The second picture was shot to a client's visual brief and required an atmosphere that would have been difficult to achieve without the use of tungsten lighting. Neither of the final results, however, would have had the same effect had 'normal' exposure and development techniques been employed. Both pictures were given more or less than the recommended 'normal' exposure, and more or less than the recommended 'normal' development.

There are several exposure and contrast problems associated with ordinary on-off-camera flash techniques. In some instances, the negative may be a good one, with a full range of tones in the straight line section and of a contrast which allows for controllable printing exposures on a variety of paper grades. Less exposure would result in a thin negative, given normal development. Increased development would effectively compress the highlights (raising contrast), resulting in a negative that is simply too dense to print easily. How does this happen? Part of

This shot was effectively grabbed in a few seconds in the street, with no time to meter or set exposure on the camera. I prefer to work with high-speed panchromatic films and down-rate them. Typically, this was shot on HP5 Plus rated at EI 320. Exposure 1/500th second at f4. The film was processed in HC110 dilution B for 5.25 minutes at 20°C (68°F). Had time permitted, I would have opened the lens another stop to blur the background more.

the answer has to do with basic equipment which is, in many respects, inadequate for the task at hand.

Most single lens reflex (SLR) cameras used today are equipped with a focal plane shutter. Most older cameras of bellows type, twin lens reflexes and some medium-format SLRs, like Hasselblad and Rollei, are equipped with leaf shutters – metal blades which open and shut concentrically as in the Compur shutter type.

Both types of shutter can be synchronized to bulb or electronic flash. In the leaf type, the shutter is opened to make full use of the peak output of the flash cycle. In the focal plane type, the shutter is opened towards the end of the peak. This timing factor creates a somewhat uneven negative exposure when a focal plane type shutter is used with electronic flash. The difference is less noticeable with bulb flash.

A more important factor is the difference between the duration of bulb and electronic flash. Because of the bulb's longer flash duration and greater illuminating power, a reciprocity factor is introduced which helps to expose silver halides more efficiently. In negative comparisons, using normal exposures and standard development, the bulb-flash negative will show better exposure of shadow detail, resulting in a richer print. To obtain similar results from an electronic flash of equal power, a slight adjustment to exposure and development is required. For this reason, it is useful to conduct a series of tests, using electronic flash, to discover the most suitable exposure development combination for a variety of circumstances.

The darkest area of the tree required f2, the lightest area of the van on the corner required f32. Straight print from negative.

BASIC BLACK-AND-WHITE FILM PROCESSING TECHNIQUES

A wide range of convenient and practical darkroom tools are available to the modern photographer. These have evolved since popular photography in the home became a widespread hobby more than 100 years ago. In this and the first edition of this book, I have assumed that the reader will have a basic working knowledge of the procedures required to develop film and, in addition, may own or have easy access to some of the essential tools.

These circumstances may not exist for every reader, however, so this chapter is dedicated in part to very basic film-processing techniques employing primitive household utensils. In the very earliest days of photography, pioneers of the medium, while endeavouring to conduct experiments in an orderly and fairly scientific manner, were nevertheless required to get their fingers wet. Aside from the tabulated facts and figures which were the outcome of these endeavours, photographers also gained intangible benefits from their increased familiarity with chemicals. This aspect is increasingly missing from today's professional world of photography where film (and prints) have for many years been machine processed. Indeed, now and in the years to come, we will see less and less of the wet processes described in this book, as computers and digital imaging becomes the norm.

Photographic industry leaders have said publicly that digital imaging systems will continue to co-exist alongside conventional silver halide photography. But the facts are writ large. In a few years from now, optical magnetic recording devices will have largely replaced conventional film for the vast majority of users. To obtain a hard copy of images stored on CD disks, most people will have to use specialist laboratories, at least until such time as the price of the electronic hardware capable of providing acceptable near-photographic quality prints is reduced to a more affordable level.

Conventional film and photographic products may continue to be made by some manufacturers for a small but highly specialized sector of the market. The emphasis will be on high-quality products for photojournalists and photo-artists engaged, say, in high-quality book and original print making. The essential techniques of film processing and print making are unlikely to change dramatically. It has always been my contention that in endeavouring to attain the highest levels of quality in this respect, it is necessary for the photographer to experience the relevant chemicals at first hand. The knowledge gained from, sometimes, messy experiences can only help the enthusiast understand and appreciate the medium more fully.

When conventional photographic tools cannot be easily obtained, the following procedures can be used to process lengths of medium-format and sheet film. Miniature film may also be processed in the same way, but longer 36-exposure lengths should be cut in half to make them more manageable. The following items will be necessary: three wide-rimmed and fairly deep soup dishes, a watch, a table, litre-sized jugs to hold solutions, and a room which can be completely darkened. This is a messy procedure, so be sure to wear an apron and cover the floor or carpet with newspapers or, better, with a sheet of polythene.

Proceed as follows. Mix developer and fixing chemicals to make a maximum of 8 fl oz (230ml) working-strength solutions. Raise the temperature of each solution by immersing its container in a bowl of hot (not boiling) water. Test the temperature with a finger. When the liquid is no longer unpleasantly cold but barely lukewarm, remove the container(s) from the water-jacket. Slightly warm the three

soup dishes in the same bowl of hot water. If you have chemicals to make a stop bath, use the same procedure to raise the working temperature. Otherwise, use water. Lay out the three dishes on a table or bench, so that they are about 12in (30cm) apart. Pour the developer into the left-hand dish, the stop or water into the middle, and the fix into the third, on the right. Make a mental note as to the position of each dish in relation to the table or bench edge. Assuming a roll of medium-format IZ0 film to be processed of known type and speed, consult the developer recommendations for a development time at 20°C (68°F). The time will be given in minutes and seconds. Calculate the total time required in the developer in seconds, which you will have to count to yourself in units of a thousand. Take the film roll in the left hand and, with a pair of scissors, cut the exposed paper seal. Peel off and discard, keeping a firm grip on the film, so that it does not unravel. Extinguish all room lights. Check that no light is entering the room.

The next stage is decidedly tricky and requires a certain dexterity on the part of the operator. Still holding the film roll in the palm of the left hand, place the thumbnail between the backing paper and the bulk of the roll. With the right hand, grasp the end of the backing paper and peel away slowly until you feel the edge of the film itself click over the thumbnail. Drop the backing paper and continue to pull the film out and away with the right hand. It is important to do this in one straight movement. You will find the end of the film attached to the backing paper with a length of sticky tape. Keeping the film straight, gently tear it away from the paper using your thumbnail as a cutter. If you cannot accomplish this, move the hand towards the mouth and tear off the film from the backing with your teeth.

It is an essential part of the technique to keep the film straight at all times before immersion into the developer. Move to the dish containing the developer, raise the left hand directly upwards and place the right-hand end in the dish. Keeping sufficient tension on the film, slowly bring up the right hand, allowing the left to follow in a downward direction. Start counting in stages of 1,000, 2,000, and so on as soon as the process has begun. When the left-hand end of the film has travelled through the developer, reverse the process and continue it back and forth until you have counted the entire developing sequence. By this time, your arms will ache but the film will have lost much of its spring and will be far more manageable. Drain at the end of the sequence and then transfer to the stop bath and finally to the fix. When this is completed switch on the light.

Drain off the fixer and then immerse the film in a bowl of fresh water, basin or sink. If running water is available, leave the film loosely coiled in the sink for at least 45 minutes to wash. The tap should be adjusted to permit a continuous flow of clean water at a little less than half pressure. At the end of the wash process, hold the film at both ends so it is taut; drain off surplus water and then hang the film from a line in a convenient place to dry. A clothes peg affixed to the film end will provide sufficient weight to prevent it curling.

By now, you will have already seen the results of your endeavours. If this is your very first attempt to develop exposed film, don't be too disappointed if most or all of the film appears black. Somewhere along its length there will be printable images. One of the pitfalls of this method is that of accurate time-keeping. Counting in thousands can vary from one person to another, so it is best to get in some practice with the second hand of a watch before attempting this procedure. If the negatives look much as you had hoped they would, with plenty of variation in the highlight and shadow for each frame, I can imagine your excitement. I began processing film in this manner at about 14 years of age and the feeling of expectation and thrill at seeing a really good set of negatives for the first time has never left me.

TANK LOADING TECHNIQUES

Now we will move on from the soup dishes to more appropriate equipment. Darkroom

This picture works better in colour because there are small areas of colour to relieve the monotony of large areas of black. In black-and-white the picture would be better shot from an angle where there is more sidelighting and reflected light from nearby stalls to enhance shape and add detail.

mishaps usually start with an unruly film which refuses to be spooled, no matter what one does. Spool loading is an acquired knack; if you have never had occasion to load film before, be warned; a lot of practice with outdated film, prior to any real darkroom work will be of immense benefit.

Here are a few tips on loading techniques to make life less exasperating.

1 Always use fresh film stock in your camera. Try to expose all of it as quickly as possible. Even a week in the camera in a partly wound-on state will make the film less supple. Avoid storage of a loaded camera in close proximity to heat; keep it out of car glove compartments for instance. Always avoid exposing it to extremes of temperature.

2 Process the film as soon as possible after exposure. If this is within a day or so of loading, the film will remain manageable.

3 120 roll film is more difficult to load on to a spool, due to its size and thinness, compared with 35mm. Old roll film has a tendency to curl tightly when pulled away from its backing paper. This can present problems with automatic processing machines, where roller feed tension is slightly slack; film may not be properly processed.

With small tank nylon spools, carefully follow the next few steps.

1 Hold the roll of film in the left hand, palm uppermost (see page 60). Cut the paper preventer with your thumbnail or scissors.

2 Hold the film as shown and gradually but carefully pull the paper backing away from the body with the thumb and forefinger of your right hand.

3 Stop when you feel the film base protrude over the left thumbnail. Move two fingers

Here colour is the predominant factor which is used to enhance the three graphic shapes which make the composition.

around the back of the roll to keep the backing paper tight against the roll. Tear off the loose end with your right hand.

4 Now clasp the roll with the slightly protruding film base with the backing paper between the thumb and index finger of your right hand. The backing paper affords some protection of the film as you unravel a further $^{1}/_{2}$in (13mm).

5 Take the spool in your left hand, the film gate uppermost, and clasp it in the palm of the hand. Using your thumb and index finger, manoeuvre the film into the gate and pull forward until a full rotation is nearly complete.

6 With a hand on each side of the spool, now allow the film to drop between your body and hands. Begin an alternate back- and-forth winding motion to feed the remainder of the film on to the spool.

7 This action should be carried out smoothly and with gentle pressure on the spool towards the centre. Too much pressure will buckle the film and cause it to jump out of track. You will feel when the secured end is approaching. When there are only a few inches to go, stop winding and, with the spool pressed against your abdomen and held in place by your arm, use both hands to tear off the backing paper.

8 Resume winding until the film is secured on the spool. Place it in the tank and secure the light-tight lid.

Tank loading guides for nylon spools are available from manufacturers such as Jobo and Kinderman. If problems continue, insert a scrap of backing paper between the film tracks before loading commences. The paper acts as a guide for the film end, but it must be removed before processing. An alternative is to use a length of card or very thin plastic sheet cut and sanded with wet emery cloth.

Always ensure that nylon spools are perfectly dry before loading fresh film. Film will stick in the tracks if there is the slightest trace of dampness on spools. Inadvertent use of force to shunt the film on will only result in near disaster, or worse. The only course of

action is to remove the film, rewind all of it, except the leader, back into the cassette, and thoroughly dry the spool. A small electric hair dryer is a very useful darkroom tool for this and other purposes.

Roll film can be salvaged even after the paper backing has been discarded. Keep a cardboard box (a shoe box, for instance) permanently in the darkroom for these emergencies. A black polythene packet from a box of paper can be used to store the film in its natural and loosely coiled state. Fold over the end of the bag and place it in the box. Cover with the lid. Now you can turn on a safelight, or even a white light if the situation demands.

With stainless steel spools the film take-up starts at the centre of the spool, where the film end is inserted under a spring clip. The procedure for handling the film is the same as in 1-4 above. Then, proceed as follows.

5 Hold the spool in the palm of the left hand with the thumb over the spring clip and finger underneath. Marry the film end in your right hand to the thumb of your left. Use the thumbnail of your right hand, still holding the film firmly, to press down on the spring clip and insert the film.

6 Ensure that the film is centralized in the spring clip.

7 Continue to hold the spool in your left hand and, using the thumb and forefinger of your right protruding over the ends of the film spool as a guide, begin winding slowly. The exact amount of tension must be kept on the film to allow it to find its own way between the grooves.

8 Use the same procedure at the end, above, to release the film from the backing paper.

9 Place the loaded film in the tank and secure the light-tight lid. Some stainless steel spool manufacturers also supply loading guides, but once you have acquired the knack, these will not be necessary.

With 35mm film, loading is simplified due to the fact that there is no backing paper to contend with. With nylon spools, follow the same procedures as above. Always shunt enough of the leader around the spool grooves before attempting to wind on. Let the film cassette hang between the body and spool. Pull out about 12in (30cm) of film at a time and wind on firmly but slowly.

When using stainless spools, follow the same procedure for loading the spool as for roll film. Use your thumb and forefinger as a film guide, keeping the cassette firmly clasped under the palm with the little finger to hold it in place. As you wind on, the film will leave the cassette easily.

Some 35mm cassettes need a bottle-opener to remove the tin cassette end. Wall mounted darkroom cassette openers are also available. However, these implements are becoming more essential, as modern electronic cameras often rewind the film leader into the cassette. It can be retrieved using another special tool, but it is less of a nuisance if you practise the habit of not winding the leader into the cassette after the film has been exposed. Some professional cameras, such as the EOS-1N and Nikon F4, can be self-programmed to leave the leader out. With cameras fitted with a manual rewind, wait until you feel a slight increase in tension as the film comes up tight on the take-up spool, then give an extra sharp half-wind or so. The leader will be off the take-up spool but will not have disappeared completely.

Because some cameras have a take-up spool system which winds the film on emulsion outward, any delay in rewinding it back into the cassette after exposure invariably causes a 'reverse-curl' effect which makes darkroom handling more than just a nuisance. To overcome this malady, extinguish the darkroom lights, pull the entire length of film from the cassette and snip off the end, keeping a firm hold on it once this is accomplished. Now load the film on to the spool starting with the film end. It should feed on without further difficulty. Stainless spools do not need to be bone-dry to load. They can easily be loaded, unloaded and reloaded when dripping wet. Practice is the key.

SHEET FILM

This is best processed in a tank of the type mentioned in Chapter 2. Stainless sheet film hangers, which have four small spring clips in each corner and a hanging rail, are preferred for larger tanks. It is possible now to obtain spools of similar type to roll and miniature film types which allows 5x4in sheet sizes to be processed in cylindrical tanks.

When all that is required is an occasional negative, it is easier to clip the film into a stainless hanger and dish-develop in total darkness. Less solution is required and the dish needs only a gentle rocking motion to ensure adequate agitation. When there are more to process, I use a three-litre box tank which I made up some years ago from sheets of opaque black perspex. A few hours spent with a sharp electric fine-toothed saw and a tube of Weldite enabled me to make seven of these tanks which, at the time, were required for colour reversal processing. Plastic holders

for sheet film should be avoided, if possible, as they stain quickly, become brittle with age and are liable to fracture which could cause irreparable damage to film.

Except for some graphic arts process film, all sheet film, whether it be colour or black-and-white, has a series of notch codes in one corner. The number and, in some cases, shape of the notches indicate the type of film. When they are at the top right-hand edge of the film, the emulsion faces towards the user. These are manufacturers' guides to help with dark slide-loading as well as film processing. Notch codes are invaluable when using the open-dish developer method. Sheets can be easily checked to ensure film is not lying emulsion-side-down where it is liable to be scratched by the dish surface.

Agitation of all film during the development and fixing sequences is vitally important. With sheet film developed in a deep tank on hangers, the procedure should be as follows.

1 Lower the hangers into the tank and knock smartly on the tank bottom or side to dislodge air bubbles that may adhere to the emulsion surface when the film is left to stand.

2 Agitate the film back and forth through the developer for between 5 and 10 seconds every minute, or every 2 minutes until time is expired.

3 To avoid the risk of air bubbles before development starts in a tank or dish, use a tank of pre-heated, filtered water in which the film sheets are immersed for about half a minute. Remove air bubbles as in 1 above.

When using a dish to develop sheet film, make sure the dish is at least twice the area of the film. Using a same-size dish creates film handling problems with increased risk of damage to one or both film surfaces. Use a dish that is large enough to hold a litre of

Confronted with this everyday situation, the photographer working in black-and-white would almost certainly want to up-rate whatever film stock was in use. Fast (ISO 400) emulsions could easily be used at their manufactured ratings, but more atmosphere, depth and contrast with the added advantage of higher shutter speeds to help eliminate shake would be possible with higher EI values (see Table 3).

working solution and one in which you can easily move a hand. Insert the film into the liquid by raising one side of the dish slightly; hold the film by, say, the top right-hand corner and place the bottom edge of the film, emulsion uppermost, on the raised side of the dish. Simultaneously level the dish, lower the film to a flat position, and allow developer to wash over it. Once it is covered, gently knock the bottom edge of the film against the dish side to dislodge air bubbles. To agitate, work by gently raising each corner of the dish in rotation in a continuous action.

There is a theory that uniform agitation can cause development marks on the film. Whether it be miniature or roll film on a spool, or sheet film developed in a dish or tank, I have never come across this phenomenon. Development marks are usually caused by the following:

- Insufficient agitation, especially during development times of less than 5 minutes.
- Agitation periods spread too far apart and inadequate.
- Incorrect entry of film into developer when using dish techniques. This often causes large air bubbles to be trapped under film which has been immersed emulsion-side-down. The problem is nearly always apparent when too small a dish is used.
- Miniature and roll film processed in cylindrical tanks (except Rondinax type) can show uneven development marks caused by insufficient liquid to cover the spool. Always use at least twice the amount stated for each roll of film in larger tanks.
- To dislodge air bubbles in cylindrical tanks, bang the bottom of the tank against the bench in several sharp taps. If facilities for dipping film in a pre-wet are available, make use of them.
- Cylindrical tank agitation should follow the inversion/rotation procedure. Invert the tank and, when the first spool has reached the new bottom, begin rotation and right the tank to its normal standing position. Small plastic tanks have an insert which allows clockwise rotation of the film

spool during development. The tendency is always for the operator to spin the spool too fast. Only enough movement is required to change the position of the film in relation to fresh developing agents.

Remember:
- *Too much agitation* increases grain and contrast.
- *Too little agitation* decreases contrast; causes irregular development marks.
- *Less agitation* towards the end of the development sequence can increase edge acutance.

PROCESSING STEPS

The standard processing method for black-and-white film is as follows and assumes the use of the time and temperature method according to film manufacturer's recommendation.

1 In total darkness, unless a daylight- loading tank is used, load film into tank and secure lid.
2 Pre-heat all solutions, including wash water, stop bath and fix, to the selected temperature.
3 Pre-heat tank for a few seconds over a bowl of hot water.
4 Set timer to required time. Pour developer into tank. Start timer.
5 Tap tank bottom gently but firmly against bench to dislodge air bubbles. Agitate vigorously for the first 15 seconds.
6 Agitate as directed. Allow 10 seconds before the end of development to pour away the developer. Discard if using diluted one-shot solution.
7 Pour in stop bath and agitate vigorously for 15 seconds. Then pour away to container.
8 Fill tank with fixer; agitate for the first 15 seconds and thereafter every 2 minutes.
9 When fix time has lapsed, pour fix away to container and fill tank with wash water.
10 White light may now be used to inspect the film in its wet state.
11 Re-spool film and immerse in hypo (fixer) clearing agent for the time directed.

Larger-format negatives are capable of great detail; see the enlarged section of the first picture. In the picture opposite a small section enlarged would lose detail due to the enlarged grain structure.

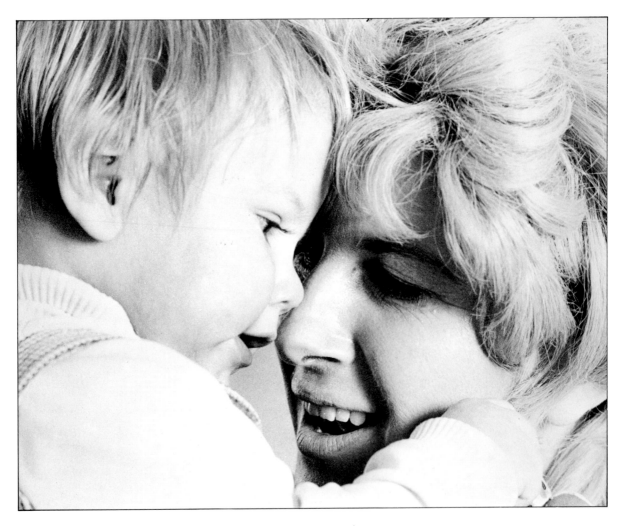

12 Commence 20-30 minute wash cycle, or at least 45 minutes if no clearing agent is used.

13 Using a clean large jug containing at least 1 litre of filtered water, add photo-flo solution. Immerse film on spool and dip several times. Remove spooled film by pulling off the spool while still in solution. Hold the film firmly at both ends, upend it and allow surplus water to drain off. Use a weighted clip on the lower end and hang in a dust-free compartment to dry.

VARIATIONS ON THE BASIC PROCEDURE

Following the above procedure will normally result in accurately developed and dried nega-tives. There are, however, variations on this procedure which will help to improve results.

TEMPERATURE

Allow film to reach the ambient darkroom temperature by leaving it to stand for up to 20 minutes. Darkroom temperature should be maintained, as far as possible, close to 20°C (68°F). This is especially necessary when the film is rushed in for processing from a cold exterior. If exposed film is stored in the refrigerator, remove and allow to acclimatize for 1 hour above before processing.

WATER-JACKET

A water-jacket for working solutions can be made from a garden tub of the window-box variety. Four containers can easily be stood in

Mother and child. Nikkor 105mm f2.5 lens and Tri-X. Window light would have given an acceptable exposure but with too many shadows. I used bounced electronic flash for the main exposure, over-exposed by one stop, and cut development by approximately 10 per cent to give a fairly high-key effect.

water, which should be changed only after the solutions have reached working temperature. Polythene and stainless containers absorb heat rapidly. Rigid translucent plastic containers take longer to heat contents.

PRE-HEATING

Always pre-heat the tank, either by holding the base over a steaming pot, or by pouring in a little warm water; swill and discard once the tank is warmed.

PRE-WETTING

Pre-wetting of the film in filtered water of the correct working temperature reduces the risk of air bubble formations and development streaks by making the film emulsion surface more miscible.

LOADING

Two methods of loading standard cylindrical tanks with film and developer solution are as follows.

1 Insert the spooled film(s) into the tank and pour in the solution. When a large quantity of developer is needed to cover the maximum number of spools, the process can take up to 30 seconds before the top film in the tank is completely covered. There is a risk that this and other film may receive only partial development. A better method, when more than two rolls of film are to be processed, is given below (2).

2 Fill the tank with developer solution. Load the spools on to a stainless hanger. Dip in one go, seal the tank and start the clock. This must be done in the dark. Have a large measure to hand filled with the correct amount of developer. The previously loaded spools can be stored in the empty tank until you are ready to start the operation.

AGITATION

Agitation will vary with different film types and developers. Ensure that the manufacturer's instructions are understood in this respect. Too much agitation, especially of the vigorous, continuous kind, can have the effect of increasing both film speed and grain, leading to excessive grain clumping and reduced acutance.

Agitation techniques can be improved with time. After printing negatives from each consecutive roll of film, you will begin to see that there is a fine line between too much and too little agitation; too vigorous and too gentle. Medium-speed films, such as Ilford FP4 Plus and Kodak T-Max 100, can sometimes benefit from controlled agitation during the first two-thirds of development, while an absolute minimum is given in the last third, with virtually none at all during the last minute and a half. This procedure allows edge acutance between contrasting tonal values to be more sharply accentuated.

DEVELOPMENT TIME

Extended development increases the overall contrast and density of the negative. As soon as a specified development time for a given film speed (ISO) is increased, highlight blocking begins to take place. Shadow areas will simultaneously become more dense, giving a negative the appearance of one which has been over-exposed. With high-contrast emulsions, it is important to establish at the outset exactly what development will be given for a film speed which is different from that recommended by the manufacturer. The commonly applied rule-of-thumb states that if exposure is pegged for the shadows, a reduction in development time permits highlights to take care of themselves. Exact results can be obtained when a light meter is used (see Chapter 6).

STOP BATH

There are two schools of thought regarding the use of a stop bath. This is a solution of mild acetic acid diluted with water to make a working-strength solution. Most photographic stop bath solutions contain a coloured dye additive which changes colour when the chemical stopping power of the solution is expired.

An acid stop bath immediately arrests the action of developing agents and, when known

Limitations of both equipment and the medium in use must be clearly understood from the outset. Of the two portraits on this spread, this one is a disaster. A face full of character like this deserves more than the slap-happy approach to composition, background detail and, most of all, in this case, exposure and development technique. This picture resulted from a two-minute session in which everything possible was not done to make the most of the subject. Meter readings were taken from the palm of my hand and transferred direct to the camera. There was no filter and no compensation in development.

development time and temperature techniques have been proven over a period of time, its use is to be recommended. Glacial acetic acid without indicator is available from some druggists.

In its purest form (approximately 99.5 per cent), glacial acetic acid is corrosive and harmful to sensitive skin. The fumes are flammable and should not be inhaled. Open the container in a well-ventilated room and prepare to make a dilute solution which will then be diluted further for normal photographic use.

This is achieved by mixing the concentrate in a 3:8 ratio with water to make a 28 per cent pure solution. The working stop bath is mixed in proportion, by adding 1 part of diluted acetic acid to 13 parts of water. If no acetic acid is available, a similarly weak solution of metabisulphite can be used; pH values should be in the range of 4.5 – 5.5.

To make an indicator stop bath, add several drops of bromothymol to the working solution. This will give the stop bath a yellow colour which, in darkrooms using the amber yellow safelight, will appear colourless. When sufficient alkali is transferred from the developer, the indicator will turn dark-blue or purple, at which point a fresh stop bath must be made up.

For this photograph, the following day, the same 6x6 camera was used with a 150mm lens fitted with a medium yellow filter. Assistance was volunteered by onlookers to hold up a plain white backcloth which obscured direct sunlight and presented a clean backdrop. Meter readings were taken from the shadow areas of the face and factored for the filter using EI320. And finally, film, HP5, was given compensated development in HC110.

As any acid bath immediately neutralizes the developer action, it may not always be preferable to use this method. Too strong an acid stop bath may also damage the emulsion by creating localized pinholes which will appear on the print as tiny dark spots. I often use plain water of the right temperature. This allows greater latitude in development techniques, especially when I am using a rapid-acting general-purpose developer. Kodak's HC110 has a very syrupy consistency which, even when diluted to a working strength, has a tendency to stick to the emulsion surface. By further dilution in a water stop bath, I have found that the development action is continued as chemical agents are still absorbed in the swollen emulsion. Very weak development action seems to have the effect of enhancing subtle shadow detail without significantly increasing negative contrast.

FIXING

Several water washes are used before employing the first of two fixes. Using two fixer baths ensures complete fixation of each film without running the risk of using an exhausted solution. Both baths are dilutions of the stock solution to which a hardener has been added. I test the first bath before each processing

session begins by dunking snipped-off film leaders and checking the clearing time. That time is then doubled to ensure proper clearance.

Some modern emulsions, Kodak T-Max 100, 400, 3200, Ilford Delta 100 and 400 especially, need extended fixation to clear properly. The second fix is used for the recommended time. As the first fixer bath is exhausted, it is replaced by the second and a new batch made up to replace that.

Film which has not properly cleared will have a slightly milky veil (unexposed silver halides) over the emulsion and, if left, these ultimately turn brown as the negatives age. The veil can be removed by further fixation as soon as the symptoms are recognized on removal of the film from the fixer. However, because partial fogging will have taken place if the film was exposed to white light, resulting prints may show faint effects of solarisation.

Sodium thiosulphate was at one time commonly used as the solvent ingredient of most 'hypo' solutions. 'Hypo' itself is an abbreviation of 'hyposulphite of soda' and has long since been discarded in the annals of photo-processing history. Modern rapid fixers use a closely related ammonium thiosulphate solvent as the working solution to which is sometimes added an emulsion hardener, usually potash alum.

Provided the strength of working solutions does not greatly exceed the strengths given by the manufacturer, a film left completely immersed in a fixing solution for up to double the recommended time will come to no harm. However, rapid fixers will attack and dissolve metallic silver salts if negatives are left immersed for extended periods. The symptoms of an over-fixed negative are noticeable bleaching of the shadow (thin) areas and, if left long enough, a reducing effect on highlights, resulting in a negative that may look as if it had been under-exposed by several stops.

Stale fixer, which has absorbed all the silver it is capable of dissolving, may still be able to partially clear unfixed film, but no matter how long the film is left immersed, complete clearance will not take place. The negative may look as if it has cleared, but time will produce a darkish-brown stain caused by silver-sulphur compounds that form in exhausted fix solutions. This is another good reason to use a second fixing bath.

A silver recovery unit uses electrolytic action to recover silver deposits from exhausted fixer. To make economic use of such a machine, the fixer throughput needs to be of reasonable quantity, say a minimum of 20 litres per month.

WASHING

To achieve archival permanence of negatives, washing must take place in running water, or several changes of water for a minimum period of 45 minutes. If no running water is available, vigorous washing action of the film by hand is necessary in one change of water every two or three minutes for the first 15 minutes. Thereafter, water changes may be less frequent. The use of a plastic bucket into which a short hose protrudes over the rim is useless. The hose must be placed in the bottom of the bucket and weighted if necessary to facilitate a proper circulation.

A hypo clearing agent may be used after the initial rinse following the final fix. If this procedure is carried out properly, washing times can be reduced to 20 minutes for archival permanence, and to as little as 5 minutes if negatives are only required to be kept for a few years. The reduction in subsequent wash times varies from product to product. I have some negatives from a variety of assignments that were given only a quick dip in clearing agent and then rinsed before drying. Some of these had begun to deteriorate after ten years of storage. Negatives given thorough washing 30 years ago for periods often exceeding 60 minutes are still in perfect condition today.

FILM DRYING

Methods of drying a film can vary dramatically. Commercial premises will use some kind of drying cabinet of the type illustrated in Chapter 2.

To take the worst kind of example first, rapid drying, or drying to a point where the negative can actually be used; the following methods are effective. Make up a fairly strong solution of methylated spirit diluted 1:6 parts of water. Remove the film from the fix and, keeping it spooled, rinse briefly in clean water. Shake and dip in meths solution. Take hold of the leader end of the film and, once free of the spool, pull sharply in a vertical direction, allowing the residue of meths to drain back. Attach a weighted clip to the bottom end of the film and an ordinary clip hanger to the top end. Hang the film. Using a dry chamois leather cloth, or a fine cotton, well-washed handkerchief, carefully wipe the non-emulsion side of the film. Begin at the top and work downward in a single movement. Repeat until all traces of water have disappeared. The emulsion side should now have had sufficient time for excess liquid to drain away. Using a hair dryer with a snout, begin drying the film by gradually passing the snout down the length of the film on the non-emulsion side. Do this several times before turning the film around and working in the same fashion on the emulsion side. As it dries, the film surface will begin to flatten and eventually buckle in concave fashion, emulsion inward.

When speed is of the essence, at the risk of introducing particles of dirt, scratch marks and dust to the wet and slightly soft gelatin base, use a clean tea towel to wipe both sides of the film free of moisture in a simultaneous downward action. You may have to do this more than once. Proceed with the hair dryer as previously described. This procedure is not recommended if negatives are valuable, but it does work well. The key to retaining undamaged negatives is first to acquire a really soft cotton tea-towel.

If your drying cabinet is efficient, dipping the film in a meths solution, draining and then hanging it under a medium heat setting will dry a film cleanly within a few minutes.

When I have time to spare, I prefer the following method. Wash the film as described. Fill a litre jug with fresh, clean water which is raised to a temperature of 20°C (68°F). Add one or two drops of domestic liquid detergent and mix evenly. Do not make a froth. Keeping the film spooled, dip several times in the detergent rinse without actually removing it from the container. Take hold of the end of the film and, once clear of the spool, pull it out sharply in a vertical direction. Holding the film upright, grasp the bottom edge with your free hand. Keep the film straight, slightly relax the tension and then snap it back sharply in a series of flicks. This action will remove a great deal of surplus water. Weight the end of the film and hang it up. Allow the film to drain for a further 5-10 minutes before applying a medium, evenly distributed heat.

Proprietary wetting agents, as detergent additives are called, are just that. Kodak's Photo-Flo and other similar agents are refined detergent solutions which make the final rinse water more miscible and thus reduce the risk of foreign matter adhering to the film surface, particularly in hard water. Provided a disciplined technique is adopted in this last and most important part of the processing cycle, negatives should be pristine when finally dry. Rubber 'squeegee' tongs for wiping film should be avoided whenever possible, even when thrust into one's hands by well-meaning colleagues or friends who swear by them. I do not think I have one negative which has ever been 'squeegeed' which is not damaged in some way, usually with a set of immaculate and deeply etched tramlines.

Film which is drying should always be hung in a dust-free atmosphere. Do not attempt to change the position of a film once the drying cycle has begun; it may cause subtle changes in density if one part of the film has dried more quickly than another. Moving film around during the cycle also increases the risk of dust sticking to a partially dry emulsion with dire consequences. Excessive heat has a tendency to increase the size of negative grain as well as distorting the film base.

Using the above methods, there is no reason why film should not be dried effectively and quickly with very little risk of contamination.

ADVANCED BLACK-AND-WHITE FILM PROCESSING TECHNIQUES

In order to present the viewer with images which demand serious inspection, the photographer must rely heavily on his or her own ability to identify, select, compose, expose and process the silver image in an effective way.

Impact in a photograph is achieved in several ways: by being selective about the choice of subject-matter, by being selective about composing the elements of a subject, by being selective about the choice of format and method used to transfer the image to film, by being selective in choosing the tonal elements of the negative and in following a similar procedure in making the final print for public presentation. Few of these selections are made on a purely objective basis, even though the knowledgeable photographer may be influenced by outside circumstances at the time an exposure is made. In the final analysis, the selection of elements which comprise and render the *pictorial* image (as opposed to the *technical* one) are based on subjective analysis. The interested viewer receives the information in a similarly subjective way, reactions being stimulated by whatever the picture contains.

If one assumes that most of the basic requirements in picture composition are met, the degree of impact of a print on the viewer will depend almost entirely on presentation. But the relative ease with which a black-and-white or colour print may be made today is certainly no guarantee that the desired effect on the viewer will be achieved.

In order to make prints which stand out from the run-of-the-mill, the photographer does need a deeper understanding of how exposure and development can affect the negative is required. Moreover, if you have been influenced by trade promotion of a given camera or lens, what you present in terms of the two-dimensional print will almost certainly be something of a compromise. If, on the other hand, you know exactly the limitations and advantages of various formats, the precise characteristics of certain objectives and the lengths to which those characteristics can be exploited, you will have already achieved much towards making a print that realizes the fullest capability of your equipment, knowledge and imagination.

CONSIDERATIONS OF FORMAT

The choice of the most suitable format for the serious hobbyist has long been debated and will no doubt continue to be so. I make no excuses, however, for devoting a little space here to a topic which some readers may feel has no place in a book which is essentially darkroom orientated.

The considerations of format are important, not just for the usual reasons of economy, versatility and the psychological aspects of ownership, but also for the aesthetic and technical values of the end result. Furthermore, its consideration here is all the more important because, in a sense, the darkroom is where photography begins and ends. In time, what one learns about processing is as much a result of what is known about photography generally, as of the application of certain chemical techniques.

Let us assume for a minute that you did not purchase the camera you now have, whatever format it may be, and that you are still considering choosing from the vast selection currently available. Many factors work on the prospective customer, not least of which are the marketing techniques of both film and product manufacturers. As much as 80 per cent

of film produced by the world's major manufacturers comes in the form of 35mm colour negative. Developments by film engineers will radically change the shape of this format so that it can be integrated with the latest electronic data technology. The short-term effect will be to present an even greater selection of miniature format hardware to the user.

The medium to large format section of the market has, until fairly recently, been dominated by the professional and pro/am sector. It is interesting to note that there is now probably a greater variety of equipment available to the enthusiast than for some years, but there are considerations which sometimes work against the very real advantages of increased format size. There is the consideration of cost. Equally important will be the 'value' factor in terms of versatility. The limitations of the format itself will not become readily apparent until you have (a) had a great deal of use from a 35mm instrument and (b) had the chance to compare its results with those from a larger format. This should not be construed in any way as a denigration of the miniature format; after all, there is plentiful evidence of its superb performance in many fields of photography. Nevertheless, the key to whether it will produce the kind of results you might hope for is in the word 'performance'. So perhaps the first consideration should be of *purpose* rather than of versatility.

The next consideration should be an examination of the limitations and advantages of format within the purpose framework. In this area we find a veritable mountain of sales and marketing information which tells us remarkably little. This is not to say, however, that aesthetic considerations are not important. The oft-quoted dictum, 'It's not the camera, but the person behind it, that counts', is misleading. The ergonomics of camera design, the way in which an instrument functions in relation to the person using it, is just as important as the resolving quality of its lens. Further, the psychological aspects of the ownership of a tool are largely based on feel and appearance. The right camera for the right hands will go a long way towards producing the right results.

Format sharpness is relative. In practice, in pictures taken in the field or studio as opposed to tests conducted within definite laboratory limitations, sharpness is only apparent and is always viewed subjectively. Light, selective focus, camera shake, flare, contrast, edge acutance, subject movement, plus all aspects of darkroom technique and the quality of the final print, all contribute to the *impression* of sharpness. By being selective in the choice of format, the photographer has some control over the degree of apparent sharpness presented to the eventual viewer.

A good-quality taking lens will be able to resolve at least 100 lines per mm, which is a measurement of its ability to render detail sharply. Modern multi-layer lens coatings, combined with improved objective formulae and optical glass, have made such significant advances to the extent that even moderately priced 35mm format optics are capable of excellent resolving power. On occasion, and when conditions are favourable, such objectives can produce results which might be considered outstanding. As a general rule of thumb, however, better-quality optics tend to be more expensive and, if consistent high quality or a certain type of result is expected, a bigger investment may have to be made. The human eye is about 15 times more powerful than even the best lenses, so even when a near-perfect optic is used in conjunction with the finest-grained film, results obtained under average outdoor conditions may not be perfect.

Lenses designed for use with the 35mm format are generally computed to have greater resolving powers than those designed for larger formats. This is because smaller format negatives have to undergo significantly greater magnification in the enlarger to achieve larger print sizes. The 4x5in negative needs only to be magnified twice to make a standard 10x8in print, whereas the 35mm negative needs an 8x magnification. For this reason, and contrary to popular photographic folklore, larger format lenses are generally not sharper than smaller format lenses, and using them with adaptors on smaller format cameras will not normally produce sharper results.

This information may be of importance to the photographer engaged in special projects where the final result (the print or reproduction) may be larger than usual. Exhibition display prints, illuminated display transparencies and large-size original bromides will all benefit in terms of perceived sharpness. Achieving the same goals with smaller formats is not impossible, but a more meticulous approach, matched to perfect internegatives, is frequently required and, even then, the final result can rarely compare in terms of overall quality with the larger format.

Another factor to be taken into account today is the method by which lenses are now tested.

Modulation transfer function (MTF) tests are optical and electronic methods of testing a lens without using a camera or film. An electronic collimator measures image contrast at 'x' cycles per mm resolution of one sample. In practice, 'x' is a nominal figure equal to the finest detail discernible by the human eye for a given print size held at normal viewing distance. The results of such tests can be expressed in terms of a percentage figure, where the maximum is 100 per cent, or in terms of lines per mm where the range covered is 0-100. MTF tests have been largely accepted by both reviewers and manufacturers as the new standard by which the majority of modern lenses are compared. The system can only be viewed as a very rough guide to the possible quality of an optic. From the manufacturer's point of view, it is also only part of an overall optical test function. In practical field tests, using film and paper, a number of important variables must be taken into consideration. The final arbiter of whether a lens is any good or not will be its ability to produce a crisp and well-defined image under a variety of lighting and exposure conditions.

Next, we need to consider the resolving capability of film. Panchromatic emulsions for general-purpose photography are capable of resolving between 50 and 200 lines per mm. Films with a thinner emulsion base and slower ISO rating have a higher minimum figure, between 150 and 200 lines per mm. Compared with the glass plates of the past, modern film is capable of greater resolving power on a format-for-format basis, but glass plates were capable of immense clarity of detail and quality of tonal range which is often difficult to match when making use of modern smaller formats. Some 35mm users may want to argue that they can produce black-and-white prints of a quality equal to and perhaps even better than some larger formats. I have used the same argument myself, particularly in the early years of my career when it was necessary to be able to prove, not only to myself, but to others, that really excellent results were possible using the smaller format. It took me some time to realize that, while quality could be coaxed out of the 35mm negative exposed under certain conditions, it was in fact much easier to achieve that same level by using a larger format. Going larger still, there is no denying that no matter how badly one treats a 5x4in negative, the end result is far superior in terms of apparent sharpness and tonal range than anything produced using the smaller format.

Once this was clarified, I knew that there would be certain assignments which could only be shot on a larger format, and certainly if very high technical quality was a requirement. Other assignments, such as news, sports, reportage, and many other subjects, could be photographed well by exploiting the operational versatility of the miniature. By clearly establishing the limitations of each particular format, I was able to begin exploring the medium in a way I had not previously considered. That realization opened up a whole new book of ideas and experiments which has necessitated building a tool-kit which can cover most eventualities.

In considering format, the darkroom photographer must also endeavour to match the quality of the photographic equipment with that used to make the print. As already discussed in Chapter 3, only the finest optics should be used for print making. The type of enlarger illumination, whether it be low-voltage halogen, cold cathode, diffuser or condenser, will have a direct bearing on how the negative image is rendered on paper. To

The 35mm format has been the mainstay of documentary photographers worldwide for decades. Modern lenses are capable of great resolving power and depth of field which is essential for this approach to subject-matter. The sheer bulk of medium- and large-format equipment inhibits the street photographer's rapid response to immediate situations which require quick thinking and execution.

The 'zone' system of exposure and development enables the photographer to pre-visualize the printed result. Rather than use an averaging exposure method whereby all film is exposed for a given ISO and then processed accordingly, the zone system allows exposure to be made so that any one of a number of shades of grey may be obtained when development is adjusted to compensate. Ideally, the system is suitable for one-shot, large-format work where several different exposures and development treatments can be given to each piece of film. With 35mm cassettes it is only practical to select one option – that of development compensation. Here, detail in the shadows was more important than the highlights, but sufficient detail needed to be retained here. Tri-X, ISO 350, yellow filter, D-76 diluted 1:1.

This reproduction is from a colour print which was made for newspaper reproduction. The great variety of colour in some pictures often makes it difficult for a printer who is not the photographer to make the correct filtration assessment. In this case, skin tones were selected and the print made to a density level that would easily convert to black-and-white reproduction where necessary.

sum up, these are the major points to consider in establishing format size:

- Photographic purpose.
- Own personality.
- Ergonomics of equipment design.
- Optical quality.
- Own knowledge of medium.
- Processing facilities.

The third and fourth may be considered to have equal importance in assessing small and medium formats. Better-quality camera systems are known to have first-class optics throughout a lens range and, in this case, there may be very little to choose between the quality of one marque and another. There may, however, be numerous design and operating differences, and in that case only those differences need to be considered. Large-format cameras of the monorail and flat-bed field

type can usually be fitted quite easily with a vast range of optics not necessarily supplied by the camera maker, and in this case more research will be necessary to establish which are the most suitable objectives.

The professional photographer who hopes to satisfy the demands of innumerable clients will be equipped with a small arsenal of equipment of varying format size, though I hasten to add that there are exceptions to this general rule; in photojournalism, for example, 35mm has long been considered the most versatile and practical tool for the task. In the field of amateur photography, cost invariably governs both quality and variety of equipment. A fairly small proportion may be using large format (5x4in or over); the fact that the roll film market is expanding again after a dull and relatively static period is an indicator of the returning popularity of the medium format; 35mm, however, outstrips all other

formats. Much of what follows is of particular relevance to the medium and 35mm user, although there is no reason why the large format user may not apply similar controls.

THE ZONE SYSTEM

Since the beginnings of photography, a variety of methods have been perfected which are primarily designed to give the photographer more control of exposure, development and print making. One of the most accurate, and also the most complicated to comprehend fully, is the 'zone' system developed originally by an American photographer, the late Ansel Adams (1902-1984), in conjunction with colleagues of the F64 group of photographers founded in California in the nineteen-thirties.

The F64 group became known throughout the photographic and art world, not only for their interpretations of the wonders of nature, but for the clarity, tonal range and presentation values of their prints. Adams himself

spent years developing techniques based on the zone system, to such an extent that finally his prints were given the kind of acclaim normally reserved for paintings.

Adams wrote several books devoted to the explanation of light in photographic terms, and the first, *Exposure Record* (1945), is essentially a description of the zone system of exposure which he and another F64 group photographer, Fred Archer, developed from the results of a number of tests conducted by the Western Electric Instrument Company a few years earlier.

Rather than follow the normal practices of photography, whereby a particular grade of paper is chosen to match the contrast range of a negative produced quite arbitrarily through normal development and averaging exposure techniques, the zone system allows the photographer to pre-visualize the final print, to select accurately a particular contrast range and to visualize the gradation of tonal values of a subject from 0 to 10, where 0 is the richest area of black on the final print and shows no

In this situation, it is unlikely that the subtle balance of colours and general ambience in this tannery would benefit from shooting on black-and-white stock rated normally. Some increase in contrast and tighter composition would be necessary to give a similar effect. Ektachrome 200. Available light.

detail, and 10 is the purest white equivalent to paper base. In between are 8 zones of varying shades of grey, of which one, 5, is always estimated to be equivalent to the tone of an 18 per cent Kodak grey card. By measuring the brightness range of the parts of the subject required for printing, it is possible by shifting exposure one full stop in either direction to render tones exactly as required, and then by compensating during development to produce a negative the contrast of which exactly matches a pre-selected grade of paper.

Adams' techniques were particularly applied to the use of one-shot cameras: large format cameras capable of exposing one plate or piece of cut film at a time. As the reader will have already realized, such procedures arc extremely difficult to follow when using lengths of roll or miniature film. In addition, the physical size of miniature film precludes taking full advantage of tonal gradation due to excessive magnification of the negative.

ASSESSING EXPOSURE

Brightness range has already been discussed in Chapter 4 in some detail. In adapting the zone system to roll and miniature photography, the reader should be prepared to make a deeper investigation of the metering capability of his or her camera. The vast majority of small-format SLR cameras use a through-the-lens (TTL) metering device, measuring some 60 per cent of the total field, which is biased toward the central section of the frame. More modern, top-of-the-range professional equipment now also provides the facility for measuring a partial screen area (approximately 13 per cent) as well as providing a 'spot' measurement facility which measures only a central 2-4 per cent area. Some medium-format as well as large-format marques also offer optional metering equipment capable of sophisticated exposure measurement. The Hasselblad 205TCC is currently the only example of the kind of professional level equipment fitted with a TTL metering system specifically programmed for zone system exposure measurement.

Most TTL metering devices, however, are not practically suitable for adaption to the zone system, which is based primarily on calculating the brightness range of the subject – sometimes referred to as 'subject brightness range'. Remember, it is the luminescence of each of the respective tones which make up the subject that you are trying to record; averaging reflective light meters cannot accurately measure such subtle differences when they are used normally from the camera to object position. What is needed is a meter with a very narrow angle of acceptance – a spot meter – which allows the photographer to measure accurately each of the identifiable tones.

In most cases where a small-format camera with integral metering is used, the normal practice of 'needle matching' – selecting a shutter speed/aperture to balance whichever priority mode is used – or utilizing a programmed exposure, will be employed. All of these readings and automatic exposures rely on one small piece of user-input information, the setting of normal ISO film speeds, assuming that in most cases normal development will be given for each respective film exposed.

Each film may have up to 72 frames exposed on a wide range of different subjects, all demanding different exposures for changing levels of brightness. When the whole film is developed, each negative may have a different contrast as well as wildly different gradations of tone. To make acceptable prints, it may be necessary to spend considerable time matching the paper to negative in a series of tests before a final print can be produced. It would be much easier at the outset to visualize, as Ansel Adams and his colleagues did, how the subject would best be rendered and on what grade of paper. Exposure for the gradation of tones and development for contrast are the key factors. How can this work unless the film is cut and each individual frame processed separately?

The normal procedure in assessing exposure is based on the measurements indicated for the brightest and darkest parts of the subject, the average of the two being taken as a general reading for the whole scene. The drawback is that the resulting print may be

deficient in both shadow detail and highlight detail when measurements are taken in bright, contrasty light; in even, diffused light, prints may lack a pure black and base white. Result? A print of even, mud-grey tones.

To overcome this, some photographers bracket their exposures a half to one full stop or more either side of the so called 'normal' exposure, in the hope that one or more negatives will have the correct gradation and contrast. This hit-and-miss approach may produce the odd negative from time to time from which an excellent print can be made. However, the system is full of drawbacks and offers no guarantee of success at all.

In most instances, the photographer will be aiming to produce effect, rather than a pure record. The resulting print is a tonal interpretation of that part of the scene which moved him or her to make the exposure in the first instance. Using roll and miniature formats, some latitude in exposure, development and print making is desirable if the final result is to come anywhere near our expectations. Table 1 may be useful in helping to determine certain tonal values, contrast and negative density.

The figures are based on techniques which I have used for a number of years to obtain predictable results from the following types of lighting situations:

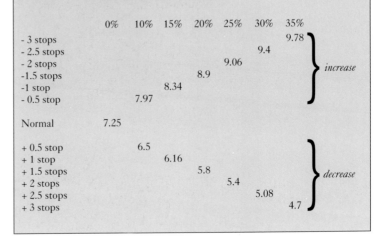

TABLE 1: EXPOSURE COMPENSATION DEVELOPMENT

Times are given for a working solution and tank temperature of 20°C (68°F). Films = Ilford HP5 Plus rated at 400 ISO (slight variations for Kodak Tri-X at same rating). Stock solution of HC110 diluted to a working strength of 1 part stock developer to 9 parts of water.

DEVELOPMENT TIME IN MINUTES
EXPOSURE % OF DEVELOPMENT INCREASE/DECREASE

	0%	10%	15%	20%	25%	30%	35%	
- 3 stops							9.78	}
- 2.5 stops						9.4		}
- 2 stops					9.06			} increase
-1.5 stops				8.9				}
-1 stop			8.34					}
- 0.5 stop		7.97						}
Normal	7.25							
+ 0.5 stop		6.5						}
+ 1 stop			6.16					}
+ 1.5 stops				5.8				} decrease
+ 2 stops					5.4			}
+ 2.5 stops						5.08		}
+ 3 stops							4.7	}

📷 Bright, contrasty, deep shadow, little cloud.
📷 Bright, haze, sun and cloud.
📷 Bright, diffuse light.
📷 Overcast or dull.
📷 Available light.

Over-exposure or under-exposure geared to percentage increase/reduction developing techniques allow the photographer more control at the print stage. Normal metered readings are used in most instances where the light is even or diffused, except where more or less emphasis is desired at the main point of interest. In bright, very contrasty conditions which would normally render shadow areas in the 0 to 11 zone of blackness, and lighter areas as zones equivalent to VII, IX or X, some

further adjustment may be necessary to control the extent of the brightness range. In this case, pick out the zones which are of most importance and work on the assumption that only 7 zones, including deep black and brilliant white will be available. It is also worth remembering that the luminescent value of a Kodak 18 per cent grey card is equivalent to a zone V tone. Hand-held meters can easily be calibrated for a range of preferred tones where compensating development is the norm. Medium- and slower-speed emulsions can cope with a wide brightness range when rated at their normal ISO, even though it may be necessary to make small adjustments for exposure and development under any extremely contrasty conditions, such as in snow or seascapes. With high-speed film it is necessary to increase the apparent contrast range by lowering the actual film speed and decreasing development.

There are limits to the extent to which this can be done and much will depend on the type of film used. Modern emulsions such as Kodak's T-Max 400, for example, are best used at the manufacturer's rating. Tri-X, on

This photograph relies on the predominant use of black-and-white tones to achieve the desired effect in combination with side lighting at 45° to the photographer on both sides of the subject. A shallow depth of field emphasizes the hands and syringe. Film was Pan F processed in Microdol-X.

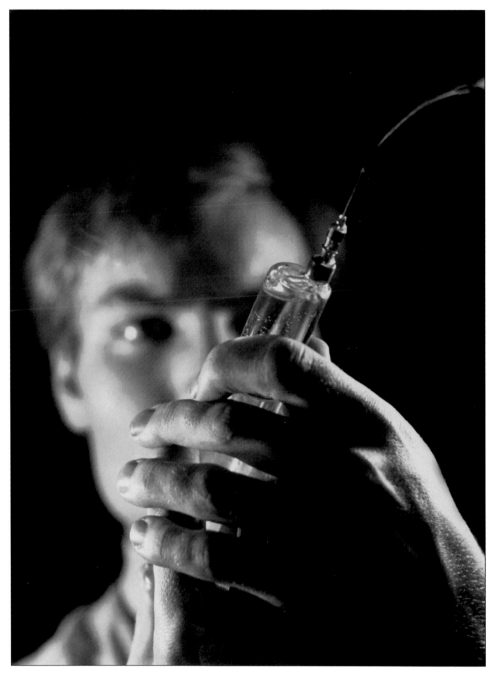

the other hand, can be effectively rated at EI320 or even 200 in extreme cases. Ilford's HP5 Plus takes less kindly to reductions than its predecessor HP5, but it can still be used effectively for contrasty scenes at EI320. Table 1 (page 80) shows a range of development times which should be used by the student as a starting guide. Individual process-

ing techniques can make a substantial difference to the final result – the method adopted for agitation, for example, and the length of time taken to fill and empty a tank with developer, and whether a stop or water bath is used. Use the table to make accurate adjustments to your own timings for a preferred negative contrast and tonal range.

Here are two examples of pre-visualization exposed under two entirely different lighting situations. In the left-hand shot the light came from a single yellow-filtered spot some 40ft away on a balcony. I used Tri-X rated at 650, a Nikkor 105mm lens wide open at f2.5 and moved in close. Exposure was 1/60th second and the film developed in concentrated D-76 for 10 minutes. In the second picture the light came from a large window on a wintry morning. The camera was tripod-mounted, which I used to give me an exposure reading of the highlight-only areas. The film (Tri-X) was then developed in dilute D-76 and a print made in a grade 3 paper which was burned-in slightly around the figure to eliminate the cluttered background.

CAMERA METER ZONE TECHNIQUE

Unlike the professional, whose work frequently demands one or more rolls of film to be exposed on one subject, the amateur has usually to exercise greater economies. This restriction does make it difficult for the miniature or roll format user to take full advantage of the zone system. There are, however, a variety of simplified versions which, when properly manipulated, are capable of producing excellent results. These rely to a large extent on the discipline of the operator and sophistication of equipment available.

Most modern electronic 35mm cameras incorporate a centre-weighted average-light metering system which is coupled to a microprocessor. When the photographer activates the meter, a numerical assessment of the exposure is flashed through light-emitting diodes on to, or to one side of, the viewfinder screen. By selecting one of several metering modes, the photographer can either let the camera set shutter speed and aperture (as in programmed mode), or let the camera select shutter speed only when the aperture is fixed – or vice versa – (shutter/aperture priority), or take complete manual control. The current trend in camera design is more and more towards full automation with only a patronising nod in the direction of the purist. The exceptions in this complicated area of optical manufacture are the makers of top-line professional equipment – Nikon, Olympus, Canon and Leica. Autofocus camera systems use a range of electronic-metered programmes which can be manipulated in the centre-weighted, partial and spot modes. Leica's M6 Rangefinder and R series SLR cameras offer whole-field centre-weighted and 'selective' metering. With the exception of Canon (EOS1[N]) and Olympus (OM4Ti), the configuration used to transmit data to the camera user cannot easily be matched to a basic zone exposure technique.

Of the two, the Olympus OM4Ti TTL meter offers a spot meter measuring 2 per cent of the total picture area. The same meter is used in the discontinued mechanical OM3. The meter operates in tandem with a centre-weighted averaging system made possible by incorporating what the makers call a silicon blue cell in the electronic mechanism. The image transfer mirror is only half mirrored in the central section; this allows some light to pass through the mirror, where it is reflected by a fresnel sub-mirror to three collecting

lenses behind which are the silicon blue cell light sensors. The collecting lenses are aimed in the direction of the film plane and, in the normal centre-weighted metering mode, part of the SBC array is activated to provide an average light reading. As soon as the spot meter is activated, readings are given for the 2 per cent central area of the subject.

Both the current OM4Ti and OM3 have a sophisticated central processing unit (CPU) with an integral random access memory (RAM) allowing up to eight spot-metered evaluations to be computed simultaneously or selected individually. From a zone user's point of view, the most interesting aspect is probably not so much the sophistication of the SBC/CPU circuitry but the way in which Olympus designers have transferred the visual information for the photographer to use.

The manual mode liquid crystal display in both the OM4Ti and OM3 is set out in such a way that it facilitates a set-up whereby 9 of the 10 zones previously described can be visualized in step form on the LCD. If zones 1-9 are used, the central marker is taken as zone V which would be translated as an 18 per cent medium grey patch. The markers either side of the central marker are used as shown below.

OM4Ti/OM3 ZONE SYSTEM LIQUID CRYSTAL DISPLAY

```
IX VIII VII VI  V  IV III II  I
 :   :   :   :  :  :   :  :   :
 +   *   *   >  I  <   *  *   -
```

The markers on either side of the central marker indicate tonal values corresponding to the Roman numerals. The display allows a rapid comparison of tonal values and enables the photographer to set spot readings at predetermined tonal print values.

DEVELOPER CHARACTERISTICS

The best developer for your film is not necessarily the one recommended by the film manufacturer, even though the film and developer may have undergone exhaustive laboratory and practical tests. Because conditions outside the laboratory vary so much in terms of the equipment used for measuring liquid quantities, in the mixing of dry powder chemicals, in temperature control, and in handling techniques, the recommendations normally accompanying film are given as user guides only. In practice, in the home or professional darkroom, recommended developers are often found to be lacking when more varied results are desired.

With few exceptions, most film developers currently available may be used in conjunction with almost any type of film. Except for one or two formulae specially designed to enhance characteristics of different emulsions, nearly all developers will give a different effect when used to develop the same film type. Some reduce contrast, boost shadow detail, enhance edge acutance, produce fine or coarser granular structure, and so on. Others will have a very different effect. In selecting a developer, the following points are worth bearing in mind.

- Effect on contrast.
- Effect on grain structure.
- Ability to enhance shadow detail, control highlights.
- Economy of development time.
- Economy in use.
- Powder or liquid mix to stock solution.
- Storage life.

Products of the trade names in Table 2 (page 85) are commonly available through most photographic equipment dealers and, if not available off-the-shelf, can be ordered from the manufacturer. They can be used with most panchromatic film, except where indicated by an asterisk (*). Development times given are for normal film speed ratings. Times may have to be varied according to local conditions and these can only be successfully established after tests.

Development times for a particular contrast, suitable for printing through a condenser or diffused enlarger system, must also be taken into consideration when

This contrasty subject needed careful printing. The sea has been burned in around the boat and helicopter to achieve the desired effect on a hard grade of paper.

A straight print on normal contrast grade of paper lacks the vitality of the print above. It would reproduce adequately, but with less of the impact.

conducting first tests with these times. You may be surprised to find that some figures will vary quite dramatically. Some readers may also be surprised to find that their favourite 'soup' is not listed in this section, although it may be in the following one. The reason for this is fairly straightforward.

Nearly all photographers interested in their craft eventually manage to find the time, either through necessity or pleasure, to try out the many different types of developer available. Some I know have gone through just about every available off-the-shelf product only to revert to formulae long ago discarded by the packaging industry. Using developer, and discovering which is the most suitable for your purpose, is a little like wearing-in new shoes; one is either eventually glad to be rid of them or comfortable in the knowledge that, until they wear out, there is no reason to buy another pair.

Because different formulae produce varying developed results, a notebook for recording characteristics, times, temperatures and agitation sequences will be useful for future reference for the occasions when you feel that certain exposures should be given different treatment. This darkroom notebook is also useful for other reasons which I will come to

soon. While researching my own notes for this book I came across some interesting entries. First, I discovered that, over a period of some 25 years, two types of developer have frequent entries: D-76 and HC-110, both manufactured by Kodak. One is available in powder form, the other comes in a thick, syrupy liquid form which is further diluted to make the stock solution. Scattered through the notes and requisition pads are entries for other types, and it is fairly apparent that, when these supplies were exhausted, I seemed to have

automatically returned to old favourites. I recall that, at one time, Agfa introduced a product called Studional Liquid which, in order to work effectively over long periods with high throughput, needs a replenisher. I was given a sample by Agfa one day, but it was not used immediately. Several months later I decided to push through some of the then new Agfapan 400 I had also been asked to try out. The results were, as one might expect, superb.

With a little adjustment, both Kodak and Ilford emulsions were quite happy in this brew; it produced crisp, fine-grained negatives that printed well on Agfa papers. Unfortunately, I could not get the same results on other paper stock, whereas the contrast range of negatives developed in D-76 or HC-110 could be printed on almost any make of paper. In recent years, I have stuck rigidly to HC-110. It is a great all-rounder, which can be diluted to different strengths for a variety of applications.

Used at the normal dilution of 1 part stock to 9 parts water, a film can be loaded, developed, fixed, partially washed and damp dried for use within 15 – 20 minutes. Stronger solutions decrease the time significantly, but in this case, great care is required to see that sufficient, but not excessive agitation, is properly controlled. Too much agitation may cause uneven development, excessive partial development or streaking, or a combination of these. With 35mm film, too vigorous agitation may also cause perforation streaking. This is caused by the wave action pattern of developer rushing back and forth through perforations and is manifested typically in an uneven development sequence on the horizontal frame edge of the film. The phenomenon does not exist with roll film because there are no perforations, but unevenness is sometimes apparent when nylon spools are used. The slightly thicker nylon groove mouldings, being of different shape to stainless spools, set up other wave patterns which can cause problems. When development times of less than 5 minutes are used regularly, it will pay to presoak the film in a water bath which, as already described, helps to dislodge air bubbles and swells the gelatin sufficiently to allow more effective development.

The type of tank used, quantity of and dilution of solution in which the film is immersed are factors which will affect the *gamma* (contrast) gradient. On average, contrast tends to be higher when small tanks are used with a solution of less dilution. Deep tanks, i.e. those that accept a full length of 36 exposure film folded and weighted in the centre, require slightly longer development times to achieve the same contrast rating.

PUSH PROCESSING

As we have already seen, film speed in ISO terms is established by the manufacturer after extensive laboratory tests calculated from the amount of light required to give a density of 0.1 above the base fog level, the point at which non-image-forming silver is changed in character during development and begins to show traces of having received exposure from a point source light. At this point it may be as well to elaborate further on the subject of film speed and how it can be used by the photographer to manipulate characteristics of certain emulsions.

TABLE 2: DEVELOPMENT TIME (IN MINUTES)

DEVELOPER DILUTION IN BRACKETS, E.G. (1: 'X' WATER)	FILM TYPE								
	1	2	3	4	5	6	7	8	9
Aculuc (1:9)	9	9	9.5	6	9	7.5	5.5	5.5	6
Acuspecial (1:29)	*	*	*	13	14	18	12	12	15
Acutol (1:10)	*	*	*	7	6	7	5	*	*
Acutol (1:15)	*	*	*	*	*	*	*	7.5	9
Atomol (n/d)	10	11	10	8	12	9	6	9	7
D-76 (1:1)	10	17	13	7.3	14	9	7	12	10
ID-11 (1:1)	10	17	13	7.5	14	9	7	12	10
HC-110 (B,1:7)	7.75	6	7	6	9	5	4.5	5.5	4.5
Microdol-X (n/d)	11	13	13	7.5	14	8.5	8	10	8
Perceptol (1:1)	18	21	16	11	16	11	8.5	14	15
Rodinal (1:25)	8	6	7	8	5	4	6	4	6
Unitol (1:9)	10	10	10	*	*	*	*	*	*
Unitol (1:14)	*	*	*	11	8	5.5	5	8.5	6

n/d = undiluted, stock solution

* = not recommended, or not applicable at this dilution, see next line.

Film Types: 1) Tri-X; 2) HP5; 3) Agfapan 400; 4) Plus-X; 5) FP4; 6) Agfapan 100; 7) Panatomic-X; 8) Pan-F; 9) Agfapan 25.

To recapitulate, each cassette, roll and sheet film packet is marked with the film speed, usually thus, ISO100/21°, where 100 represents the arithmetic and 21 the logarithmic scale. ISO is an international standard culled originally from the older ASA – American National Standards Institute, previously American Standards Association – and DIN, which stands for the German industry standard Deutsche Industrie Norm.

When the ISO number is doubled, film speed is effectively halved, which is equal to one full stop of exposure. It will pay the student to learn the accepted international ISO scale of film speeds over a broad range likely to be used for a variety of assignments: 50 64 80 100 125 160 200 250 320 400, etc.

It can be clearly seen from this range that the ISO scale jumps in increments equivalent to $1/3$rd of a stop increase in exposure starting from the left-hand side. Thus ISO100 is only 1 stop faster that 50, *not* 2 stops, or *double* the speed. The equivalent DIN measurement increases by $1/3$ of a stop for every increase in a single digit: e.g. 21° = 100ISO, 22° = 125ISO, and so on.

Many modern cameras of the 35mm type, including smaller compacts, automatically set the film speed ISO when the film is inserted into the camera by means of a special metallic coding pattern on the film cassette. This is called DX coding. In more sophisticated electronic AF type SLR cameras, the DX set ISO can be changed from the manufactured one to a user-preferred setting, using special customising features of the camera CPU. Manually operated cameras, such the Leica R6.2, Nikon FM2n, Canon F1(New) and Olympus OM4Ti, retain the facility to set ISO speeds manually. On larger format cameras, ISO settings must be set manually because there is no provision (yet) on roll film for DX coding.

In practical photographic terms, indicated film speed is a useful guide to exposure latitude and contrast range, as well as to sharpness, effect of grain and tonal range. The experienced student can use this information to change the 'effective' film speed by manipulating exposure and the contrast range to

Bright contrasty light in downtown Sydney might have caused severe problems. Using a 17mm wide-angle lens, I fitted a light yellow filter and exposed HP5 one full stop below the ISO rating of 400. The film was processed in HC110 dilution B for 5.25 minutes. This retained the shadow detail I needed under the shop overhang as well sufficient printable highlight detail. The print was made on Multigrade paper equivalent to contrast grade 2.

match a new set of development rules. The original film speed however – its measure of sensitivity – does not change, no matter what developer one might use, and in fact most developers used as directed for type 'x' film will not change the film speed for all practical purposes. As we have seen, contrast and actual negative density can be changed, but that is not the same thing as actual speed.

If the film speed is fixed by the manufacturer, how does the photographer determine a new speed and how is that defined for the purpose of development? Let us say, for instance, that you were using a 100 ISO film in the camera and the object required an exposure of one full stop more than was indicated by a light meter. If you expose the film at the metered reading, your film will be underexposed by one stop. The new effective ISO is defined as the Exposure Index. It is a variable which the photographer can change (linked to changes in development) depending on lighting conditions at the time of exposure. So the under-exposed 100 ISO becomes EI 200. If you were to reduce exposure by two full stops,

the EI becomes EI 400. In effect, what you are doing by utilizing this method of exposure is no different from the basic theory applied to the zone system, where each step of the 10 zones is equivalent to a brightness twice as bright as the previous zone.

Exposure Index is constantly changed in practice. Because different panchromatic emulsions are more or less sensitive to certain colours of light when you change from one subject, say out of doors, to one indoors lit by tungsten light, there is a significant shift which affects the ability of the film to record certain details. Emulsions which are more sensitive at the blue end of the spectrum may have difficulty in recording subjects under certain lighting conditions like tungsten, if no allowance is given. It was not long ago that some manufacturers specified two ISO speeds for their film – one for daylight and one for available, or tungsten, light. This is true of colour reversal film because of the necessity to use light conversion filters, but the same rules do not apply to black-and-white panchromatic emulsions.

Another variable factor affects colour filtration. Whenever a coloured filter is used with black-and-white film, the effective EI is changed by a factor corresponding to the particular filter in use.

Push-processing techniques are widely used by many photographers, and in everyday practice EI is hardly ever referred to as a means of measurement. Working photographers simply say: 'This film was rated at . . . 200, 400, 650, 800 or 3200,' and so on. What they mean is that a new ISO speed was applied to the film, set on the camera ISO indexer or hand-held meter. The whole film is then exposed at this new rating and processed as if it had been given that rating by the manufacturer in a developer known to give acceptable results at the new speed rating.

Suppose you had inadvertently exposed your 100 ISO film at EI 200. If this were developed for the standard time in a standard developer for that film at its given 100 ISO rating, the resulting negatives would be thin, if not translucent. In order to build up the deposits of silver halides on the areas of film which have been exposed, more development time is needed to obtain a printable negative. However, push processing, or forced development, also has one or two undesirable side-effects.

In a scene of low average brightness such as a floodlit football match or street scene, where the bulk of the picture area is comprised of say 85 per cent shadow and 15 per cent highlights ranging in strength from fairly dim to excessively bright, forced development of the exposed parts of the image simply adds more and more silver. In the 85 per cent shadow area, even the parts of the scene which have received some exposure may not have had enough. The result is usually very much one of compromise. Contrast of the resulting negative, if not chemically fogged, may be so high that, no matter what grade of paper is selected for printing the overall effect will be one of 'soot and whitewash'. There is loss of detail, definition is impaired, grain clumping takes place and, unless the resulting effect is deliberately planned ahead, the quality of most prints from push-processed negatives leave a lot to be desired.

Modern emulsions, such as Kodak's T-Max types and Ilford's Plus varieties suffer a lot less from these effects when uprated and push-processed. However, high-speed films such as Kodak T-Max 3200 Professional and Fuji Neopan 1600 Professional are specially formulated to cater for low-light, fast-action photography, such as might be encountered in a floodlit stadium. Both emulsions have a greater latitude toward over-exposure, producing better tonal gradation than films with conventional silver halide structure. Negatives from these films can produce excellent quality, fully graded prints; but there are penalties for the increase in clearly recorded information. Prints are noticeably grainy; combined with an increased tonal range, the effect is less of the grittiness which gives prints from conventionally structured push-processed emulsions their graphic appeal.

Another school of thought argues that forced development, especially of conventional emulsions, often produces negatives which, because of their opacity (i.e. density of

silver deposit) makes them unsuitable for printing in condenser type enlargers. Most diffuser source enlargers (modern colour head and cold cathode) are better suited to the more dense, contrasty negative. If you use only condenser types for black-and-white printing, as I do, you will soon begin to appreciate that there is a fine art to the production of any negative, whether it be one produced through normal developing methods or by the push-process technique. I switched from the diffuser type of enlarger many years ago simply because I found that higher contrast negatives gave me prints that were altogether too soggy. It is sometimes said that it is not possible to tell the difference between a print from the same negative produced using either type of light source. Prints produced using all condenser type enlargers exhibit a superior quality in my view. Overall print sharpness is enhanced by an apparent increase in the print brightness range which is achieved by a real improvement in grain delineation. Diffuser and semi-diffuser (with only one condenser and light diffusing glass) enlargers tend to flatten the edges of the grain structure, giving a softer edge. This has the apparent effect of improving the contrast range.

It has always puzzled me slightly as to why some photographers, having spent fortunes on the best camera glass available in order to obtain the sharpest negatives, opt for a type of enlarger whose light source actually degrades the quality of resulting prints. Many budget-priced modern enlargers will only produce mediocre black-and-white prints at best, even when fitted with the most expensive enlarging lens. Incongruous as it may seem, however, compact enlargers with diffuser and semi-diffuser light sources can produce excellent quality colour prints, where the apparent effect of granular reduction through diffusion improves colour differentiation.

CHROMOGENIC FILM

Ilford's XP2 is now the only emulsion in black-and-white which uses dyes to form the image instead of silver halides. Because it is

TABLE 3: TIMES FOR FORCED DEVELOPMENT

STANDARD ISO	NEW ISO	DEVELOPER MAKE AND TIME IN MINUTES AT 20°C (68°F)	
Agfaplan 400	800	Tetenal Emofin	2 x 2.5 } †
Agfaplan 400	1600	Tetenal Emofin	2 x 3 } †
Agfaplan 400	1250	Acuspeed (1:7)	12
Agfaplan 400	800	Promicrol (1:1)	15
Fuji Neopan 400	800	D-76	12
Fuji Neopan 400	1200	D-76	15
Fuji Neopan 400	1600	D-76	20
Ilford HP5 400	650	Microphen (n/d)	8
Ilford HP5 400	800	Microphen (n/d)	8.5
Ilford HP5 400	1200	Microphen (n/d)	9
Ilford HP5 400	1600	Microphen (n/d)	10
Ilford HP5 400	3200	Microphen (n/d)	15
Ilford HP5 400	6400	Microphen (n/d)	20
Ilford HP5 400	1600	Acuspeed (1:7)	9
Ilford HP5 400	800	Promicrol (1:1)	15
Kodak Tri-X 400	800	Tetenal Emofin	2 x 2.5 } †
Kodak Tri-X 400	1600	Tetenal Emofin	2 x 3 } †
Kodak Tri-X 400	1600	Acuspeed (1:7)	9
Kodak Tri-X 400	1600	Promicrol (1:1)	14
Kodak 2475 Recording	1000	HC110 (1:32)	9 +
Kodak 2475 Recording	1600	HC110 (1:32)	15 *
Kodak 2475 Recording	4000	HC110 (1:32)	22.5

† = normal contrast; + = average subject brightness; * = low subject brightness

This is typical of the kind of problems the photographer can experience in exposing for scenes which have a tremendous brightness range. The actual film exposure allowed for this by reducing the effective ISO. A straight print was made on a normal paper without dodging or burning. A lot of work would be required to retain all the shadow detail while achieving the right balance in the highlights. Reducing the EI further and compensating in development would have produced a negative that lacked sufficient contrast to print effectively.

constructed in the same way as colour negative film using colour couplers, it can only be developed in Ilford's own special developer or by the C-41 process used for colour negative film. The correct name for this type of film is chromogenic. At the time of publication of the first edition of this work, Agfa also produced a similar emulsion, called Agfa Vario XL, supplies of which can sometimes still be found. It too is developed in C-41 or AP70 and I have deliberately left in the development sequence for this now discontinued film, detailed in Table 4 (page 90).

C-41 type chemicals are readily available to the home user in kit and bulk form. If you are already a student of colour negative processing you will find no difficulty in processing Ilford's XP2. The advantages of this type of film in low-light photography are its excellent speed-to-grain relationship, enormous exposure latitude, fine grain and superb definition. It performs best in the mid 200-800 ISO range. When fine grain is the main criterion, black-and-white chromogenic film is best exposed at EI 125. If high emulsion speed is essential, as is often required for indoor sports events, it should be exposed at EI 1600. In general use for a wide variety of outdoor subjects, users will find that XP2 performs rather better for being over-exposed.

Chromogenic emulsions do not normally respond well to forced development (see Chapter 11) by extending the time in the developer. I have, however, carried out experiments where raising the developer temperature by as much as five degrees and maintaining the stipulated time produces well-graded negatives when the film has been exposed in low-light situations. The user will be well advised to make several tests before undertaking important assignments of this nature.

One other very real advantage to the busy photographer who specializes in colour negative, but who has an occasional requirement to shoot an assignment in black-and-white is that XP2 can be used alongside standard colour negative materials and processed in the same chemistry. When processed in a commercial mini-lab or professional laboratory, XP2 negatives will exhibit a strange browny cast after the final wash. This does not disappear and can make such negatives rather difficult to print. Exposure times tend to be longer than for films processed in regular XP2 chemistry.

HISTORICAL CONSIDERATIONS

For the past few years, the majority of high-profile black-and-white film emulsions available have been based on the relatively new 'T' grain type formulations first introduced by Eastman Kodak. Other manufacturers soon followed this trend with their own variations (see illustrations on page 44). The granular structure of these films is similar to that used in modern colour negative emulsions. It improves tonal range as well as overall definition.

There are, however, still many conventionally formulated emulsions available to the photographer. Some of these are manufactured in what were previously Eastern bloc countries and imported as budget-priced 'own label' films by distributors in Western Europe and the United States. The majority of these films are manufactured using what is now considered to be old conventional silver halide technology. Typically, the student may find that some of these emulsions have characteristics which are similar, if not the same as, say, Ilford FP4 or HP5 (not the same as FP4 Plus and its faster sibling.) Other types are available which approximate closely to the characteristics of older Agfa emulsions.

Conventional silver halides are crystalline in structure, similar in shape to snowflakes but so small (1/10,000in) that their shape is unidentifiable to normal unaided eyesight. The problem with conventional structures is that, in order to increase film speed, the grain size has to be increased, which makes it more noticeable to the print observer as both film speed and print magnification increases. 'T' grain structures are more uniform in size and distribution over the light sensitive film layer and are closely interlocked, unlike conventional halides, which are deposited in a more random fashion.

Younger students of photography may not yet have had the opportunity to experience the delights of conventional emulsions, some of which, in my view, were capable of truly exotic results. Part of the problem is that, as film technology has inched forward to its present state, largely to satisfy the demands of industry, some of the exciting volatility of the older emulsions has been replaced by more uniformity. In fact, whereas it used to be the case that quite large variations existed between films of a different make but of a similar ISO speed, now these have been reduced to a minimal level.

'Own label' emulsions may satisfy the needs of some photographers, but production quality tends to be a little erratic. Films bought off the shelf in the West are often found to be lacking once they are processed. The kind of faults most likely to be found in the emulsion are small scratches and a tendency to acute softness when wet. These films invariably require a hardener added to the fix solution.

One black-and-white film of the conventional type which, in my opinion, outshines all the rest is Kodak's Tri-X Pan (ISO 400). The original formula for this film has been around for almost 50 years and the film in its present configuration has been available for some 35 years. Ideally, it should be developed in a dilute solution of D-76. It has a latitude of approximately one and half stops either side of the recommended speed, but can be down-rated or up-rated to two stops with very little degradation in quality (see illustrations on page 82). Some younger photographers have mentioned to me that the film produces negatives which are often unsharp and overly grainy when compared with more modern emulsions. In my experience, it has the ability to produce negatives of excellent quality and sharpness, For the best results, exposure should be made for the mid to lighter tones and the film processed with the absolute minimum of agitation, as recommended by Kodak, and the temperature strictly controlled. Daylight tanks, such as those described in Chapter 2, may be found to be beneficial in spite of the need for more or less constant agitation.

TABLE 4: DEVELOPMENT TABLE

TRI-X PANFILM (ISO 400) at 20°C (68°F)

DEVELOPER TYPE	TIME IN MINUTES
T-MAX	6
T-MAX RS	6
HC-110 (Dil B)	7.5
D-76 (Concentrate)	8
D-76 (1:1)	10
MICRODOL-X	10

N.B. Microdol-X diluted 1:3 may be used at the higher temperature of 22°C for 14 minutes. Kodak recommend 13 minutes at 24°C for best results.

The following times are recommended for Tri-X rated at EI 320; in descending order for developer types listed above: 8, 4, 8, 5.5, 10 minutes, at 20°C.

The following times are recommended for Tri-X pushed to the following EI values (times are given for varying temperatures which are in deg. C and follow in () after the time given in minutes; developer type precedes time).

EI 800. T-MAX – 5.5 – (24°C), D-76(CONC) – 8 – (20°C)
 HC110 (Dil B) – 7.5 – (20°C)
EI 1600 T-Max – 8.5 – (24°C), D-76(CONC) – 13 – (20°C)
 HC110 (Dil B) – 16 – (20°C)
EI 3200 T-Max – 11 – (24°C).

N.B. Times for other developer brands are shown in Table 3. All times and temperatures are given above for use in small hand tanks with agitation at 30 second intervals.

AGFAPAN APX 100 AND AGFAPAN 400 PROFESSIONAL AT 20°C (68°F)

DEVELOPER TYPE	AGFA APX 100	AGFA 400 PRO
REFINAL	5	6
ATOMAL	9	10
STUDIONAL LIQUID		
RODINAL SPECIAL	3.5	4.5
RODINAL 1:25	8	8

N.B. Time and temperature are given for processing in small hand tanks. Continuous agitation is recommended for the first minute followed by a single inversion of the tank every 30 seconds thereafter.

The following figures are for Ilford Films developed in ID-11 at 20°C (68°F), exposed at manufacturer's ISO rating.

DILUTION	PAN F+	FP4+	HP5+	400 DELTA	100 DELTA	ILFORD ID-11
STOCK	6.5	6	7.5	7 7		
ID-11(1:1)	8.5	8	13	10.5	10	
ID-11(1:3)	15	18	20	16.5	15.5	

PUSH PROCESSING FOR HP5+

Use Ilford Microphen stock solution at 20°C (68°F) for the following EI ratings. EI 800 – 8 mins, EI 1600 – 11 mins, EI 3200 – 16 mins.

BLACK-AND-WHITE PRINT MAKING

It is ironic in a peculiar sort of way that, since the very earliest days of photography in the mid eighteen-hundreds, practitioners, pundits and critics of the craft have mostly concentrated their energies on inventing, improving or criticizing the medium of colour. From the earliest days of commercial photography, practitioners hired colouring artists to hand-tint the portrait photograph, a skill still as much in demand in some circles today as it was then. The inventor sought ways to transfer the colours of nature on to a single photographic plate and has been improving it since about 1907, when the autochrome process became the first practicable method. Critics, of course, have drawn attention to the lack of suitable colour emulsions for years. Why then, when black-and-white film forms a mere 5 per cent of the output of the most prolific manufacturer, is there such a following for its evocative appeal?

It is unfortunate, perhaps, that the term black-and-white is so inappropriate. In recent years, the word 'monochrome' has become yet another fashionable adjective used to describe what is essentially not black-and-white photography but continuous and variable tone, from white through a variety of grey tones to black. Black-and-white prints are frequently not black-and-white, but have some colour which is manifested through the ingredients of the paper or, as is often the case, added in a further processing step after the developed image has been fixed.

The really silly thing about black-and-white photography is that most of us do not view the world in continuous and variable tones of grey. The real world is coloured and, somehow, a black-and-white reproduction of aspects of it is not enough to satisfy our appetite for more realism. Hence, reproductions in books and magazines which use black-and-white are often tinted with a colour overlay. Magenta is commonly used because it adds more depth to black, making the in-between tones and highlights appear brighter and thus easier for the brain to associate tone with shapes and shapes with detail. Sepia tints, or reddish-brown tints, are sometimes added to black-and-white prints to evoke nostalgic associations; the mind recognizes instantly that older prints are often faded, tinged with yellow or brown. Colour washes added by hand are common, perhaps in the vain hope that, through some miracle of what is now fairly ancient technology, the print will evoke a similar feeling to that associated with seeing the exquisite and original work of a painter.

The photographic print is not, and never should be, compared with the works of artists or other practitioners using a different medium to express their emotions or interpret images of the real world. A photograph is a photograph, a two-dimensional image of some object, or person, or scene reproduced by various mechanical devices. A photograph may be labelled 'work of art'; photographs and photography may use the traditional values of art and its own historical background in forming and reproducing the image, but the result of the silver image process cannot lay claim to the quality of art. Photography is a medium; making a decent print is a craft.

As everything in photography is, in some way, related to colour (even the safelights are coloured), in producing a black-and-white image the photographer in the field must try to think about the outside world in a series of mono tones. This thought process must be unbroken, as it continues through the negative development stage and on to the enlargement process.

What we are mainly concerned with from this point on, through to the final print wash

and drying, is quality. Black-and-white printing in most professional jobbing darkrooms is a hit-and-miss affair primarily aimed at offering the customer a degree of adequacy. With a little care and attention to the basic process of exposure, development, stop, fix, wash and dry, using commonly available materials, however, even the novice can make great prints.

A little later in this chapter, various paper and paper developers are listed and discussed, but for the time being let us assume that stocks of any 'regular' type resin-coated paper and processing chemicals are available.

TEST PRINTING

First select a negative for printing that looks normal: one with good tonal gradation, clearly identifiable regions of translucency (black in the print) and reasonably dense areas of silver (light in the print). Select a negative in which the subject-matter is bold – portraits, buildings, cars or objects, rather than vague landscapes or vast areas of wilderness.

Turn on the enlarger and remove the negative carrier. Adjust the printing easel to the paper size in use but, for maximum effect in conducting a test of this type, the larger the paper size the better; 10x8in is a useful size for evaluation in ordinary white light.

Inspect the negative to be enlarged under the light of the enlarger by holding it away from the body in a horizontal position, emulsion-side-down to the baseboard. Remove any traces of dust by gently brushing the surface with a squirrel-hair brush. If there are traces of wash water deposit, finger marks or other foreign matter, one of the following procedures can be used to clean the surface.

Take an empty glassine negative bag or six-strip glassine leaf and lay it on the easel. Place the dirty negative emulsion-side-down on the bag and, while holding it in place with the tips of two fingers on top and bottom perforations or edges, wipe the surface gently in one direction with one of the following:

 a moistened well-washed white cotton handkerchief;

 the soft side of a fine chamois leather;
 a well-washed white cotton handkerchief dipped in proprietary film cleaner;
 carbon tetrachloride;
 the softest underpart of a finger moistened on the tongue.

Always stroke the negative rather than grind it; when all traces of foreign matter are removed, polish the negative surface using a clean part of the same cloth or the finger.

Lift the negative off the glassine bag, turn it over and, while holding it obliquely against the enlarger light, inspect the emulsion surface.

DO NOT rub or stroke this surface with anything other than a squirrel-hair brush. A compressed-air blower may be used. Most dust particles, even stubborn ones, can be removed using a brush. Scratches on the glossy protective base can sometimes be filled in by lightly rubbing them with the softest part of a finger which has been stroked against the side of the nose. The grease from the skin acts as a gap filler to scatter light passing through the scratch, thus making it less noticeable in the final print. Finally, once you are satisfied that the negative is as clean as it is ever likely to be, carefully hold one edge between thumb and forefinger of one hand and flick the other edge sharply with the nail of the index finger of the other. This is a practised technique which relieves the negative of any stored or accumulated static electricity which, if allowed to remain, will attract more dust as soon as the negative is positioned in the enlarger. Tapping the edge of the negative sharply against the easel will have the same effect.

Now position the negative in the carrier and adjust the magnification and fine focus until the 10x8in area is covered with exactly the portion of negative to be printed. It is important at this stage to ensure that image-cropping and picture-sizing are carried out as if the print were to be the final archive copy. Its success will depend on accurate exposure and development, and any assessment made on the basis of a shoddy test will only tend to extend time spent in the darkroom.

The next step is to take the base of an empty paper box (10x8in) and carefully cut off the sides until you have a piece of flat, matt black card. This must be black on both sides. Daler card purchased from an art shop which is blacked on both sides is quite suitable and has the advantage of being cut to any desired shape. Without paper in the easel, turn off the safelight closest to the enlarger and run a short, say 5 second, exposure. This will give you some idea of how the enlarged image looks when you stand slightly back from it. It is a good idea to repeat this procedure until you feel entirely comfortable. The idea is that, by concentrating on the 5-second exposure, the negative image, its density and contrast values, will become more precise in your mind. After a while, and after you have successfully made many prints without too many failures, you will begin to recognize instinctively how certain negative images can be improved, either by holding back parts of the image (giving less exposure) or burning-in (giving more exposure). These techniques are discussed below; at this point it is important to use the mind almost as though it were a camera, exposing the images in slow motion

for your retention. You may find that other safelights are still too bright and reduce your ability to concentrate. If that is the case, turn them off. In time, you will be able to leave most of them on.

Now reset the enlarger timer to, say, 3 seconds. Adjust the lens aperture two stops down. If you are using an f4 lens, stop it down to f8. If the enlarged image looks too dark (i.e. virtually indiscernible) open up one full stop to f5.6. With the timer off, insert a sheet of paper into the easel. Lay the black card over the image at right angles to it, leaving a 1in (2.5cm) gap at the right-hand side. Each time you make a 3-second exposure, the gap will be increased by a further inch (2.5cm) until you have completed 10 steps across the paper, or 8 steps if the image is vertical (portrait style) rather than horizontal (landscape). Now begin the exposure sequence, taking your time. Move the card after each exposure is complete to the new position.

When this test exposure is finished, return the sheet of paper to a safe box. You can use an empty paper box for this purpose. Then take another sheet of unexposed paper, fold it diagonally and cut along the fold. Insert one half into the easel and position as if it were a whole sheet. Return the unexposed half to the paper box. Now lay the black card along the diagonal edge of the paper, leaving a 1/2in (13mm) gap. Begin the exposure sequence again, using the same time as above. Move the card the same distance at the end of each exposure until the whole half-sheet has been exposed.

Return this exposed paper to the safe. Now move to the 'wet' bench area and check that all three solutions (developer, stop and fix) are of even temperature. This should be one of a range of temperatures recommended by the manufacturer; 21°C (70°F) is a useful working temperature. Note the maximum development time, and if you have a dark-room wall clock above the 'wet' bench set this time on it. If not, use a watch or conventional darkroom timer. Take the exposed 10x8in sheet and place in the developer tray face down, simultaneously drawing it through the solution, and quickly turn it emulsion-side-up. Start the clock immediately. Agitate the dish

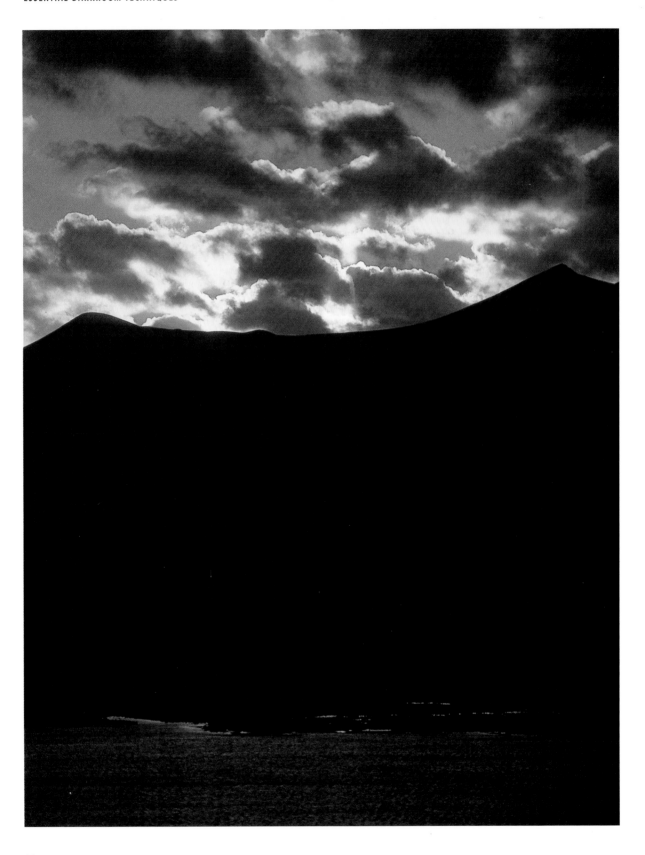

evenly by lifting each corner alternately. Keep an eye on the time; 15 seconds before time is up, take hold of one corner of the paper, begin lifting and drain for 10 seconds. Swiftly transfer to the stop bath for half a minute and then into the fix. Agitate vigorously for the first 15 seconds and then gently keep the print on the move for a further minute.

Repeat the same procedure with the second half-sheet of paper. When the fix time is up, lift and drain, and transfer to the wash. Resin-coated paper only needs a minute at most in running water, so you should be able to remove these test strips to a white-light area very quickly. While you are waiting for the wash to complete, check that all unexposed paper is carefully repacked and sealed. You should always make a habit of doing this before turning on any white light. It will save a lot of frayed tempers in the long term.

ANALYSIS

Although it is not absolutely necessary to dry the prints before viewing, wet prints tend to display slightly darker tones, so if exhibition quality is a requirement, assessment of dry test prints is essential. Use a rubber blade 'squeegee' to remove the surplus water after draining, and then hang the prints in an airing cupboard using two plastic pegs on a piece of line, if you do not own a print dryer. Hang each print from a corner. Properly 'squeegeed' prints will dry in a few minutes; resin-coated papers curl when air-dried and distort when overdried. If placed on a cold surface after the normal drying time has elapsed, the paper will gradually assume its normal flat state.

The test strips should show clearly delineated steps of exposure increases in strips. The top one, the one you started the exposure sequence with, will be almost black throughout its entire range of tones. There may be some highlight detail just visible. It will be fairly obvious that neither this nor the next step will be close to the ideal exposure required. As you proceed down the steps, the ones closest to the middle of the 10x8in sheet will show a marked improvement in tonal

values. Select the one which is about midway and then each one up and down the scale either side of it. You will notice that parts of the print in all three strips will look just right, and other parts may look a fraction heavy or a shade too light.

Make a mental note of the exposure times of each of the three steps which, if you used 3 seconds to start with, will be that figure multiplied by the step number calculated from the first step, e.g. step 5 x 3 seconds = 15 seconds.

Now take the half-sheet which was exposed diagonally. Find the same exposure value strips as the three selected on the full-frame print. Look carefully at the highlights and the shadows and compare one with the other. You should, by now, be able to make fairly accurate subjective decisions with regard to the way in which each separate tone is manifested. It is up to you to decide whether detail in the shadow area is important and, if so, in what direction. Will the overall effect be better if the shadow detail is eliminated, particularly near the print threshold, or better if more detail is visible? If the answer to the latter is yes, look again and see if there is enough detail to print and whether this shows on the test steps at the minimum exposure end of the scale. Next, look at the highlight end. If the negative has been properly exposed (i.e. if you made the exposure, having previously judged the tonal value required for the highlight areas), definite areas of bright white should be visible within the upper end of the tonal range.

If the negative exposure was based on a TTL average of the scene, the chances are that tones in the highlight region will appear to run together in the test strips selected for inspection. In the strips where maximum print exposure has been given, the light areas at the very top of the brightness range may be quite clearly delineated, even if they appear to be more grainy and less sharp than other darker areas. More subjective application is needed here to help decide which parts of the negative are important to print with more or less exposure. Taking the three basic exposure times for each selected step in the areas required will tell you exactly how

much more or less exposure must be given for those areas.

Now look at the mid tones. Are all of these satisfactory? Is detail clearly visible in this, the main part of the picture? Is there any area here which could be improved by more or less exposure? A useful accessory in establishing which parts of a print need further manipulation is a yellow chinagraph pencil. The areas concerned are ringed or marked more carefully, so they can be identified on the test print when new prints are being exposed. Write the exposure times of relevant steps on the back of the print with a felt-tip.

To assess how much more, or less, exposure will be necessary, first calculate from the test print the basic exposure required for the mid tones of the print. Remember that you will be developing all prints from now on by time and temperature, until the day comes when you can actually assess what is emerging under the developer. Note the areas of the print where further work is to be carried out. That means making a physical note on paper and including the additional time: main exposure +/- difference of the required step tone or time reduction.

PRINTING METHOD

At this point we are not concerned with paper contrast, brightness range or colour when processed and dried. The colour of black-and-white papers is frequently described by the ability of that paper to produce 'neutral', 'warm' or 'cold' tones.

The main requirement is to produce an acceptable print, a print in which the subject-matter is presented with sufficient impact. This crucial aim may be defined as follows:

- The subject-matter should be clearly defined and identifiable.
- The print gradation should flow from rich black to white paper base, with clear delineation of mid tones (if any).
- The photographer's intention should be clear.
- The presentation must be faultless.

Prints showing the following characteristics are unacceptable:

- Clearly over-exposed and under-developed.
- Appearing as a collection of mud-coloured tones: no whites, no black and nothing much in between.
- Are speckled with foreign matter appearing as irregular white dots, hairlines, etc., which have collected on the negative or in the negative carrier.

The following are key factors in successful print-making:

- The ability to recognize a good negative (i.e. one that contains all the requirements of exposure and development previously discussed).
- The ability to assess correct print exposure at a glance, to within half a second.
- The ability to match paper contrast grade to negative on a subjective basis without regard to technical accuracy (i.e. the finished print can be visualized, *except* when the print is required for reproduction by a process known to produce a result equal to the desired print effect, in which case the print becomes part of an ongoing process and must be exposed and developed accordingly).
- A disciplined approach to print making: each stage should be carried out methodically until it becomes second nature.

Notice that, in the second item above, I have made a point of not making any reference to mechanical or electronic exposure aids in printing. You will learn more, and more rapidly, by taking the trouble to make a test strip as already described. Some readers may find this approach contradictory. After all, quite a large proportion of funds invested in camera equipment covers the cost of expensive in-camera or hand-held light meters with which to measure negative exposures accurately. Why do without similar equipment in the darkroom?

Here colour is the key to the picture. Try to imagine this in black-and-white.

Print exposure meters of any kind, provided they can be relied upon to work accurately, are very useful and I would certainly recommend acquiring one. However, until you have learned to print without one, there is very little a print exposure meter can teach you. They are invaluable time-saving aids when many negatives of different contrast have to be printed quickly, but as most meters of this type are either linked electrically to the enlarger, or give a numerical read-out which is then transferred to the main timer, my experience is that they are practically useless as teaching aids. I would even go so far as to say that, in the wrong hands, information assessed by such meters can be positively misleading.

Assessment of exposure time for the print is based on three factors:

📷 the average negative contrast;
📷 the degree of enlarger magnification of the negative to baseboard image;
📷 the 'f' stop required on the enlarger lens.

Ideal exposure can range from 1 to 30 seconds. When a negative requires a full minute or more to produce a fully developed print image, beware. Exposures of more than this time are perfectly possible, of course, especially when floor-thrown magnifications are being used to make a much larger than normal print. But if we take 10x8in as being a nominal average size, the exposure for a 'normally graded' negative will be relatively short. For purely practical assessment, it will be obvious that a 'thin' negative (i.e. one that is less dense) will require less exposure time than the one which appears to be darker or more dense. However, a negative which appears to have larger areas of translucency may not necessarily be 'thin'. Closer inspection may reveal parts of the negative which have been correctly exposed and which will, given the right treatment, print perfectly on a normal grade of paper.

See if you have two negatives in which the subject-matter has been rendered correctly.

One should be a general scene with a good range of tones, the other should have very few tones. Compare both negatives on a light box or suitable illuminated source. Look closely at the lightest highlight areas under a magnifying glass. (If you do not possess an inspection glass [Lupe], use the 50mm lens from your camera; hold the rear element close to the eye with the front almost touching the negative; the diaphragm must be set at maximum aperture.)

Make a mental note of the apparent density of the highlight areas in both negatives. If they look similar – an accurate check is difficult without the aid of a densitometer – then both will print acceptably on the same grade of paper. If, however, the apparently thin negative is obviously less black in its highlight areas (less silver deposit), this is going to print as a darker shade of grey, given the same exposure and same grade of paper as the other negative. Because of under-exposure in the camera, or too little development, or both, the negative has insufficient contrast range to print correctly on a normal grade of paper. Paper contrast, therefore, will have to be increased to allow for the contrast reduction in the negative.

Several things happen when paper contrast is lifted to higher than normal. Table 5 shows a range of paper grades and, in addition, matching types of negatives which can normally be made to print on them. In general practice, selection of the correct paper type and grade, and attention to accurate exposure

TABLE 5: PAPER GRADES AND THEIR CHARACTERISTICS

PAPER GRADE	NEGATIVE CHARACTERISTIC					MATCH WITH
	VERY THIN	THIN	NORMAL	DENSE	VERY DENSE	
0 = very soft					*	very contrasty
1 = soft				*		contrasty
2 = normal			*			normal
3 = hard		*				soft
4 = extremely hard	*					very soft

GRADE PAPER CHARACTERISTIC

0 = very soft	Produces softly-graded grey-looking prints.
1 = soft	Produces well-graded prints from normal negatives but paper characteristics vary with maker.
2 = normal	Good tonal range from normal contrast negatives, but some grade 2 papers are equal to other grade 3.
3 = hard	Produces contrastier image. More snap to blacks and whites, slight merging of in-between tones.
4 = extremely hard	'Soot and whitewash' from normal negatives. Good blacks and whites, fewer in-between tones. For 'thin' negatives where subject warrants.

Singer Felice Taylor. Nikon F, 105 mm, Tri-X rated at ISO 650 and processed in D-76 full strength for 8 minutes. Available stage light. Printed on a grade 4 paper and burned in around the edges.

and development technique will allow the photographer a great deal of latitude in making acceptable prints. As you will see from the summary chart, some paper manufacturers make grades of paper which, although numerically equal to other makes, actually produce a different result. If you are prepared to experiment with different makes, you will find after a process of elimination which are most suitable for your style of photography and certain specific requirements: for newsprint, magazine or book reproduction.

Before attempting to make a first-time, first-class print from the test negative, here is a short check-list of several points discussed so far:

1 Before mixing any chemical solutions for developing and fixing the print, assess the contrast, sharpness and density of the negative.

2 Use the paper characteristic summary to select a grade of paper on which the negative will give the desired result.

3 Remember: if the negative lacks contrast, choose a harder grade of paper; if the negative appears too contrasty, choose a normal or softer grade of paper.

4 If there is any doubt, use a normal grade of paper and make a test print as already described.

5 Density and contrast are not the same. Over-exposure and normal development, and over-development and normal exposure, can both produce negatives which look dense. The former may be less contrasty than the latter.

6 As a general rule, thin negatives of normal contrast will print well on normal to hard grades of paper. Thin negatives which lack contrast print better on hard or extra-hard grades. Dense negatives of normal contrast print well on softer papers, but dense negatives that lack contrast will print better on normal to hard grades.

7 A negative which is excessively thin or excessively dense may not print acceptably on any grade of paper. Chemical manipulation, using an intensifying or reducing formula, may be necessary before

the negative will produce an adequate print. I make a habit of dumping negatives which fall into either of these two categories. They are invariably the result of sloppy workmanship and attention to detail in exposure and are frankly not worth the effort. Exceptions to that rule, of course, are earth-shattering news events where only one negative exists.

The sub-heading to this section on printing included the word 'method'. Everything that you do in the darkroom must follow clear-cut routines. For example, you will find little mention in this following sequence of print tongs. These instruments are rather like miniaturised old-fashioned laundry tongs that one's grandmother used when she was boiling the clothes in a cauldron. They are useful if:

- you are used to using them;
- you are allergic to the chemical compounds used in photographic solutions;
- you don't like getting your hands wet, but that is hardly a good reason for using them.

My darkroom is arranged so that, during and at the end of each develop, stop and fix sequence, I can reach over and give my hands a thorough swill in fresh running water. Clean dry towels are kept handy at all times and, provided a meticulous and disciplined approach to this part of the operation is applied, prints will not be marked and you will be unlikely to end up with badly stained fingers. The alternative is to wear surgical gloves, but you will still have to rinse your hands in between and after each stage.

BURNING-IN OR HOLDING-BACK

There is one more point to be made before we actually get down to making the print. During the analysis of the test prints, I mentioned that parts of the negative may require more or less exposure than the main part. This is called 'burning-in' or 'holding-back'. There

Simple burning-in techniques involve the use of hands or a piece of black card in which a small oval-shaped hole has been cut. In the first picture, a straight print with no burning or dodging produced a fairly flat result lacking depth. In the second, a hand used to burn-in the large areas of sea and sky has produced a much more acceptable result. Burning and dodging techniques also employ the use of matt acetate sheet, lipstick and chinagraph pencils to achieve the desired effect. Control using hands, fingers and black card cut-outs is very effective for most work and not difficult to master.

are a variety of methods by which this exposure technique is carried out, and these include the use of specially made 'dodging' tools: pieces of black card stuck on the ends of lengths of piano wire or translucent plastic strips, holes cut or torn in squares of black card, shapes which correspond to that part of the negative to be held back during printing, and so on. All of these items you can make yourself from sheets of black paper used to interleave cut film, double-sided black card, empty paper boxes, or just about any waste item that comes to hand which is black or which can be blacked with matt black paint.

Except on very odd occasions, most of my own burning-in and holding-back is done with a square or rectangle of black paper or card, usually an interleaf from a box of cut film; the centre has a hole about 1/4in (6mm) in diameter cut, torn or punched in it. It helps sometimes if the hole is oval in shape with ragged, torn edges.

When I am not using this method, I use my hands and fingers for a little local and often very discreet holding-back, just a few seconds taken out of the main exposure to keep more detail in some shadow areas. This is not an unusual technique and is used by just about every newspaper printer with varying degrees of flair.

Begin by trying just a few fingers. Imagine that you are holding a shallow plate and that you are scooping water out of a garden tub. That is the action you need to practise. Just allow the fingers or whole hand to come into the image area; as it does so, it is scooping away excess light reaching parts of the negative that will obviously be over-exposed. You must keep the hand on the move at all times, but you can count out the number of seconds in units of a thousand as you go. With practice, you will become quite adept at this technique, being able to tell more or less instinctively when the time is up.

Burning-in can also be done with the hands by allowing extra light to pass through a couple of fingers while the rest of the hand blanks off the negative area which has already received enough exposure. Using thumb and forefinger to make a small hole for light to pass through is another method which, when practised efficiently, can help to improve a

In this picture, both burning and dodging techniques were used to even the overall density of the main image while retaining some recognizable detail in the background. The middle and lower right-hand side of the print were shaded during exposure and slightly more exposure than normal was given to the upper left portion to reduce the flare effect.

print very quickly without having to revert to other, more complicated methods.

PRINTING

Well, now that you have established more or less what the main exposure for the first print will be, make a note of the areas to be given more or less exposure. Load the negative back into the enlarger, open the lens diaphragm and switch on, ready to focus. Switch off the closest safelight, or all of them if you feel more comfortable working with the enlarger light source only. Satisfy yourself that the composition on the easel is the most suitable for the subject. If not, readjust enlarger magnification and fine focus.

To establish just how much burning and shading would be required for the final picture, I first made a 'thin' print on Ilfospeed grade 3 (top left). This enabled me to see clearly any detail in shadow areas which might need to be retained in the final print. Next (top right) I made a print with more or less correct highlights. I used the exposure for this as my guide for the final print. Shading and dodging were carried out with fingers and hands in steps, completing one side and then top and bottom of the print (bottom left). Finally, I chose a grade 4 to give better whites against the darker areas and shaded more under the horse and behind the rider's head to bring them out of the picture (bottom right).

If you are using a condenser source enlarger and glassless negative carrier, there is a fairly good chance that, during the course of the time it takes to focus accurately the negative image, the negative will buckle under the heat created in the lamphouse; this will be especially noticeable when no heat shield is used.

If the enlarger is now turned off, the negative will assume its pre-focus shape as soon as the lamphouse begins to cool. This will happen quite rapidly, certainly within the space of time it will take for you to extract a sheet of paper from the box and fit it into the print easel. When you have made the exposure and the print is processed, it will appear to be out of focus.

You can get round this problem to a certain extent by using the built-in enlarger safelight. Simply swing this in place in front of the lens while paper is extracted from the box and placed in the easel. Once ready to expose, turn off the focus switch, slide the safelight away from the light path and begin the exposure. If repeat prints are to be made at any time, simply check the focus before each sheet of paper is exposed. There is more about this in Chapter 9, where techniques in exposing and processing long print-runs are discussed.

To check the focus of any negative accurately a really good-quality grain image magnifier is essential, particularly if you are using medium- or larger-format negatives which are

This fire scene was shot with a 200 mm Nikkor lens on a Tri-X through a medium yellow-orange filter, and developed in dilute D-76. The print was made on a grade 3 paper and required some careful burning in the smoke areas to achieve the right effect. Because of the shape of the subject this was quite easily done using the hand in a scooping and circular manner.

torn out of the centre. Hold this horizontally just below the enlarger lens with the hole in the card to one side of the image axis. Re-start the timer.

You will see the image on the card now. Carefully manoeuvre the hole towards the part to be burned-in. Simultaneously begin to move the card in eccentric circles. Now look for the part of the image being exposed on the paper. Move the card to areas of the negative which still require more exposure, making a mental note, if these areas fall on the edge of the frame, to give those parts a really good dose. It is absolutely essential to keep the card moving all the time the negative is being exposed. Do not worry overmuch at this stage that the print may be over-exposed in these areas now being treated. Complete one full cycle of the re-exposure time (same as the main exposure). Because the card is continuously being moved about, these areas will in fact receive a lot less exposure than the overall exposure.

When you are satisfied that the print has received sufficient overall exposure to give the effect you want, return the exposed paper to a safe box. Switch on the darkroom safelight and check the temperatures of all chemicals and wash water. Developer temperature is not too critical, provided it is kept within a certain range; 20–24°C (68–75°F) is practical. When print developer temperatures are increased above or decreased below this range, the colour tone of the print will be affected. Cold developer works sluggishly, forcing extended development times and risking stains on the print, particularly if the solution has been standing around for any time. Keep the stop bath and the fixing solution within the same working temperature range.

Modern resin-coated papers, such as Ilford's Multigrade, are normally fully developed in about a minute at 20°C (68°F). Other types may require more time, but usually not more than 90 seconds. Try to stick to the manufacturer's recommended times; if you extend them because the print is obviously not developed within that time frame, something is wrong. Remove the exposed paper

medium- or fine-grained. Do not rely on subject detail, although if you are using an adjustable glass carrier the edge of a negative is often a useful guide to sharpness.

Once you are certain that the easel image is sharp, swing the enlarger safelight into place, or switch the timer from focus to time. Now take a sheet of paper and place it in the easel. Set the time ready to start the exposure. Remember that this will form the main exposure for the print, but parts of the image may need to be held back and/or burned-in. Start the clock and simultaneously bring your hand scooping in to the area which needs less exposure. Do not worry about the rest of the image; it will not move while you are manipulating the exposure. Count, not quickly, '1000, 2000, 3000', and so on, until you think that the shaded part has been obscured long enough. Do not jog the enlarger bench or touch the easel once the main exposure has begun. Now take a square of card with a hole rough cut or

The most common cause of vertical distortion, particularly in architectural photography, is the use of fixed-axis lenses. Some correction can be effected using the time-proven method of raising the easel at one end on a pile of books. More control can be obtained from enlargers utilizing a swinging head and negative carrier. Distortion in the accompanying photograph, however, was deliberately employed at the time of exposure.

from the safe box and insert in the developer as already described in the section on making a test print. Swiftly pull it through the developer and turn emulsion-side-up. If you prefer, take the exposed paper by the middle of the longest side, hold one side of the tray an inch off the bench and place the opposite edge of the paper on the raised side of the tray. Lay the paper flat in the developer as the tray is smartly lowered. As soon as it is covered with solution, turn the print over, emulsion-side-down. Now start the timer and begin agitation. Every one has a sort of habitual agitation sequence, but if you are starting from scratch try to adopt the procedure of raising each corner of the tray in alternate rotation.

After 30 seconds have elapsed, turn the print emulsion-side-up, if it is not already. If your exposure was correct, the print image should be clearly visible and developing rapidly in the shadow areas. After one minute, the print may look as if it is going to over-develop. Allow the development time to complete, and then, 10 seconds before time is up, remove the print by a corner, drain and transfer to the stop bath. Give it a fairly rapid and vigorous rinse here for 30 seconds and

then drain again and transfer to the fix. Give more vigorous agitation for the first 15 seconds and then rock the tray gently for a further minute. You will now be able to remove the print to the wash, rinse, drain and inspect it under white light.

Do not be disappointed when you inspect the print under ordinary room lighting if it is not quite right. However, if your original negative selection and subsequent test prints were fairly accurate, the print you are now inspecting should be very acceptable. If the main areas of the print look right, make a close inspection of the areas which you held back and burned-in. This is invariably where further work will have to be done if you are a perfectionist and intend to get the print right. If you are reasonably satisfied that you have made progress, even if another print has to be made, you will have achieved a lot. Prepare to start the same procedure over again making absolutely certain as far as possible that you follow the same sequence as before.

It cannot be over-emphasized that it is essential at this early stage to adopt a disciplined method whereby all future prints will be made using the same technique.

OTHER BLACK-AND-WHITE TECHNIQUES & PRINT MATERIALS

If processing is the most tedious part of photography, then printing must rate as the most exciting occupation next to using the camera. In some cases, no doubt, it takes precedence over even that. The apprenticeship to print making is often long and punctuated with disasters. Most of the latter happen because of lack of knowledge: about materials and their applications; concerning the technicalities of original exposure; concerning the chemical properties of certain materials and how they are likely to react to certain chemicals, to certain lighting techniques; and about many other things. Ultimately, it is only by dint of application of all the knowledge that you gain that producing acceptable work becomes a little easier. So make note of your mistakes, be patient and try to develop as much style in the darkroom as you do out in the field with your camera. It will come together in time.

So far, exposure and contrast have been discussed at length. The more technically minded may advise the photographer that printing papers must be accurately matched to negatives, and in fact I have even been told on more than one occasion that this is the only acceptable way to make a print. My methods make use of a modicum of knowledge regarding contrast and the levels to which print contrast can be manipulated, irrespective of the negative contrast.

The reasoning for this is quite simple: by far the major part of my work is produced exclusively for reproduction around the world in a variety of publications. Publishers use widely different printing techniques, from hot-lead letterpress of appaling quality, lithography and web offset processes, through to fine art gravure, using etched copper plates. All of these reproduction processes take a different approach to the technique of origination, the method by which photographs are processed on to film or metal blocks for eventual transfer to the printing plate. The final reproduction is made with ink which is a very different medium to the one photographers use. In order to get the best possible reproduction using ink from a photograph, a number of other processes are necessary, and all of these have inherent characteristics which, if allowed, will distort the photographer's images. To combat this (not always successfully), certain tolerances must be incorporated into the print at the darkroom stage.

A really good graphic arts technician will no doubt dispute my argument on the grounds that 'what is not in the original cannot be reproduced'. That assumes that, if everything which should be in the photographic print is there, it should be possible to reproduce it on paper using ink. It is possible to make very accurate reproductions of original prints, but only using the finest gravure process. Most ordinary lithographic processes are totally incompatible and are subject to an enormous range of potentially troublesome errors, not least of which is the possibility of, sometimes dramatic, variations in ink levels.

When (rather than if) there is time and I can spend a few uninterrupted hours in the darkroom alone, I find that enormous amounts of energy are expended in getting the print right. How do I know when it is right? When it looks right. This is a totally subjective evaluation loosely tied to knowledge of acceptably printable contrast ranges and so on. The actual process of producing a print, however, is fairly meticulous, with each stage of the operation closely monitored to ensure that unnecessary wastage of paper and chemicals does not occur.

When there is very little time and prints have to be produced rapidly, I adopt a different approach. This is also based on a sound

knowledge of material capability, knowing how far I can push a print exposure and nearly boil the paper in developer to get a rapid print. But it is as much the method by which these various techniques are utilized which helps to keep a degree of control over what is going on. For example, I know that the print developer is way above the normally practicable temperature range. To get rich blacks and fully developed highlights in double-quick time, the paper is given a heavy exposure, dipped in the developer for a few seconds, and then whipped out into a basin full of cold water as soon as the blacks in the image begin to appear. This sudden dive in temperature slows down the development process but allows it to continue in the brighter areas. By the time I have finished swilling the print around, the image is nearly complete. Then, it's back into the.developer for a final few seconds and then stop and fix normally.

If I make a marginal over-exposure and, instead of using an acid stop bath, use plain water, I can process up to a dozen or so 10x8in prints of the same subject simultaneously. Hot and cold water baths can also be used to manipulate the paper image using normal exposures, to help intensify highlight areas and reduce the development action in shadow areas. Keep a basin of each in fairly close proximity to the developer so that, whenever necessary, prints can be fished out of the developer and quickly dipped.

Such methods are frequently frowned upon by more academic technicians, but I can assure you that these practices work when called for. One needs a degree of deftness and a little elementary experience to take full advantage of them, though I do not advocate use of the practice on a continuous basis. Try to make your exposures accurate in the beginning and utilize the time and temperature method to its fullest extent. Enhancement techniques, such as those described, are put into practice when: (a) speed is of the essence; (b) normal processing methods fail to produce the desired result.

There are other methods by which prints may be made. The traditional tray method is convenient if you have a large enough bench space and, despite the claims of the manufacturers of some automatic print processors, large quantities of prints can be tray-processed very rapidly and often more economically.

For a few years now, I have had the pleasure of using a Nova Print Processor. This is a simple plastic tank with integral water-jacket and thermostat to control the temperature of processing solutions. A range of models is available. A unique paper clip allows the operator to agitate each print while avoiding the hands-on technique. The makers claim that it is possible to process up to thirty 10x8s in an hour, though I must admit that I have yet to prove that. Its greatest asset, however, has nothing to do with throughput, but lies in the tiny amount of space it occupies. Provided that print exposures are accurate and you have a tried and tested time and temperature method, the Nova is undoubtedly one of the most convenient print-processing methods available.

In addition, Nova tanks can also be used for colour processing and in fact were primarily designed for that purpose. They are certainly economic in use and make a lot less mess than conventional methods. A print-washer of similar construction can be used in tandem with the processing tank. The whole set-up utilizes about the same amount of space as the area of a single 16x20in tray, so anyone working under the stairs or in a loft/attic conversion where space is at a premium would certainly benefit from the Nova system. One other point in its favour is that mixed solutions tend to keep longer when not in use, provided the water-jacket temperature is maintained. Even a heavily concentrated developer mix left in a tray overnight begins to deteriorate quite rapidly when temperatures fall. With the Nova, I have been able to carry on processing after a gap of several hours without any noticeable deterioration in print quality.

Automatic print processors using the activator-stabilization process in two- or four- bath machines, such as the Ilford Ilforprint Super 24, Kodak Ektamatic and Agfa Rapidoprint, as well as older table-top machines, are still used in many darkrooms. Agfa's Agfaprint BW37

For general press work, standard film/developer combinations which give known results under a variety of exposure and working conditions are the lifeline of busy darkrooms. Here, Tri-X normally rated at 400 was used in this picture shot for the Daily Telegraph. The film was developed in full strength D-76 and printed on grade 3 paper for this reproduction. D-76, ID-11, HC110 are all standard use developers which can be relied upon to turn out a very usable negative in a fairly short time.

negates the advantage of rapid machine processing where usually the only requirement is for a print of reasonable quality that can be used as a proof, placed on a wire transmission machine or handed to a client for more or less immediate reproduction. Once the art of exposure has been mastered, it is possible to make prints of very good quality; some of the illustrations used in this book are examples.

The professional with a large throughput of black-and-white material will do well to consider alternative processors, such as the Ilfospeed 2240 RC or 2000 or the Fujimoto table-top machines (CP-51 & CP-31). There are many other manufacturers of auto print stabilization processors in the United Kingdom, Europe and in the United States, including some small units which are suitable for amateur usage. Both the Ilford bench-top 215ORC and the older Durst RCP 20 and 30 machines are perfectly suitable for use in a small darkroom. The Durst machines can be used for a variety of black-and-white applications as well as for processing colour negative print materials. As bench-top processors have been around now for a few years, there is a good used market for models of all shapes and sizes at very reasonable cost. Make sure that the rollers are in good condition and not worn or chipped. A thick coating of brown stain inside the machine is a certain indication of it having had a hard life.

One of the best of the older machines, but requiring slightly more bench space than the much smaller Durst RCP types, is the METO-FORM 5040 which is made by Meteor-Siegen in Germany. This is an extremely sophisticated machine capable of processing all resin-coated black-and-white papers with a throughput of up to 120 10x8s an hour. In addition, the machine can be used for colour negative and reversal print processing.

and BW66, Ilford's table-top 215ORC and Kodak Royalprint processors can all be utilized to process Ilford's Multigrade III RC Rapid paper. At the cost of some sacrifice in print quality, my miniature Ilfoprint machine cannot be beaten for convenience. I can produce a damp dry print that is fully stabilized, from exposure to white light, in a matter of seconds. Exposure is fairly critical; there is not the latitude one has even when using resin-coated materials in tray processing. The other main disadvantage is that prints are only partially fixed. They do not like exposure to ultraviolet or very strong fluorescent or tungsten light, and if left lying around the workroom for a week or less soon begin to change colour. To maintain proper permanence, stabilization prints should be fixed in the normal manner on exit from the machine, and then washed and dried. To me, that additional process rather

PAPERS

The resurgence of interest in black-and-white photography over the last decade has led to an unprecedented re-introduction and re-structuring of papers that were once considered obsolete by modern photographic standards.

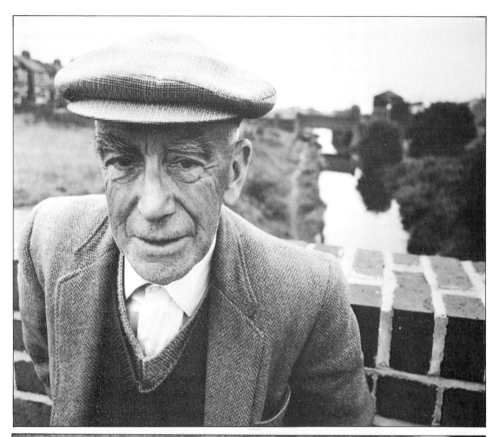

The effect of grain in fairly small reproductions and prints from 35mm negatives is not easily seen by the unaided eye. Used large, grain patterns become more noticeable, but any unpleasant side-effect may be just as easily overlooked by the viewer if the subject matter and compositional presentation is good enough. Different development techniques, particularly the method adopted for agitation, push processing and so on, whether large or small tank, will all have an effect on the resulting print. In this picture Tri-X was exposed on a bleak wintry day at 400 ISO and developed in diluted D-76 to give a fairly thin negative which printed well on grade 3. Grain structure is barely noticeable and quite acceptable in the original 12x10in print. Note enlarged section.

I suppose much of the interest in this medium stems from the fact that, as far as the amateur is concerned, black-and-white affords the user so much more control than colour photography (and is one reason why at least two-thirds of this book is devoted to the former). In my humble opinion, it is the very lack of manipulative control, as well as the materials used to render the image, which makes colour photography so unexciting. It is, of course, perfectly possible to manipulate colour in colour photography, but the result is invariably a lack-lustre effect that is frequently inferior in both quality and depth to the effect which can be achieved with black-and-white. This, of course, is aside from all the other factors which influence taste. But more of that later.

Resin-coated (RC) papers, as we know them, were originally introduced by manufacturers for a variety of reasons, not least of which, one suspects, was the consideration of a bigger profit when all the other factors – handling convenience and speed of processing – were noted. As I am one of those lucky photographers who began a career at a time

This print was made from two-thirds of a 6x6cm negative, shot on HP5 with Bronica EC and Planar standard lens. Developer was HC110. The right-hand picture shows an enlarged section in which it is apparent that grain structure is more fragmented and clumped than in the preceding illustration. This is equivalent to a 12 times enlargement of a 35mm negative and shows that 'apparent' sharpness is not only relative to the ratio of enlargement and format size.

when the general availability of RC papers was not a threat to quality, it must be said that, on the whole, those two factors are about the only things that RC papers have to their advantage. The ability to produce a print of sophisticated tonal quality or even sharpness is not one of their strong points, so if you require exhibition quality do not even think about RC; conventional fibre-based papers are what you need.

Resin-coated paper is made up by using a layer of paper which is coated both sides with a synthetic polymer, usually polyethylene. This forms the base on to which the emulsion is coated. As the base is virtually impervious to water and does not, like fibre-based papers, act like a sponge, development and fixing times are much shorter. Washing and drying times are equally rapid.

In choosing which type of paper might be suitable, several factors need consideration:

 The facilities available for washing and drying prints.

 Fibre-based papers can be air-dried, but are better glazed using a ferrotype, highly polished stainless or chromed steel plate. The quality of a drum-glazed glossy fibre print is far superior to any resin-coated paper. Motorised drum dryers are no longer readily available; one can only hope that they will become so. Flat-bed heated dryers can be used, but accurate thermostatic temperature control should be provided. Cheap models simply bake the print which shrinks the paper and distorts the tonal values of the image.

 Fibre-based papers need large volumes of water for effective washing. This can be reduced, however, when a washing aid (hypo clearing agent) such as that manufactured by Paterson, is used. Single-weight papers need a minimum of 30 minutes and double-weight at least double that time for non-aided washing to remove at least 90 per cent of chemicals retained in the paper base.

 Resin-coated papers can be washed in a few minutes, 'squeegeed' and air-dried or dried rapidly in a hot-air blower type machine (see Chapter 2).

PAPER TONE

CHLORO-BROMIDE

This is a paper type using a mixture of silver salts of bromide and chloride to give an image tone from warm black to reddish brown, depending on length of exposure, type, length and dilution of developer. Fixing is more critical with these papers than with ordinary bromide. Rapid fixers with hardeners can be used, but the clearing time should not exceed that recommended by the maker – usually 5 minutes. If the time is greatly extended, the silver image is attacked and dissolves out of the paper. Exposure latitude is superb and development time can be as long as 10 minutes in some developers. Paper speed is about a quarter to a half that of ordinary bromide.

BROMIDE

This gives a neutral to cold black tone which is only slightly affected by development type and technique. Fibre-based papers are capable of immensely superior quality to that of RC papers. Paper speed varies with the make, as does contrast. An interesting point here, though, is that one or two photographic magazines have made observations regarding different paper makes after conducting so-called 'tests'. In one I noted that two papers of a different but popular alternative label were given different results. On checking my own files I discovered that both papers were manufactured by one of the two packet trade names who told me that the 'other' was the same as their own, but re-packaged.

BLACK-AND-WHITE PRINTING PAPERS AND THEIR CHARACTERISTICS

Here then is a list of some of the best papers currently available. Prices vary and will be different from country to country.

AGFA PE PAPER

This is a water-resistant, resin-coated base for high-speed processing. There are two types: *Brovira-Speed* is a bromide paper which gives

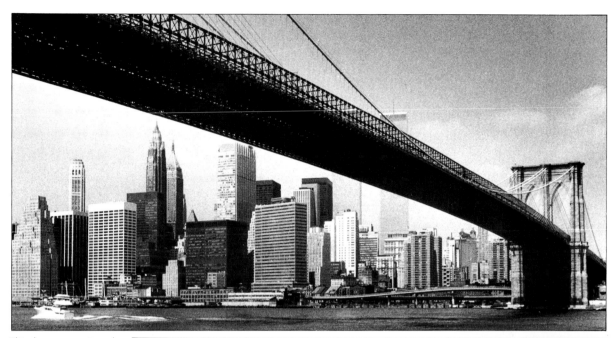

This shows approximately half of a 10x8 print from the full frame of a 35mm Tri-X negative exposed through a 24mm Nikkor lens without filter. The film was processed in a Kreonite auto film processor for a rating of 800. In the enlarged section, grain structure and image disintegration is clearly seen, even though the recorded image remains sharp.

neutral to cold tones and is available in five different grades; *Portriga-Speed* is a chlorobromide paper which gives warmer results (four grades are available in standard sizes).

AGFA-BARYTA PAPER (fibre-based)

This has a baryta coating on a fibre base under the emulsion. It is not resin-coated. Three types are available: *Brovira* and *Portriga* baryta papers exhibit the same characteristics as PE versions; *Record Rapid*, third in the range, is a chloro-bromide paper with variable tonal characterists depending upon the processing method used. It is ideal for exhibition work.

N.B. It is possible that chromogenic film negatives used with chloro-bromide papers may have the effect of reducing contrast due to the inherent brownish colour cast of the film. Light tones on the print may appear darker than when a normal silver image negative is used, thus creating the effect of more visible detail in those areas.

FORTE

This paper is manufactured in Hungary. *Fortespeed* is a resin-coated material with medium black and fairly average overall gradation; three grades are available. *Forte Porturex Speed* is another resin-coated chloro-bromide paper with warmish tones, but fairly slow in use (available in three grades). *Forte Porturex Rapid* is a slow chloro-bromide with a light cream coloured base; it gives rich blacks and good overall tonality (one grade is available).

GUILBROM

This paper is made in Paris by the oldest makers of light-sensitive materials, R. Guillemont Boestflug et Cie who began manufacture in 1858. It has very good tonality with rich blacks and an extremely white base. It is a bit prickly to dry, and available in double-weight in grades 2 and 3. The same company also manufactures *Guilbrom* for Zone VI Studios Inc., of Newfane in Vermont, who market it under the trade name of *Brilliant*. Zone VI claim that 'Brilliant's technical specifications exceed those of any other paper. They make possible the more ethereal qualities that artists demand. Prints on Brilliant create an illusion of depth, substance, clarity and light.' As far as I have been able to establish from the English importers and Silverprint Ltd, who market the paper, *Brilliant* and *Guilbrom* are one and the same paper.

ILFORD

Ilford are noted worldwide for their excellent range of papers. *Ilfospeed* and *Ilfobrom* are two of my favourites for general press work. They are very tolerant of shoddy workmanship, with good exposure latitude and handling qualities. Ilfospeed resin-coated paper is probably about the closest thing to perfection in a plastic-based paper. Proper drying ensures super flat prints with no curl tendency. The emulsion surface is a little soft and scratches quite easily. Both types are available in a variety of grades and surface finishes.

ILFOBROM GALERIE FB This is an exhibition-quality fibre-based paper with neutral tones, rich blacks and brilliant whites. The tonal rendering is not to my liking, but a lot of people like it. This is a double-weight paper with a baryta-coated fibre base, so it accepts retouching materials rather well. The paper has bright white base tint which prevents it from yellowing with excessive washing. It is available in five grades (glossy surface) and four in matt finish.

ILFORD MULTIGRADE IV RC DE LUXE This is the now much loved and much tweaked variable-contrast paper which began its life many decades ago. When using Ilford's Multigrade speed matched filters, the paper can provide 7 different grades of contrast in half-grade steps. It is similar to Kodak's Polymax and Agfa's Multicontrast Premium. It is very good if you do not want the trouble of keeping several different grades in stock. It gives good blacks and the base is a tinted bright white. Pearl, gloss and matt finish are available. It needs time to get used to and to discover how the contrast of different parts of the image can be changed at will. Image colour remains cool to neutral under daylight or fluorescent lighting (see Chapter 9).

ILFORD MULTIGRADE III RC RAPID A variable-contrast, developer incorporated paper with rapid drying properties; this paper can be

dish or machine processed and is available with six full grades of contrast when used with Multigrade filters or with the Ilford Multigrade 500 system. The paper has a bright white base tint and image colour remains neutral (see Chapter 9).

KENTMERE

This English company is noted for its fine range of papers available at slightly lower cost to the giants of the industry. Great improvements have been made in the past few years to its resin-coated stocks, but my favourites have always been Kentmere's Bromide papers. The large majority of prints for this book were made on this stock, some of them more than 25 years ago. None have shown any sign of image degradation or colouring.

KENTMERE BROMIDE This is a good all-round paper with neutral image tone, dense blacks and brilliant whites; but it is one of the papers in which a grade 2 is more contrasty, nearer grade 3, than some other makes. The single-weight dries well with a good glaze. The double-weight requires careful handling. It should not be overheated on flat-bed dryers. Large exhibition-size prints are best dried between sheets of blotting paper or on fibreglass nets. It glazes well on a professional drum. It is available in three grades and glossy, stipple or matt finish.

KENTHENE This was one of the first manufacturers to bring a polyethylene-coated paper on to the market. Today's *Kenthene* has a fairly high-speed emulsion coated on to a medium weight base which provides good 'flat' properties and stability. Normal grade 2 is closer to a 3. It has a nice finish when dried, and a neutral image tone. Available in three finishes; glossy, satin (semi-matt) and stipple.

KENTHENE VC Kentmere's answer to Ilford's Multigrade and Kodak's Polymax; a high-speed variable-contrast paper with neutral image tone. It has good blacks and a clean white base. Suitable for dish or bench-top machine processing. Five contrast grades are covered. Available in three finishes: fine lustre, satin and gloss. The best result for the latter is achieved when using electrical dryers. (see Chapter 9).

KENTONA This is not a coloured paper, but a chloro-bromide with a very pleasing range of tones. It has a good white base and a much slower speed than other Kentmere papers. There are two grades and two surfaces: gloss and stipple. Ideal for sepia toning.

KENTMERE ART COLLECTION Special papers suitable for high-quality exhibition work: *Art Document* (high-speed with rough drawing surface suitable for hand-colouring and re-touching, neutral image tone, graded 2 and 3); *R.C. Art* (resin-coated version of the preceding paper); *Art De Luxe* (same surface as *Art Document* on a heavier 175gsm fibre base, graded 2 & 3); *Art Classic* (same as *Art De Luxe*, but coated with a warm-tone ivory-tinted chloro-bromide emulsion on a substantial fibre base of 240 gsm, grade 2 only available).

KODAK

Kodak's range includes the following: Kodak *Elite Fine-Art* (new Polymax Elite Fine-Art paper was under development at the time of going to press with this new edition of the present book); Kodak *Kodabrome II RC*; Kodak *Ektalure*, Kodak *Panalure Select RC* (for making black-and-white prints from colour negatives); Kodak *Polymax RC* and Kodak *Polyfiber* (see Chapter 9); Kodak *Ektamax RA Professional Paper*. Once you get to know their respective characteristics compared with other makes, the chances are you will not want to change very much. Kodak materials have a consistency in quality and finish that is unrivalled. Their RC paper is fast with plenty of punch, but *Elite* does not quite come up to expectations. Somehow, one always expects more from Kodak. Nevertheless, their papers are difficult to fault. The tone is often described by some as 'neutral', but to my mind there is far more than that. Kodak papers have an intangible tone quality all their own which is possibly why, when using it, one takes a great deal more care over producing the print.

ORIENTAL SEAGULL

As its name implies, this is a product of the Far East – Japan to be exact. It is highly rated in America, where it was imported long before it became available in Europe. It is a fibre-based

Effect of exposure tends to be cumulative. Sensitivity of film emulsion decreases as exposure is increased; simultaneously, contrast is increased until a point is reached when detail in the negative, which would be normally visible in the subject with the unaided eye, becomes blocked by increased contrast and over-exposure of highlight areas. The first picture represents the scene as the human eye would see it, recognizable but lacking detail. 1/8th second at f5.6. The second picture: exposure of 4 seconds at f5.6. In the third picture an exposure of one and a half minutes at the same f stop has effectively blocked out all detail. HP5, ISO 400, developed in HC110 for 6.5 minutes.

paper with neutral tones and brilliant whites. It is suitable for exhibition-quality printing and is available in four grades in double weight gloss or stipple finish. The designation code is RP-F. RP-R stands for 'resin-coated'.

PAL

Pal Print and *Pal Brom* are both fibre-based papers, the former with a maximum black, and slightly warm compared with some other makes. *Pal Brom* has a warmish base, too, and is much faster than the *Print* version. *Brom* is available in four grades and Print in three, single- and double-weight. *Brom* is available in gloss finish only and *Print* in gloss, matt, crystal and silk.

PAPER DEVELOPERS AND OTHER CHEMICALS

Some of today's developers are now based on modern technology and matched to manufacturers' papers in order to obtain the best results. However, there is still a wide variety of older formulae readily available off-the-shelf in liquid and powder form. Until you have had a chance to try out some of the other types, it will be best to stick with those recommended by paper manufacturers. This will permit the standardizing of print tones and development times necessary to establish a particular effect. Most universal paper developers can be used with virtually any make of resin-coated and normal fibre-based bromide papers to give acceptable results. If you require longer development times for more control, it is best to experiment with other types of developer; some powder-based types and some photo-mechanical (used in graphic arts processing) solutions can be used to boost contrast or give a softer, warmer tone. If you are making prints for reproduction in magazines and newspapers, general-purpose print developers that allow plenty of manipulation and which are noted for their longevity and aggressive action are probably best. The quality of reproduction in the vast majority of newspapers and magazines, and in many books, is often poor; in order for your prints to stand any chance of reasonable reproduction a fully toned, medium-to-high contrast print

is desirable. Many working photographers complain of atrocious reproductions of their work, often without realizing that the fault is often not with the publisher's printer, but with their own random approach to print making.

ACUGRADE FX-31

This developer exploits all the attributes of modern variable-contrast resin-coated papers; it has the reputation of being able to separate shadow detail at virtually any grade of contrast than many other developers; it leaves clearly defined middle tones and brilliant whites; development should be complete in 60 seconds with RC papers, twice as long with fibre-based products.

ACUPRINT FX-17

This is a general purpose print developer designed for use with fibre and resin-coated papers; it produces good blacks, highlights and shadow detail.

AGFA BLACK-AND-WHITE PAPER DEVELOPERS

These have an excellent shelf life and are suitable for use with other paper makes; the range includes *Adapanetin*. (Other makes of developer, however, do not appear to bring out the best of Agfa's paper qualities.) In particular, *Neutol* and *Record Rapid* paper work well together; in the case of other regular PQ type developers, the paper lost a lot of its snap and blacks were warmed.

DEKTOL

This is a cold-tone developer with excellent working properties and is particularly suitable for producing images of exhibition quality; it is available in liquid form. Kodak's D-163 is a powder-based general-purpose print developer which must be properly dissolved in the correct order to make a liquid stock solution which is then diluted; it gives a neutral-warm image tone with Kodak and other-make bromide papers; it is based on an old formula, but is still a favourite of many black-and-white print-makers. Kodak's range of chemicals is huge and their professional handbook is a valuable asset for any enthusiastic photographer.

The advantages of chromogenic film in low-light level photography are its excellent speed, grain relationship, enormous exposure latitude, fine grain and superb definition. This picture was taken as part of a series on the famous 'Field Gun' event held in London. For the black-and-white I used Agfa's Vario XI rated at 1600 and an f/2.8 180mm Zuiko lens.

EMBASPEED DEVELOPER

This is a PQ type rapid print developer from May and Baker; it has a rapid image appearance of around 6 seconds at dilution rate of 1+9; its dish life is around 24 hours, depending on throughput and circumstance; it is available in 1 and 5 litre concentrate; *Suprol* is available in 250ml, 1, 5 and 25 litre liquid concentrate. Five litres of concentrate is said to develop more than 2,800 prints of 18x24cm in size; it has a fast image time with a long working life; it produces an image tone inherent in paper which I found a little soft with normal grades of Kentmere and Ilford resin-coated papers; it is ideal if you have huge quantities of prints to process. Suprol can also be used as a film developer, producing fine grain and high acutance at high levels of dilution. The makers also market *Suprol A* which is thermally stabilized for use in tropical climates. *Embrol* is specially formulated for variable-contrast printing papers such as *Multigrade* and *Polymax*.

NORMANTON ST18 DEVELOPER

This is a black-and-white print developer

from Ornano of Milan; it is a neutral-tone, high-capacity dish developer for fibre or RC papers; dilution 1+9; it has a good working dish life; development time: 2 minutes at 20°C (68°F); shorter times and higher temperatures can be used with RC papers; dilution between 1+5 and 1+14 gives contrast control without change in image colour.

POLYMAX LIQUID DEVELOPER (see Chapter 9)

UNIVERSAL FX-26

This developer dilutes 1:7 for prints and 1:19 for film; it is recommended as a beginner's developer, but do not expect exhibition quality results, especially from film with high ISO ratings processed in this brew; to make a rapid acting press-type print developer, it can be diluted 1:4.

FIX

Virtually any type of modern fixer solution is suitable for black-and-white papers. Prolonged

fixing of prints (and/or negatives) in fixers containing ammonium thiosulphate to which a hardener has been added will cause 'pin-holing' and eventual bleaching away of the image. Resin-coated papers are usually temporarily fixed in most rapid fix solutions in about 30 seconds; a minute and a half will fix them permanently, while 5 minutes is enough to fix fibre-based prints for archive permanence. Typical fixer trade names are *Hypam* (llford) and *Acufix* (Paterson). When using these concentrated solutions, it is not wise to exceed the recommended times. If space is available, the two-bath method of fixing is desirable. This extends the life of fixing solutions which would normally become rapidly exhausted when a single bath is used. Even the use of a stop bath does not prevent large quantities of alkali being carried over from the developer. The simplest way to test for exhaustion, apart from using chemical test strips, is to keep all the cut-off leaders from miniature film. Drop one into a tray of well-used fix from time to time and note how long it takes to clear. When the duration exceeds one minute before the first noticeable signs of clearing, the solution will already be well on the way to exhaustion. Using a replenisher system is more economic when large quantities of film and print materials are being processed.

Ordinary hypo can be made by dissolving 500g of anhydrous sodium thiosulphate in approximately 5 litres of cold water, to which is added 125g of sodium metabisulphite. The salts are normally readily available from a pharmacist. Add the anhydrous salts slowly to the water, stirring all the time, until complete dissolution takes place. If the powder is added too quickly it will form a large lump that is difficult to break up. This formula makes a non-hardening acid fixing bath which is ideal for most amateur use. Most modern film and paper emulsions are now hardened considerably in manufacture; so there is no real need to use a hardener, which in any case slows down the actual clearing process. The above quantity is sufficient to fix 25 10x8in prints or 10 135mm/120 format films.

Plain hypo exhausts quite rapidly and can be tested without resort to chemicals using the method described above. Give approximately double the clearing time for complete fixation, though this may never be enough in a solution which is nearly exhausted. Another way to test the strength is to one part of a 4 per cent solution of potassium iodide to 10 parts of used fix solution. If a yellow precipitate forms that cannot be dissolved on shaking, the fix solution will be overloaded with silver, preventing any further efficient clearing action. Fixing times for paper, using hypo, are between 5 and 10 minutes at temperatures of between 15 and 24°C (59–75°F). Temperatures of fixing solutions which are higher than the latter figure are best avoided, as considerable swelling of emulsion will take place with the consequent risk of mechanical damage to the film or paper. Temperatures lower than 15°C (24°F) will slow the clearing time significantly. For best results, hypo concentrate should be about 35–40 per cent of the mixture. Higher concentrations will only increase the rapidity of the clearing time by fairly insignificant amounts.

WASHING

Fibre-based papers, popular for their superior image quality and longevity, have one big disadvantage. Paper retains processing chemicals, requiring up to 30 minutes for single-weight papers and double that for double-weight to ensure the removal of 90 per cent of the chemicals. Paterson introduced a washing (hypo clearing) aid which reduces recommended washing times and improves image permanence. Similar products are available from most regular photographic materials producers, but times may differ from one product to another. After fixing, prints are rinsed in water for 30 seconds and then aid-treated for 1 minute. Films are then washed for 5 minutes and prints of either weight for 20 minutes.

Although hypo clearing agents do generally make for a shorter wash time, fibre-based papers should be washed after HCA treatment for at least double the recommended time (see Chapter 9 for 'Fixing for Archival Permanence').

BLACK-AND-WHITE VARIABLE CONTRAST PRINTING

Variable-contrast printing papers have been with us on and off for a very long time. In 1940, the Ilford Company of Great Britain introduced the first variable-contrast paper called Multigrade. It was generally available in the post-war years until the early nineteen-sixties when, for what appear to have been purely economic reasons, it was discontinued. But much research had been carried out, and when the same company took advantage of what were then relatively new polyethylene-coated papers in colour photography and introduced the Ilfospeed system in 1974, the reintroduction of a much improved variable-contrast paper four years later was just the next logical step towards improving the lot of those who still had a need for black-and-white pictures.

In its own way, Ilford has probably done more than any other company to maintain as well as create the 'new' interest in black-and-white photography, partly by offering products which have a 'convenience' handling factor as well as very high quality, and partly through their annual competitions for best photographer and best printer. Such is the esteem which these awards carried that, when Kodak re-introduced its range of black-and-white papers, the event was heralded by the simultaneous announcement of a competition with even bigger prizes. The advent of digital-imaging technology and the widespread use of press colour photography forced both companies to drop the awards; the legacy, however, was the recognition gained for the skills of the black-and-white printer.

The Multigrade IV (Ilford) and Kodak's Polymax range of printing papers have become the mainstay of many professional photographers and small jobbing print houses who cannot or do not wish to carry large stocks of individually contrast-graded papers. They have found favour with many amateur photographers for the same reasons and, in view of that, it will be worthwhile to discuss them further in this chapter.

In a nutshell, variable-contrast (VC) paper is just what the name implies; its contrast is variable by the introduction of filters of varying strength at the exposure stage. In practice, this means that paper from one box can be exposed and processed at any grade in the equivalent conventional range from -1 through 0 to 7 in whole- and half-step grades. The range available to the student will vary depending on the marque of paper used. Some VC papers have a reduced range (see Chapter 8). It also means that any one sheet of paper can have separate areas exposed by varying the amounts of exposure through individual filters or a combination to produce differing grades of contrast in those separate areas.

For example, suppose you had a negative in which the foreground was thin and the background or skyline a little too dense. Printing on a normal grade of paper would produce a print with blocked-up shadow detail in the foreground and some acceptable tonal values in the sky areas.

Landscapes, seascapes and other photographs where large areas of light and shade predominate are often the ones which require some manipulation in the printing, either by dodging or by burning-in. Using VC paper, the same techniques can be used but to a lesser extent; much more local control is afforded the printer to vary contrast of the paper in the areas which require it. So, you might print the forepart of the picture through a filter to produce a relatively hard (higher) contrast and the sky through another filter to produce a softer (lower) contrast which will bring out the highlight detail.

ILFORD'S MULTIGRADE SYSTEM

As the second edition of this book goes to press, Ilford are in the process of launching a new Multigrade paper system, and Multigrade IV is expected to have advantages over other makes. The current Multigrade 500 filter head and exposure control system are compatible with the new paper, but existing visual filters will require changing. Multigrade III RC De Luxe is part of Ilford's range of variable-contrast papers, which includes Multigrade RC Express, Multigrade FB and Multigrade III RC Rapid. Seven full grades of contrast are now available in conjunction with the twelve Multigrade filters, numbered from 00 – 5 in half-steps. These filters are gelatin-coated on a polyester base measuring 3.5x3.5in (8.9x8.9cm) or 6x6in (15.2x15.2cm). Larger filters of 12x12in (30x30cm) and 16x20in (40x50cm) are available to special order; all

may be cut to fit the filter drawers of older enlargers. In addition, a special filter kit is available to fit below the enlarger lens and includes a safelight filter.

In this chapter you will find contrast grade equivalent tables as well as conversions for the dial-in colour heads of some enlargers. Ilford's Multigrade 500 enlarging heads and exposure control system fits many brands and models of professional enlarger, including those made by Beseler, De Vere, Durst, Leitz and Omega. This special head is capable of producing a whole range of contrasts at the touch of a dial. Owners of enlargers with dial-in-filter systems used for colour printing have also found that it is a very simple matter to convert Ilford's (and Kodak's) specified filter values to correspond with variable values of the magenta, cyan and yellow. Not all enlarger filter heads can cover the entire Multigrade IV contrast range, particularly at the extremes of high and low contrast. To obtain the very best from this paper you will need to purchase a complete set of the Ilford Multigrade IV filters. Use of these filters requires no change in exposure times when moving from one grade to another. The student using an enlarger with a built-in colour head will need to recalculate exposure times when moving up or down the contrast scale. Filter transmission values are based on the use of tungsten or halogen light sources. Cold cathode sources may be used, but exposure times and filtration will need to be adjusted.

Using older types of enlarger (those without integral filter heads) in conjunction with the Multigrade Filter set can produce minor problems. Depending on the enlarger, light source and lens in use, denser filters at the higher end of the contrast range can make it difficult to focus the image when negatives of near-normal contrast are being printed. To avoid disappointment, focus the image on the baseboard without a filter and then insert the correct grade as soon as you are ready to print.

Multigrade IV filters and paper have been specially designed to match the contrast range of conventional photographic papers; each whole filter number corresponds to the full grades of Ilfobrom Galerie FB. The half

TABLE 6:
ENLARGER FILTER EQUIVALENTS FOR MULTIGRADE IV RC PAPER

Find your enlarger type in the left-hand column and read off the corresponding filtration system in column 2.

AGFA	AGFA
BESELER	KODAK
CHROMEGA	KODAK
DE VERE	KODAK
DUNCO	DURST 1
DURST (with max 170 Magenta)	DURST 1
DURST (with max 130 Magenta)	DURST 2
IFF	KODAK
JOBO	KODAK
KAISER	DURST 1
KIENZLE	DURST 1
KROKUS	AGFA
LPL	KODAK
LEITZ	DURST 1
LUPO	DURST 1
MEOPTA	MEOPTA
OMEGA	KODAK
PATERSON	KODAK
SIMMARD	KODAK
VIVITAR	KODAK

grades will give contrasts mid-way between each whole grade of paper. The Multigrade I series required a set of tedious exposure factors to be applied whenever a change of grade was made because the effective speed of the paper changed, but Multigrade IV does not inherit that problem. Photographers with dichroic colour heads will find the dial-in-filter facility extremely useful in making minute adjustments to print contrast. Ilford recommend using the filter values shown in Table 8 which correspond to the listed Kodak grades.

N.B. With the introduction of Multigrade IV paper, these factors may well have changed by the time this edition of the book is in print. As stocks of the new paper become available, they should be packed with conversion factors for the visual filter packs. When these are not available, tests should be made using Kodak recommended filtration to establish exact contrast grades.

The advantage of using this system, as opposed to a system which combines yellow and magenta to maintain a fixed paper speed, is that the printing light is effectively brighter, necessitating lower exposure values, but paper speeds are changed as if you were using a regular Multigrade filter kit. In this case, paper speed from grades 0 – 3.5 remains the same, but the speed is halved using grades 4 – 7. Practical tests will almost certainly be required to establish correct contrast levels for individual colour heads as the filter characteristics frequently differ. Table 8 is based on Kodak Colour Compensating Filter values.

Ilford's own filter heads can be adapted to fit a variety of different enlargers, including some Durst models, Beseler, Omega, Leitz and De Vere. Once the head is set up and calibrated, electronics are used to determine accurate exposure, irrespective of grade or magnification changes. Using manual Multigrade filters and Table 9, tests will have to be made to establish the exact parameters of the material. As a rough guide, exposure increases are approximately 10 per cent per grade increase towards 7 from 2. The reduction in exposure for lower-contrast grades is insignificant.

TABLE 7: ILFORD MULTIGRADE IV RC FILTRATION VALUES

Use the information gained from Table 6 to convert your enlarger type filter head values to the correct Ilford values with the figures given in the filter type columns below.

| VALUES | AGFA | MULTIGRADE FILTER SYSTEM | | | |
		DURST 1	DURST 2	KODAK	MEOPTA
-00	150Y	120Y	199Y	150Y	
0	120Y	90Y	70Y	90Y	90Y
0.5	70Y	50Y	70Y	70Y	
1	30Y	55Y	40Y	50Y	55Y
1.5	30Y	25Y	30Y	30Y	
2	20M	-	-	-	-
2.5	20M	10M	5M	20M	
3	110M	45M	30M	25M	40M
3.5	65M	50M	50M	65M	
4	290M	100M	75M	80M	85M
4.5	140M	120M	140M	200M	
5	420M	170M	130M	199M	-

TABLE 8: FILTRATION EQUIVALENT VALUES FOR AGFA MULTICONTRAST CLASSIC

Contrast Control Filters	0	1	2	3	4	5
Filtration with KODAK CP – or CC filters	80Y	30Y	10M	50M	110M	200M
Filtration with DURST colour filter head	60Y	25Y	10M	30M	60M	130M
Agfa Printing Filters*	120Y	30Y	20M	110M	290M	420M

N.B. As with Ilford Multigrade IV RC, the filtration systems on a variety of enlarger makes differ. Some experimentation may be required to find the right values to match all Agfa Multicontrast Premium and Classic contrast grades. Exposure factors will also need to be applied when changing up or down the contrast range.
** Agfa printing filters are no longer manufactured but may be found on older equipment.*

OTHER VARIABLE-CONTRAST PAPERS

The discerning photographer/printer will be aware that, while Ilford's Multigrade IV can be relied upon to meet most demands of general-purpose printing, there will often be a need for a variable-contrast paper which closely approximates to the qualities of conventional fibre-based products. Kodak's range of VC papers offer a wide choice of finishes and paper type from polyethylene-

coated to a heavy double-weight variable-contrast fibre paper. The papers and their characteristics are listed below.

POLYMAX RC PAPER

This is available in three finishes, glossy and semi-matt and fine-grain lustre. The paper is a medium-weight 'selective contrast' resin-coated with writable reverse side type for dish or machine roller-transport processing, and is available in sheets and rolls. The paper is designed for exposure using normal tungsten enlarger or low-voltage halogen light sources filtered to control contrast. Other light sources may also be used, but sources such as cold cathode may need additional filtration to

provide the full range of paper contrasts. Light source correction filters are needed in addition to the appropriate Polymax filters and are as follows for the light sources indicated:

- fluorescent lamps, cool white (4,500K), use CC or CP 40Y;
- fluorescent lamps, white (6,500K), use CC or CP 70Y;
- mercury vapour lamps, use Wratten gelatin filter No.6 + CC or CP 40Y.

There are 12 filters in the Polymax range giving 12 different levels of contrast, from grade -1 (very soft) to grade 5+ (very hard, or high contrast). Polymax filters -1 and 5+ can

be used to upgrade the older Polycontrast III filter sets. No exposure adjustment is necessary at the optimum paper speed point for filters between grades -1 to 3.5. An extra stop in exposure is required for grades above 3.5. The filters are available in two sizes; 90x 90mm and 150x150mm.

The paper has a bright white base and gives a warm-black image tone. It cannot be processed in activator/stabilizer machines and is only suitable for dish or machines using conventional chemicals. Polymax paper is ideally matched to Kodak's range of T-Max films, since it was specially formulated for their extended tonal range. Table 10 gives details of development times, latitude and capacity, using Kodak's Polymax Developer. Use a Kodak OC safelight filter (light amber).

KODABROME II RC PAPER

This is a *fast*, medium-weight, resin-coated, developer-incorporated paper, designed especially for activator/stabilization processing and machine printing. It can also be easily dish developed. It is available in a gloss, semi-matt and fine lustre finish and graded in the contrast range 1-4m. The same details regarding enlarger light sources as for Polymax paper are applicable.

POLYFIBER PAPER

This is a heavy, double-weight, selective-contrast paper, available in a gloss and semi-matt finish. The former may be glazed in the traditional way, using a drum glazing machine or ferrotype or chromed plates on a flat-bed dryer. When naturally air-dried on muslin stretchers or fibreglass netting, both surfaces yield a high-quality finish suitable for exhibition and display purposes. Polyfiber has an incorporated optical brightener and dries with a neutral black image tone. Contrast range is varied from a single stock, using the Polymax filtration system described above. The paper is designed mainly for dish processing and has a very wide processing latitude. Kodak recommend toning the paper for extended image life. Table 10 gives recommended dilutions and times in minutes for the above papers using Polymax liquid developer.

Kodak variable/selective-contrast papers rely on the use of acetate or gelatin filters fitted below the enlarger lens or between the lens and light source. Filtration as given in the

Final print quality depends on several factors, the prime one of which is an understanding of what a first-class print should look like. If you are wallowing in the mire of turgid greys, a visit to a black-and-white print exhibition will open your eyes to what is possible. Adopting a faultless negative exposure/development combination is the first step. Next comes a thorough understanding of paper characteristics and how to make the perfect test strip using a methodical approach to exposure and development. Once these skills are acquired, and they are not difficult, high-quality prints are relatively easy to make.

In reproduction, this picture loses much of the original quality of print, which measured 15x12in. The print is from virtually the whole of a 35mm negative taken on a 28mm lens using Tri-X developed in D-76 diluted 1:1. The original print was made on a Kentmere double-weight grade 3 bromide over fifteen years ago and, like many others contained in my picture library, has lost nothing in the ageing. Mechanical photo reproduction using normal lithographic and web-offset techniques cannot retain the quality of a really good original. For that quality to be retained in print, a gravure process using etched copper plates is the only suitable one.

tables above using earlier yellow/magenta types can be utilized for Kodak VC materials. The Kodak Polycontrast III and Polymax filter sets for use between the lens and light source is available in two sizes (see above). Ilford's Multigrade 500 enlarger head is also suitable for use with these Kodak materials.

Larger sheets of acetate filter material in grades 1, 1.5, 2, 2.5, 3, 3.5 and 4 are available from Eastman Kodak in Rochester, New York, in sizes from 10x8in up to 12x48in as well as in 1x100ft rolls. Kodak introduced these alternatives because of the growing demand from photographers to contact-print larger format negatives.

Other brands of high quality variable-contrast papers include:

AGFA MULTICONTRAST PREMIUM

This has a full contrast range from 0–5. Paper base is slightly off-white. This is one of the slower speed papers, with a longer development curve. Fully developed prints exhibit brilliant whites and deep blacks. Ideally, full development is achieved at between 90 and 120 seconds. Available in gloss and semi-matt finish. It is ideally developed in Agfa's Multicontrast developer (50-90 seconds), or Neutol Liquid (60 -100 seconds). A 2 per cent Acetic acid stop bath is recommended before fixing.

AGFA MULTICONTRAST CLASSIC

A variable-contrast paper on traditional fibre base; the fully developed paper exhibits a full range of 6 grades and 5 half-grades, with excellent tonal range and depth. Whites tend to be warm with rich, deep blacks. The image tone can be controlled by the choice of developer. Using Agfa's own paper developers, the following tones are possible:

DEVELOPER	TONE
Adaptol	Maximum Warm
Neutol Liquid	
Neutol WA	Warm
Multicontrast	Neutral/Warm
Neutol NE	Neutral
Neutol BL	Neutral/Cold

STERLING PRO RC VC

A fairly high-speed paper manufactured in India with a contrast range similar to that of Agfa's Multicontrast Premium. Gives a warm tone image in about 60 seconds. This paper needs careful drying as it has a tendency to curl. Paper base is slightly ivory tinted and surface gloss is not as high as some other papers.

TETENAL TT VARIO ULTRA

Excellent, very white base. Very high gloss finish with a neutral to cold image tone. Typically, full development time is between 90 and 120 seconds. Dries well with no tendency to curl. This paper is available in gloss and semi-matt finish.

Success in using variable contrast papers, as with all other conventionally graded types, lies in the key areas of method of application and in the disciplined control of those applications. It has already been noted in the previous chapter that excessive heat, for example, used to dry resin-coated papers, creates a tendency for the paper to curl. Kodak advise that air temperatures should not exceed 88°C (190°F) for variable-contrast RC papers and that normal room temperatures should be used for the drying of Polyfiber papers ('low drying temperature gives best dimensional stability and least curl'). It is interesting to note Kodak's concern with long-term conservation of print materials. At the end of each technical data sheet a recommendation is made to tone prints which are liable to be displayed or which may be subject to adverse storage conditions which may induce rapid oxidation of the silver image.

Of great importance to the print connoisseur is the stability of image tone. In modern polyethylene-coated papers a degree of instability is inherent in the product. When RC prints are exposed to light for any length of time, the layer beneath the emulsion containing a white pigment of titanium dioxide releases an oxidant which encourages the fading of the silver image and which will ultimately cause a breakdown of the polymer base layer. Some

manufacturers now add anti-oxidants, but the long-term effect is uncertain, and for that reason perhaps any prints which are required to be kept for long periods should be made on fibre/baryta base papers and stored in metal filing cabinets in polyvinyl free, pure polythene print sleeves.

The practical advantage of using RC paper is its rapid processing characteristics. If storage of RC prints is essential for long-term re-use, as in photo-library applications, control of relative humidity between 30 and 40 per cent and the avoidance of extreme fluctuations in storage temperatures should be avoided. I have noticed a significant physical change in RC material printed and processed more than a decade ago, which has been stored unstamped and uncaptioned in cardboard light-tight boxes, compared with conventional fibre-based prints stored in the same way in the same place. Prints made on quality RC materials by well-known manufacturers have certainly fared better over long periods than those made on paper which is noticeably inferior in quality.

Most toning processes will prolong the life of a photograph; this is the reason why many photographs from the past have survived so well. Many of the prints produced by French photographer Eugène Atget, during his thirty years spent as a pioneering photojournalist documenting the growing pains of Paris from the turn of this century, were toned as a matter of course. Perhaps he knew, even though he never received the recognition he justly deserved for his work during his lifetime, that his prints would become valuable historical artifacts. With today's toning concentrates readily available in liquid form, the practice is much simplified.

All toners tend to change the actual black and white tonal range, as well as changing the overall colour of the print. Kodak's Selenium toner diluted l:20 (20 parts of water) produces no significant tonal change in the print and is possibly the best answer for those looking to add a degree of protection against constant mishandling and fluctuations in atmospheric conditions. Some chemical substances used in toning need very careful handling. One of these is thiourea (CH4-N2s), an ingredient of thiocarbamide. The substance is toxic when inhaled or absorbed through the skin and contains carcinogenic properties. The manufacturer's instructions for the use of toning kits should be followed to the letter. If you make up your own solutions from raw chemicals purchased through a pharmacist, ensure that you always mix and use the solutions in a well-ventilated space and wear the correct protective clothing.

VARIABLES IN ENLARGING USING VARIABLE-CONTRAST MATERIALS

It is possible that, in some circumstances, contrast changes may occur in enlargement from small to large print sizes especially when condenser-only enlargers are employed.

With Multigrade IV paper, speed remains the same throughout the soft to normal contrast range using exposures of between 1 and 70 seconds. Thereafter, paper speed decreases while contrast is increased. Disregard the halving of paper speed (doubling of exposure) of grades 4-7. In practice this means that the same grade selected for say a 5x7in print will be the same for a bigger enlargement up to say 12x10in, provided the exposure time does not exceed the maximum figure stated, i.e. 70 seconds. If the exposure time is exceeded it may be necessary to make a test strip using different filters to assess the new grade and exposure required.

As exposure is cumulative, any burning-in should be taken into consideration when making the print. Excessive burning will have the effect of lowering contrast in the areas worked on; therefore, if the cumulative exposure exceeds the maximum amount it may be prudent to select a higher (harder) filter grade to compensate before burning in.

RECIPROCITY FAILURE

Other causes of low contrast, or a shift in contrast from high to low in enlargement

Compare the picture on p.122 with these two prints made in a rush for newspaper reproduction. These are straight prints from the negatives with no dodging and no time for test strips. The negatives were made with an 80-200 mm Nikkor zoom lens on HP5 and processed in ID-11. Sharpness of the subject in the top picture is accurate, but not very flattering to Mrs Thatcher. In the other print slight pre-focus of the lens has resolved the main problem and in newsprint reproduction the softer image would be more flattering. However, both prints are of relatively soft gradation even though they are of the same grade as the picture on p.122. There are no really deep blacks and the whites are muddy, caused mainly by slight over-exposure of the print and 'pulling' from the developer before full development had taken place. This technique can often work well for the purpose stipulated above, provided the main subject image is fairly large and the negative contains a reasonable range of tones. It obviates the need for shading and burning when time is short.

when magnification is increased, can be due to reciprocity failure and localized fogging. The latter is often the cause of darker patches or streaks evident on the paper after processing, and is the result of flare from the immediate enlarger surroundings as well as the possibility of safelight fog. Walls and benches close to the enlarger should be painted a dark colour, preferably with a matt finish which helps to absorb any reflected light. The area immediately behind the enlarger column should be painted matt black to a height of at least 18in (45cm) above the top of the column.

Other obvious sources of flare are the enlarger baseboard, and even the masking easel, the white base of which will reflect some light back through RC and single-weight fibre papers, resulting in some loss of base brilliance. The enlarger itself can often cause problems. Chromed columns, shining safelight stalks, dirty rear lens elements and dirty condenser surfaces all contribute to lowering of the print quality.

Another frequent but often misunderstood source of irritation, which I have found more noticeable with some variable-contrast RC materials, is the ease with which slight accidental staining can occur during processing. Because these papers have rapid induction times, irregular development can take place during dish processing if correct agitation procedures are ignored.

Processing several sheets at a time can also cause problems; the nature of the material makes it difficult to interleave more than ten sheets easily in less than a 2-litre volume of working solution (10x8s in a 12x10in dish), although Kodak's Polymax and Kodabrome II RC are treated with a special back-coating to facilitate multiple dish processing. When transferring to other solutions however, staining may occur if several sheets are transferred together. For best results, begin draining sheets singly when the development time taken from the time of the first sheet immersion is complete. This should be no more than 10 seconds per print. When water is used instead of an acetic acid stop bath, continuous agitation of the print is necessary to remove residual developer before draining again and subsequent immersion in the fix. Here, best results are achieved when the print is given vigorous and constant agitation for the first 15 seconds. Thereafter, the paper may be allowed to settle while each consecutive print is given the same treatment.

INTERLEAVING AND MULTIPLE SHEET DEVELOPMENT IN DISHES

The following notes apply to dish processing techniques where a high throughput of paper is demanded in one session.

Where large quantities of prints are required from a single negative, processing discipline must be strictly observed, if quality is to be maintained with the minimum wastage. For professionals and semi-professionals, who may only have occasional demand for large print quantities, dish processing is actually more economic as well as faster than a bench-top processing machine. Only a roll-head paper projection processor has the capacity to make life more agreeable, but such machines are a luxury in the small darkroom, where print quantities are frequently less than 1000 a month.

1 Before paper exposure begins, make up large quantities of developer, stop bath and fixer solutions, preferably using a two-bath fixing system. If 10x8in prints are required, use dishes capable of processing 12x10in prints and make up a minimum of 2-3 litres of each solution. For example, using Kodak's Polymax developer or Ilford PQ Universal print liquid developers, dilute 200cc of concentrate with 1800cc of water to make 2 litres of working solution. This is a 1:9 working strength. At 20°C (68°F) this will be enough to process up to sixty 10x8in prints before signs of exhaustion become apparent. Use a larger volume of stop bath or water. Use a larger volume of fixer, up to 4 litres if the tray capacity will allow. The wash tank should be filled with fresh, filtered running water. Bring all solutions to the correct working temperatures

Red windows, Paris. OM1, 180 mm wide open on Fujichrome 50 ISO. The camera was tripod-mounted for an exposure of 1 second. Slight reciprocity failure made the reds in the window artificially bright. This effect might have been lost using higher ISO film or by push processing.

and have a basin of cold water handy, separate from the wash water.

2 When making exposures, allow for an increase in image density which may occur when several sheets of paper are stored for any length of time before processing. Density is also increased slightly during development when more than one sheet of paper is processed.

3 Expose each sheet of paper, using the shortest possible but convenient time, then store in a light-tight box or paper safe, which should be sited out of the direct path of both enlarger and safelight beams. Unexposed paper is best stored ready for use in a heavy-weight, oversized black polythene bag so that the open end is long enough to flop over the paper when exposures are being made. I normally count out the number of sheets required for each negative and place them in a separate box or bag, where they will be conveniently situated for my free hand to keep up a rapid transfer to the enlarger without risk of fogging.

4 Once exposures are complete, and as soon as possible afterward, take up to ten sheets of exposed paper. Hold in the left hand (vice-versa if you are left-handed) and fan out like a hand of cards, emulsion-side facing upward. Begin immersion in the developer by taking the bottom sheet of the fan and placing it face down in the tray, making sure that you push down on the centre of the paper. This action releases trapped air bubbles.

A timer should be started as soon as the first sheet enters the developer; this is difficult if you already have your hands full. If there is no wall-clock already running, use your watch to keep an eye on time. It is essential that you work to a time and temperature principle if you have already made a test print in this way.

Continue immersing all the sheets in rapid succession. As soon as the last is under the developer, bring the bottom one to the top of the pile so that it lies emulsion-side-uppermost. Do this by lightly pulling on the edge of

A sheet of 10x8in paper cut diagonally in half and exposed in strips using a piece of black card. Start on the left with one half of the paper, then on the right with the lower half. Joined together, the two strips give an accurate assessment of the correct exposure for many areas of the print.

the paper with a fingertip until you catch the sheet with thumb and forefinger; flick the paper over in one easy movement so that it is face-up. Simultaneously, with the left hand on the bottom left corner of the tray, begin a gentle rocking motion.

Follow this procedure with each sheet of paper until the last is at the top of the pile. Now, once more take the bottom one – which was the first sheet immersed – and flick it to the top of the pile. Inspect the print visually for image density. Full development should be practically complete by the time this stage has been reached. I normally make my visual inspection while actually draining the print for transfer to the stop bath, which is invariably of water.

Using the left hand, while draining the first print with the right, begin removing the remaining prints one by one from the bottom of the pile; drain and transfer to the stop bath where the right hand will take over agitation. It is imperative that you adopt the habit of keeping the right hand (or left) out of the developer from now on, until fixation of all prints is complete.

If you have never used this procedure before, you may find it slightly confusing to deal with a large number of prints which all appear to be rushing towards over-development very quickly. Try to work methodically from the outset; keep watching the clock, prepare to begin draining the first print immersed almost as soon as you have reached the end of the first interleaving cycle. From then on, work as fast as experience will permit and don't worry about your prints being over-developed. The whole key to success in this procedure lies in the operator's ability to concentrate on the various manoeuvres required to move the prints from one tray to another with the least amount of fuss and bother.

When all prints are transferred to the stop bath, begin the same procedure to transfer to the fix. It will help if you keep the right (or left) hand hovering over the fixing bath continuously during the transfer operation, thus avoiding the risk of chemical contamination with other solutions. As soon as transfer to the fix is complete, begin interleaving the prints for not less than 30 seconds until each print has been successfully agitated for a minimum of 15 seconds. Resin-coated papers will be fixed ready to transfer to the wash in one minute.

For greater permanence, use a 5-minute, double-bath fix sequence, half the total time in each bath. Wash RC papers in running water for 5-10 minutes, if no hypo clearing agent is used, then 'squeegee' and air-dry at temperatures up to 88°C (190°F).

Recommended wash times for RC papers vary with each manufacturer. The absolute minimum wash period should be one minute. However, it is highly likely that residual hypo and silver salts will remain in the print when such short times are used. These chemicals will combine to form yellow-brown silver sulphide, causing the print to fade and adopt

TABLE 9: SAFELIGHT MINIMUMS

Most variable contrast papers are sensitive to blue and green light. Correct levels of safelighting are essential. The following types, wattage and distances are recommended.

TYPE	MAX WATTS	MIN DISTANCE	MAX EXPOSURE TIME
KODAK OC	15	1.0. METRE	4 MINUTES
ILFORD 902	15	1.2 METRE	2 MINUTES
METEOR G7	15	1.0 METRE	2 MINUTES
ILFORD SL1	N/A	1.2 METRE	2 MINUTES
AGFA A10ND4	N/A	1.2 METRE	2 MINUTES

Other types of safelight, including DIY types may be used, but testing to establish minimum times and distances as described in the text is essential.

TABLE 10: RECOMMENDED DILUTIONS/TIME FOR KODAK POLYMAX PAPER DEVELOPER

DISH PROCESSING POLYMAX TO MAKE 5 LITRES

	DILUTION	CAPACITY	TEMP	TIME
ALL POLYMAX PAPERS	1 + 9	8 sq M	20C	3/4 – 3

N.B. Dilution may be varied and times adjusted to suit personal preference. 5 Litres of stock concentrate is enough to process the equivalent of 155x10x8in prints at 20°C. Use Polymax Stop Bath and Polymax Fixer for the best results when using Kodak Polymax paper materials.

that colour. Wash times for RC prints can be as long as 10 minutes in water of a temperature range of 13-18°C (55-68°F). Longer immersion may cause serious delamination of the paper base as well as a dulling of the synthetic gloss finish with consequent loss of image brightness, due to the washing out action of optical brighteners used in most of these papers.

Excessive washing of RC papers, especially in unfiltered water, can result in dried prints having a layer of scum on the gloss surface. This can sometimes be removed by using genuine turpentine applied to the print with a wad of soft cotton wool. Use a circular motion to clean the print; this may require several passes to remove all traces of the scum. Polish the gloss surface, using a well-washed, but clean cotton handkerchief or lint-free cloth.

Strict control is necessary in both the fix and wash procedures of RC papers if longevity is desired. Very few prints made hastily because of the rapid handling characteristics of RC paper have outlived the usefulness of most of my bromide collection, some of which were made more than 25 years ago.

Fibre-based papers need more time in the fix, up to 10 minutes if the chemicals are relatively fresh, followed by 45-60 minutes in the wash.

Constant interleaving is essential in all solutions to achieve even development, proper fixation and washing. Times for double fixation are given in the following section.

FIXING FOR ARCHIVAL PERMANENCE

There are still many RC based papers on the market which do not contain stabilizers. Fixers with strong acid hardeners added can damage RC type prints very quickly, leaving pin holes in the metallic silver surface. Fibre-base prints can benefit from the use of a hardener so long as the acidic pH range does not exceed 6.5; between pH 5.5 and 6.5 is ideal. For RC prints, the limit is pH 5.0 so, in most cases, a non-acid hardener added fixer is ideal, used at the manufacturer's recommended times.

Resin-coated prints are normally fully fixed in 20 seconds at temperatures above 20°C (68°F). Such papers processed in a stabilization type machine may benefit from extended fixation times – up to 60 seconds – using a two-bath system, giving each print half the total time in each bath. Prolonged washing of more than the recommended time is not advisable for reasons already stated.

Fibre-based prints, such as those made on Agfa Record Rapid, Ilford Ilfobrom Galerie FB and Kodak Polyfiber FB, have relatively short clearing times, from between 30 seconds to 45 seconds. However, full fixation takes up to 3 minutes (for Kodak Polyfiber FB), the others slightly less. Using a double fixing bath, these times can be extended slightly. After one minute has elapsed in the first bath with more or less constant agitation, transfer to the second bath for the total recommended fixing time. In the case of Kodak Polyfiber FB, this would be 60 seconds + 180 seconds.

Wash fibre-based prints initially for at least five minutes in running water or the equivalent of several changes. Next, treat with Hypo Clearing Agent (HCA) and then continue to wash for a further 40 minutes in running water or several changes of water. Prints should be toned where necessary directly after HCA treatment.

HANDLING PROCEDURES

All photographic chemicals in powder and liquid form must be handled with extreme care. Some people are not as sensitive as others to some chemicals, but some may show signs of allergy or dermatitis very soon after contact. In handling chemicals, whether powder or liquid, it is advisable to wear household rubber or surgical gloves if you are in any doubt as to the sensitivity of your skin. Some form of protective clothing should be worn by darkroom operators at all times. Information regarding product contents and precautions to be taken are normally available from the manufacturer.

FUNDAMENTALS OF COLOUR PHOTOGRAPHY

There are two distinct areas of colour in photography. These are amateur colour and professional colour. In the professional field of editorial and advertising colour photography, approximately 75 per cent of all work produced uses reversal (transparency) material as the base from which all other work is derived. In the field of general practitioning (i.e. portrait, wedding, industrial and commercial) the bulk of finished production is derived from the colour negative process; in the amateur field, prints from negatives are the main area of interest.

COLOUR PRINTS

There are obvious reasons for the preference for negatives in the amateur area, the most important of which have to do with presentation. It is far easier for the average home processor to pass around a few prints for viewing under whatever available lighting exists, than it is to gather people in one place to watch a screened presentation of colour slides. As soon as the colour print is dry it can be easily viewed and analysed. To view a colour slide properly, a light-box and magnifying glass at the very least are needed, but as this viewing method is often totally impractical for more than one or two persons, a small screen and projector is the usual one adopted. Setting up the equipment takes a little time and frequently requires household furniture to be re-arranged. Once the room lights are extinguished, the viewer is virtually compelled to watch whatever is being shown for as long a period as the projectionist – usually the photographer – insists on. In this respect, photographers are often their own worst enemies when it comes to selecting material for others to view, a fact which is frequently more apparent in the process of slide editing

than in selecting negatives worth printing. Visually, however, the average colour print, whether home-produced or machine-made by professionals, invariably lacks the quality of tone, colour saturation and overall effect of an averagely well-exposed colour slide of comparable subject-matter. Professional slide presentations, even those which utilize duplicates, leave no doubt in the mind of audiences as to the brilliance and saturation of colour which can be obtained, using reversal materials. The reason for this is fairly easy to understand.

The colour print relies on a certain quality of reflected light to achieve the desired impact on the viewer. Viewed under the wrong light, colours effectively change value, just as a black-and-white print appears to change tone and image density when it is viewed under various different light sources. Properly exposed and processed reversal material is inherently more brilliant and apparently more highly saturated with pure colour, even when the transmission light source is of low wattage, or of the wrong colour (of white light), or both. A good colour print will look positively dull beside an equivalent colour transparency projected to the same image size as the print, using a normally powered projector. But, by the same token, hand-made prints using artificially brightened paper can look positively stunning. Numerous professional photographers engaged solely in exhibition work have proved beyond any reasonable doubt that colour negative, properly handled, can yield the kind of superior quality one expects from large-format reversal products.

REVERSAL MATERIALS

Until fairly recently, professional photographers who reproduce their colour work in

published form, such as calendars, postcards, books, brochures, leaflets and so on, have been obliged to use reversal materials. Reproductions from prints lacked definition as well as colour saturation; this was partly due to the quality of original film material available and partly due to the capability of the instruments used for scanning and separating colours in the photo-mechanical process.

With the introduction of high quality 'T grain' and high resolution (HR) negative materials, combined with the widespread use of digital-imaging hardware, acceptable quality reproduction using colour prints or original colour negatives is now possible. Colour negative materials have become the new standard in newspaper publishing, for instance. Equipped with desktop computers, high resolution image scanners, modems and sophisticated software, newspapers no longer have any need for the traditional 'wet' darkroom; in many press photographic departments the days of the print have been long gone. If one is needed for comparative purposes it can be easily produced directly out of the computer and through a near-photographic-quality digital printer. In other areas of publishing, especially in the magazine industry, there are slow but noticeable moves toward adopting the same computerized process; there seems little doubt that, within a few years, colour negative material will be widely used in many areas of publishing.

Many years ago I was involved in some pioneering efforts by a worldwide picture agency which had at that time decided to set up a colour department to offer the more interesting of the world's news events as a regular weekly service to newspapers; a spin-off would be the production of 35mm news 'stills' for television back-projection behind the newscaster's head, a technique which is very sophisticated, but of which very few people are now not aware.

Several problems had to be overcome. It was commonly known that, in the duplication of original reversal material, much in the way of colour saturation and sharpness was lost, making the duplicate almost totally unsuitable for reproduction, particularly newsprint reproduction, where the emphasis would be on

colour, and fairly poor-quality colour at that. Another problem was that, historically, many of the staff photographers of this agency had spent virtually the whole of their working lives with black-and-white materials, a medium which, compared to colour reversal material of the time, had enormous exposure latitude. Any competent darkroom printer could get a print, a 'smudge', from a virtually transparent piece of film. The same kind of latitude was not possible with reversal materials; nor could the agency expect overnight miracles to be performed by its own photographers or the many stringers it used constantly throughout the world to produce usable colour slides. Other factors against the use of reversal materials included the agency's requirement to be able to produce black-and-white prints quickly from colour originals for telegraphic transmission. Using transparencies would have meant making an intermediate negative and, since processing the medium was already a long process, there was therefore little reason for its use.

Instead, the agency colour editor came up with a fairly novel idea. If colour negative

A test strip easel, like this one from Paterson Products Ltd, is a useful gadget to have around the darkroom if you need to make larger test prints showing the whole of the negative area. Further stripping can be carried out within each hinged frame space to increase the variety of exposure.

emulsion was used, several bridges could be crossed simultaneously. The material has a wide exposure latitude, so if a photographer working under combat conditions accidentally exposed film one or two stops over or, even worse, under, the results could be salvaged at the darkroom stage. Use of colour negative would permit simultaneous production of high-quality black-and-white prints without the need for an internegative.

The production of 10x8in colour prints also gave the editor the idea of making up a weekly story-board comprising the best colour stories from around the world. Each print was numbered and contact-mounted on to a large sheet of black card. A few hours before the despatch deadline, the whole board was taken to a local studio to be re-photographed on to a 10x8in sheet of artificial light type Ekta-chrome. The results were stunning and ideally suited to newspaper and news magazine reproduction. Using this technique, contrast was lifted marginally, but colour saturation got a real boost and, finally, picture editors received a dozen or so large-format transparencies instead of barely recognizable 35mm duplicates. Another spin-off from this system was that any number of 35mm transparencies could be made from 'B' type reversal film by photographing individual pictures from the weekly 'World in Colour' series.

Some years later, when reversal colour printing became more popular with the introduction of the Cibachrome process, the agency reverted to reversal materials and a bench-top duplicator for much of its television stills work. But even that was a fairly short-lived affair; when Kodak and Fuji began introducing improved colour negative emulsions it was perhaps only natural that the agency should revert to using it on an almost exclusive basis. Today, it is probably fair to say that Associated Press is the world's foremost news-media user of colour negative emulsions; daily colour transmissions to their bureaux and customers around the world have been a key part of their operation for some years.

Since the first edition of this book was published in 1987, considerable advances have also been made with colour reversal materials,

notably with E-6 type emulsions which can be user or laboratory processed with relative ease. Serious students of photography will be well aware of the constant efforts by the major film manufacturers to produce the highest possible quality from emulsions of this type. The quality of E-6 type reversal films in virtually every speed range is far superior to its counterpart of only a decade ago; sharpness, grain size, colour saturation and differentiation have all seen dramatic improvements.

The goal to which virtually all film makers of E-6 type materials aspire is that of Koda-chrome. In particular, Kodachrome 25, a Kodak film which requires specialized processing, as the colour is introduced in the form of dyes during development. It cannot be user-processed. In this respect, all Kodachrome emulsions (there are three speeds, 24, 64 and 200 ISO in the 35mm format; the 64ISO Kodachrome in 120 size was recently discontinued) are at a disadvantage to E-6 which can be processed in an hour or so if needed. Kodachrome's other qualities, notably very fine grain, brilliant colour saturation and superb sharpness, often outweigh all other considerations where high-quality reproduction is the principle requirement.

CHOICE OF MEDIUM

Each medium has a specific use, produces or can be manipulated to produce a specific effect and should be matched by the photographer to subject and purpose; 'purpose' is a key word and should be given careful consideration in the application of the medium. For example, there is very little point in turning up at a wedding with your camera loaded with reversal material when it is known that the client's primary interest is in colour prints. It is perfectly possible to make prints from slides, using one of two techniques, but neither will yield a product under average processing conditions which is in any way comparable to the subtlety of colour or contrast range of a print made directly from an original colour negative. For the amateur user, the professional general photographer, and in

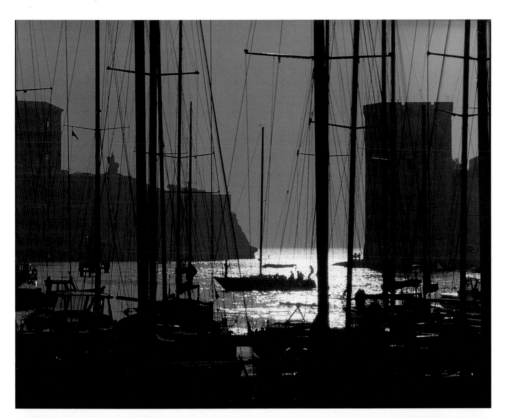

The top reproduction is from a colour print made from a 5x4 internegative of the original Kodachrome 25 transparency, and the bottom one is from a Cibachrome Print made by the reversal print process direct from the transparency. The latter is more contrasty and loses all of the shadow detail available in the original. The top print is softer and more accurate in terms of colour rendition of the original, but less evocative because of the lower contrast inherent in colour negative materials.

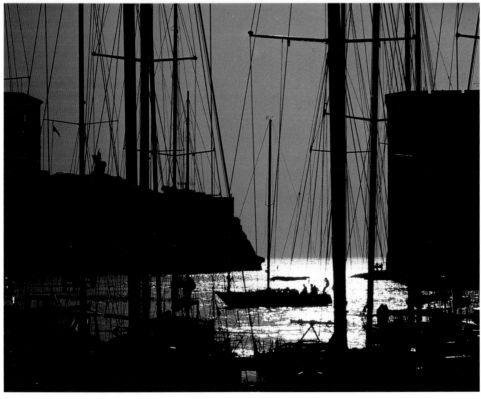

Key West. Kodachrome 25, Nikon F, 200mm Nikkor. If you want to retain the brilliance of real colours, use fine-grained emulsions known for good rendition and richness.

exactly right, colour-negative material is preferred; it has far greater exposure latitude and even badly under-or over-exposed negatives can be salvaged to produce very acceptable digitized images using the correct software. Once corrected, the image can then be transferred to a PC disk or to CD-ROM for archival preservation. When film of this is required, it can be produced to any format using a computer-linked film recorder or a digital print can be made.

The question may now be asked, 'Why should I consider using reversal materials?' The answer is that, while computer hardware and software have reached a highly sophisticated state in the space of very few years, what they can produce is still nowhere near what can be obtained from a good original transparency in terms of quality. It has taken electronic-chip producers the best part of a decade to reach the present stage of development: an image quality equivalent to 1.5 million pixels (the tiny dots or squares which make up the picture after the original image is scanned).

In photographic terms, it will be of interest to the student to know that the equivalent number of pixels of a 35mm original high-quality Kodachrome transparency is in the order of 18 million. The larger the format, the greater the quality. The advanced student will know just how good a large-size print obtained from even mediocre colour negative or reversal materials can be. A digitized image, which is subsequently reprinted after being copied to film, begins to break up once the print size exceeds 11x9in. The chip used for scanning purposes still needs to be dramatically improved, although no doubt this will happen in due course.

As colour reproduction from negative materials becomes more and more acceptable, the popularity of reversal materials may decline, except in highly specialized photographic fields such as science and medicine, and in fine-art book and calendar publication. One hopes that, by then, colour-negative emulsions will have been improved yet again so that they may be more widely acceptable to the printing and publishing industry.

some areas of professional editorial freelancing the colour negative process has definite advantages. These are mainly in the printing and processing stages which in my opinion, allow greater freedom in the manipulation of the medium with a single developer and bleach/fix process, which can also be used to process chromogenic materials.

Computerized digital transmission of photographs has revolutionized news and sports photography. Processed reversal film or colour negative materials can be ready for use as soon as they are dry. Because colour reversal materials need more careful attention to exposure to obtain a transparency which is

To sum up, the photographer should decide at an early stage what the main requirement from the medium is likely to be.

COLOUR NEGATIVE EMULSIONS

Photographers who use reversal materials tend to concentrate on one or two makes and types of film for the bulk of their work, in the same way that they rely on one make and type of black-and-white emulsion. Experience, traditional values and, to a large extent, market demands, especially with reversal films, largely dictate what will be used on a regular basis. Modern colour negative emulsions come into a different category, however, and over the past few years I have had the opportunity to use and review a wide variety of different C-41 processed brands. Very few of these have the kind of colour quality I normally like for the bulk of my work, but there are one or two which are outstanding and which can be relied upon to produce excellent print quality under a variety of light conditions. These are Kodacolor Gold 100, Kodak Ektapress Gold II, Fuji Super G100 and 400, Konica Super XG100 and particularly Konica Impresa 50; these are all films which I use regularly.

Both of these reproductions are made from prints which originated on Fujicolour negative film. The reproduction on the left was obtained by scanning a black-and-white print made from the original negative on to Panalure paper. The reproduction above was made by scanning a colour print made from the original negative.

The choice of material available off-the-shelf is very wide; for the benefit of those still undecided or those who wish to know at a glance what is available, a general list is given in Table 11. The student should know that, in their endeavours to outshine each other, film manufacturers are constantly engaged in a kind of ratings war. Many new emulsions have been introduced in the last few years and there is no sign of their rate of appearance slowing down.

The observant reader will notice that I have not included the huge range of 'own brand' materials which are sold over-the-counter and by direct-mail. In fact, most of these brands are manufactured by some of the better-known regular film producers or by independent factories. Some of the latter claim to market high-resolution colour negative materials based on the new film grain technology. Considering the results obtained from some of these emulsions, it is more likely that some manufacturers are using out-dated formulae discarded by regular producers. The films may be attractively packaged and accompanied by exaggerated claims concerning sharpness, colour saturation and so on. But if you want consistently good results, use tried and tested materials that have the guarantee backings of well-known producers.

The ISO ratings listed are those given by the respective manufacturers and, as far as I can establish, are reasonably accurate when allowances are made for accurate hand-held or in-camera meter readings. Some older high-speed emulsions were notable for their bleached highlights and black shadows, but there have been improvements, though some only marginal, in this area. Use the higher speed ratings for over-cast conditions and indoor available light for better results. The 200 ISO emulsions in larger than disc format are mainly the result of the technology gained when that small format developed. The difference between emulsions and 200 is barely perceptible in machine-processed and printed results, particularly on satin or lustre finishes. The 200 ISO emulsions do have less exposure latitude, however; they tend to react in much the same way as reversal materials, giving negatives that are either exact or under-exposed. I frequently over-expose colour negative emulsions by about half to one full stop depending on the subject and subject contrast range, and some photographers I know who use this material often set their camera ISO indexer to 150 or even 100. Over-exposure does not seem to affect the results dramatically and, if anything, slightly improves contrast and colour balance between the highlights and shadows in some high-contrast subjects.

In processing, colour negative emulsions react in a similar way to black-and-white emulsions. They can, with care, be 'push-processed' to give an effective increase in film speed, but at the risk of dramatically increased contrast. Cutting development reduces contrast, as well as colour saturation, but as there are no alternative contrast grades of paper available for such techniques, the practice seems a trifle irrelevant; better to use the correct film speed for the task and make sure your meter is functioning properly.

TABLE 11: COLOUR NEGATIVE EMULSIONS

BRAND	FORMAT	SPEED	TYPE
Agfa Ultra 50	35mm/120	50	Pro/Am
Agfa HDC	35mm	100/200/400	Amateur
Agfa Optima	35mm/120	125/200/400	Pro/Am
Agfa Portrait 160	35mm/120	160	Pro
Agfa XRS	35mm/120	400/1000	Pro/Am
Fujicolor Super G	35mm/120/220	100/200/400800/1600	Pro/Am
Fujicolor Reala	35mm/120/220	100	Pro
Fujicolor NPS	35mm/120/220	400	Pro
Fuji NLP160	120/sheet	160	Tungsten
Kodak Vericolor III	35mm/120/220	160	Pro
Kodak Ektacolor Gold			
GPF 160	35mm	160/400	Pro
Kodak Ektapress Gold	35mm	100/400/1600	Pro
Kodak Ektar	35mm	25/100/1000	Am
Kodak Gold	35mm	100/200/400	Am
Kodak VPL	120/sheet	100	Tungsten
Kodak 5072	35mm/35mm bulk	1.5 – 6	Duplicating
Konica Impresa	35mm/120	50	Pro
Konica SRG160	35mm/120/220	160	Pro
Konica SRG3200	35mm/120	3200	Pro
Konica Super XG	35mm	100/200/400	Am
Orwocolor QRS	35mm	100	Am
Scotch EXL	35mm	100/200/400	Am

COLOUR NEGATIVE PROCESSING AND PRINT MAKING

With the advent of new emulsion technology, colour processing has been modified to the extent that it is now no more complicated than the techniques required for black-and-white work. A wide range of liquid chemistry is readily available off-the-shelf, in kits, or in larger quantities from most photographic retailers. No messy powder mixing is involved; just add water at the correct temperature, load the film into a tank, start the clock and begin processing. In many ways, colour negative processing is actually easier than black-and-white; the reasons for this are partly psychological and involve the exposure and contrast latitude of the emulsion materials available.

Whereas one tends to be more manipulative with black-and-white because of its enormous exposure and development latitude linked to the printing stage by differently graded papers, making a range of different results possible, colour materials are often regarded from a different standpoint. In broad terms, there is not the great latitude of exposure available which can be easily controlled in processing, and contrast-graded paper is neither available nor necessary in dealing with the problems of the colour print.

Because it is the overall effect of colour rather than graded mono-tones which is of primary importance, the photographer is reliant to a large extent on the manufactured properties of colour emulsions and how they will best interpret the colours of each subject photographed. To change colour, to change subtle hues, to place emphasis on a colour known to be inherent in one film type, the photographer relies on a knowledge of the range of colour differences between standard emulsions. Any further manipulation away from the norm can only be achieved by complex development procedures and mechanical manipulations in print processing, such as Posterisation, Sabattier effect, mechanical toning, silk-screen printing and so on.

Understanding colour theories is one thing. Understanding and being able to use the various mechanical and chemical processes to achieve an effect which no longer relies on the inherent properties of standard colour negative (or reversal) emulsions, is another. It is not the purpose of this book to elaborate or experiment with these effects and if that is the aim of the photographer I would refer the reader to a superb book on the subject: *Creative Darkroom Techniques*, 3rd Edition revised, published by the Consumer/ Professional & Finishing Markets division of the Eastman Kodak Company, Rochester, New York.

This section of this book is intended primarily to give instruction in the basic processes necessary to get one started on the road to understanding modern colour processing techniques; and to show how it is possible for the student to achieve very professional results using the simplest of equipment. If you do not already possess a developing tank or automated machinery, refer to Chapter 2. To develop colour negative film (and E-6 reversal types) and prints, a film-processing tank of the larger size in stainless steel or black plastic is the only requirement. Both Paterson and Durst make a range of tanks ideally suited to the task. For my own colour processing I use the same stainless steel tanks and spirals as for black-and-white work. Two large polythene measuring jugs capable of holding at least I litre each are necessary, together with two large plastic buckets of 5-1itre capacity. A thermometer and timer are the only other equipment requirements for the film processing stage. A small immersion type water-heater fitted on a wandering lead, such as the Heater-Stat manufactured by Nova Darkroom Equipment in the United Kingdom may also be found useful.

Granularity in colour
varies immensely. For
35mm work, superb
detail can be obtained
with Kodachrome 25.
Virtually grain-free prints
can be obtained from
this material using the
Cibachrome print
process.

PROCESSING CHEMISTRY

A wide range of chemicals in the form of kits or in concentrated liquid form for higher throughput of film and paper is available off-the-shelf from most photo shops. The customer-service departments of most manufacturers will usually furnish technical specification data in sheet or booklet form when asked to do so. As nearly all of these chemicals are manufactured to similar formulae, they nearly all produce the same kind of results, though one or two give slightly improved colour saturation. Which is best is largely a matter of personal choice, but the student should be aware that many of these products are often modified or updated to match new film emulsion technology at frequent intervals. Brand names of particular chemicals mentioned in the following text have been found to be consistent over a number of years and, at the time of writing, no new colour film process has been scheduled for introduction by any of the big manufacturers in the foreseeable future.

The following guide to selection may be helpful. And after initial experimentation, try to stick to one brand of chemistry. The user should make this choice based on the following criteria:

 Ease of preparation and use.
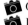 May be used for both film and print processing.
Gives the best acceptable result.
Is reasonably economic in use.

Apart from illustrations reproduced in this volume which were supplied by manufacturers and those made for me by commercial laboratories, a number of the balance were made using Photocolor II chemistry (for C-41 film and prints), Photocolor RT (for colour print making), Photocolor Chrome Six (for E-6 compatible materials), Photocolor Chrome-R (prints from slides), and Photocolor FP (used for processing Kodak Vericolor type film). RA4 chemistry is essentially similar to the more conventional C-41 process and is used for the development of colour paper, using silver chloride. In this process the bleach and the fixer are combined into a 'blix' solution which eliminates the need for separate bleaching, the first wash cycle and separate fix process. Use of a super stabilizer also negates the second wash cycle. Thus the total time for processing is dramatically reduced.

Some professional experts in the field of colour processing have suggested that elimination of the separate wash cycle between the bleach and fixer normally used in C-41, and the final wash, could be detrimental to the archival properties of negatives and prints. Using RA-4, colour development of the image takes place in the same way as in C-41. The latent image is first reduced to a black and white metallic silver image. The oxidized developing agent reacts with colour couplers incorporated in the emulsion layers creating the cyan, magenta and yellow in the separate layers. During the 'blix' cycle, metallic silver is converted to a soluble silver salt, which is immediately removed from the emulsion by the thiosulphate fixing agent. The wash cycle in the conventional process simply prevents bleaching agents being carried over to the fix, thus enabling this solution to be easily desilvered.

PROCESSING METHOD

Although the number of steps required to develop a colour negative film have been dramatically reduced, it is worth noting here that accurate temperature controls of chemistry are important if consistent results are to be obtained. Processing temperatures are high (38°C, 100°F). Unless a thermostatically controlled water bath is available, the operator must revert to more basic means. Use one of the 5-litre plastic buckets, or a basin, to contain mixed chemicals. The water-jacket temperature should be kept at approximately 1°C (1.8°F) above the working temperature. If you have access to mixer taps on the kitchen sink or in a bathroom, use rubber hose to run a constant supply of water at the right temperature through the water bath.

Contamination of chemicals must be controlled to avoid film staining. An easy way

to mark measuring vessels or separate containers, if you use them, is with a red felt-tip marker. The ink will wipe off when lighter fuel is applied with a cotton wad. Alternatively, you could use large self-adhesive labels which are marked and stuck on each container before the latter are filled. I prefer this method as the lettering is more obvious, especially after time and constant washing-out has taken its toll.

Photocolor II chemistry is suitable for all C-41 emulsions producing negatives with rich colour saturation, bright whites, rich browns and blacks. It may also be used for the development of colour prints. Photocolor II uses a print additive concentrate with the developer which seems in practice to produce more saturated print colours. Its main advantage, however, is that it is equally suitable for a wide range of applications from dish and hand to rotary-machine processing and is available in replenisher format. This is very useful if one has a high throughput.

1 Load the film to be processed into the tank in total darkness. Make sure that all darkroom equipment lights, such as tiny light-emitting diodes on some timers, are either extinguished or obscured from the loading path; otherwise you may just end up with a fogging veil over parts of the film. Follow the same instructions for spiral/spool loading as in Chapter 5. Close the tank and switch on the main lights.

2 Adjust the temperature of the chemistry water-jacket to 1°C (1.8°F) above that required in the manufacturer's processing instructions. Mix sufficient quantities of the developer and bleach-fix as directed in the instruction leaflet. Place the chemistry containers in the water-jacket and check their temperatures frequently. To avoid any possible risk of contamination, two graded thermometers should be used, one for each solution. I always use a pre-wet bath before development commences, so into the water-jacket also will go a container of filtered water. You may decide not to employ the water rinse between the developer and bleach-fix

(blix) stage, in which case adequate supplies of conventional stop bath as used in black-and-white work may be used. Fill a container with the right quantity and place this too in the water-jacket. When using the higher temperature of 38°C, a relatively short development time of 3 minutes is all that is required, and when such short times are used consistent agitation is important.

3 As soon as the chemistry has reached the correct working temperature, begin processing. Carefully pour in the pre-wet bath and invert the tank slowly, then turn it back to a standing position. Give the tank a gentle tap on the bench to remove any air bubbles and allow it to stand for 15 seconds. Now pour this away. Do not worry about the slight discoloration of the water; this is due to dyes used in the film make-up and will not affect development.

4 Immediately pour in the developer. Start the clock running simultaneously and watch agitation times carefully. Bang the tank on the bench-top (or sink) to remove air bubbles and agitate fairly vigorously for the first 15 seconds. Invert the tank twice at every 15 second period following this throughout the duration of the development time. Approximately 10 seconds before time is up, begin to pour the chemicals back into their container. Do not worry too much if you exceed the stated development time by a few seconds. If the film was exposed at the manufacturer's recommended ISO speed, there is a good chance that some darker shadow areas will be a trifle under-exposed. A little extra development will do no harm. When processing colour negative emulsions, I tend to follow the same kind of procedures that I use with all of my black-and-white development techniques, including the omission of the last agitation stage, in the belief that edge acutance is slightly enhanced by allowing the film to stand in perfectly still developer for a while. If I omit beginning the change-over 10 seconds before the end, this more than makes up for the loss of agitation.

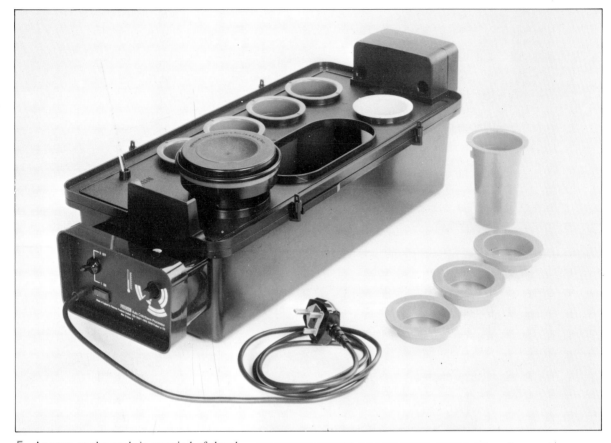

Paterson Auto Colortherm processor rigged for colour negative/reversal film processing.

Nova Darkroom tanks are ideally suited to making colour prints. Large numbers of prints may be processed quite rapidly once you have sorted out the exposure and filtration required. Leave at least 1 minute between each print before development commences.

5 As soon as the tank is emptied of developer, pour in the water rinse or stop bath and agitate for a further half-minute. Discard a water rinse. The stop bath can be returned to its container for further use.

6 Now pour in the bleach fix (blix). Agitate for the first half-minute and then, if you wish, allow the tank to stand. Agitation is not so critical at this stage, although it is good practice to invert the tank every minute or so. When time is up, pour the blix back into its container. You may now remove the tank to facilitate washing of the film. For best results, use filtered water of between 32 and 38°C (90–100°F). At least two changes of water are required every minute for four minutes.

7 When the wash cycle is complete, refill a measuring jug with a litre of water to which is added a few drops of wetting agent. Paterson Anti-Static, Kodak Photo-Flo or a drop of domestic washing-up liquid will make the water more miscible with the film emulsion, allowing it to drain evenly and rapidly without risk of drying marks. The processed film will have a

slightly milky appearance which gradually disappears as drying takes place. If you use a drying cabinet, hang the film with a weighted clip and allow all surplus water to drain off before turning on the heat. Two or three minutes is normally sufficient. **Do not** overheat in drying; a constant supply of warmish air is all that is required. If you are drying the film on a line in an open space, try to prevent the main access door to the room being constantly opened and shut. This simply stirs up the atmosphere and deposits all kinds of nasty foreign-matter on to the emulsion as it dries. To speed up the drying process, allow the film to drain for at least five minutes, and then begin applying heat with a hair-dryer set to the lowest setting. Start on the non-emulsion side at the top of the film with the nozzle of the dryer about 4-5in (10-13cm) from the film surface. Work steadily downward until you reach the bottom and then go back to the top. After five minutes, begin working in the same fashion on the emulsion side. As the film begins to dry it will curl inward (emulsion out) first, and then assume its normal shape.

Most liquid chemistry may be re-used for further processing with some adjustment to the developer and blix times which you will find in the instructions. In processing chromogenic black-and-white emulsions, exactly the same procedures are followed in conjunction with the longer development and blix times necessary. These are also given in the instructions. There is no good reason why, if manufacturer's instructions are followed to the letter, and if your original exposures are reasonably accurate, you should not be able to achieve success at your first colour negative developing attempt. It really is very easy. The fault chart in Table 12 will give you some indication of how to remedy any faults that may occur. Apart from under-exposure in the camera, the most likely and frequent cause of problems is contamination. Do watch out for this, particularly when checking temperatures before processing begins.

TABLE 12: COLOUR NEGATIVE PRINTS

NEGATIVE PROBLEM	LIKELY CAUSE
Lack contrast and density	Film under-developed; temperature too low; incorrect development time.
Too dense, too contrasty	Film over-developed; temperature too high; incorrect development time.
Dense brownish unexposed-areas of film	Blix contamination of developer.
Density low, contrast normal	Film under-exposed in camera.
Density high, contrast normal	Film over-exposed in camera.

TABLE 13: PHOTOCOLOR II CHEMISTRY PROCEDURE

STAGE	TIME MINUTES	TEMPERATURE
Preheat tank	1	2°C (3.6°F) above process temperature
Development	3.25	38°C (100°F)
Stop bath/rinse	0.5	38°C (100°F)
Bleach-fix	4	35-40°C (95-104°F)
Wash	5	30-35°C (86-95°F)

Note: times increase as the temperature decreases. The full range is given in the comprehensive instructions with the kit.

FORCED DEVELOPMENT FOR COLOUR NEGATIVE EMULSIONS

Unlike conventional black-and-white panchromatic emulsions, film using the C-41 process do not like being under-exposed and then pushed in development. This can be done, however, but any gains in an increased contrast level are not equalled by similar gains in colour saturation. In normal outdoor situations, where lighting is even and bright and

colours are well defined, forced processing of a film under-exposed by two stops will produce a reasonable result, though not always satisfactory in my view.

Under available light conditions, the result may be pleasing depending on the type of light; there may be an increase in colour contrast. One or two stops is about the maximum which it is possible to push this type of emulsion. In general, films with a higher ISO speed give better results than slow or medium speed emulsions, and it is recommended that films with an ISO of less than 400 be given an effective increase of only one stop. Films of 400 ISO can be effectively uprated to EI 1600. If you know in advance that you are likely to require the extra speed afforded by faster films, results will be better with a higher manufactured rating.

Push processing can be successfully accomplished in Tetenal C-41 chemistry as follows:

Exposure	Speed Rating	New Dev. Time
Normal	Normal	3min 15s
1 stop under	+ 1 stop	3min 45s
2 stop under	+ 2 stop	4min 15s

Using Photcolour II chemistry, development times need to be increased by 50 per cent to achieve an equivalent 2 stop increase in EI at a temperature of 38°C (100°F). Photocolor II may also be used to process black-and-white chromogenic film. Follow the same procedure as for colour-negative emulsions, but use a development time of 4 minutes at 38°C (100°F) as a trial time. This figure can be adjusted to suit personal taste up to half a minute either side, and best results will be achieved from film which has been consistently exposed at the same effective EI. Ilford's XP2 needs no increase in development time for an effective increase in film speed; contrast may increase, but this particular film exhibits better grain quality when exposed at less than the manufacturers recommended ISO. XP2 film can be exposed at a range of effective ISO speeds of between EI50/18 DIN to EI1600/33 DIN, at which extremes some dilution of quality may be

evident. The best range for this film is between EI200 and 800. Ensure that bleach-fixing is not less than the recommended 6 minutes at any working temperature. Incomplete fixation will result in higher contrast and coarser grain due to the residual silver image.

PRINT-MAKING FROM COLOUR-NEGATIVES

Now that you have successfully processed your first colour negative film you will want to start making prints from the best negatives. One of the great advantages of being able to print your own work is that you can be more selective in the choice of negatives and choice of colour balance as well as the size of the print. Sending work to a commercial laboratory invariably results in a collection of prints

This strongly side-lit photograph was made toward the end of the day. It required a fair bit of manipulation in printing. I held back the face with a dodging tool made with a thin paintbrush to which I taped a ragged-edge disc of black paper. The sky was burned-in at the top of the print to help balance the tones. The cup was lightened briefly to improve the highlights.

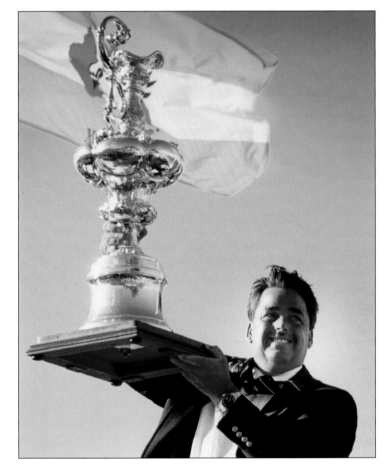

that are hardly ever looked at, and there is no guarantee that developed film will not be returned scratch-free once it has travelled in haste through the machinery used in some of these establishments.

The first essential to grasp is that colour printing is no more difficult than film processing. The actual time from exposure to completion of a fixed print is approximately 15 minutes (less using RA4 chemistry). In some ways it is less complex than black-and-white printing and can be great fun. The stumbling block for amateurs has always been colour filtration and the correction of various imbalances in print colours or casts. With modern dial-in dichroic head filtration and better papers, filtration is not the complex problem it was a few years ago, and no doubt as time passes it will become even more straightforward.

In recent years I have switched colour print production from my old MPP enlargers to a more modern Fujimoto 60M-C computerised colour head enlarger. The MPPs are great for black-and-white work, but somewhat slow when longish runs of colour prints are required from a variety of negatives. The Fujimoto is ideal in this respect, for once the computer is properly calibrated for paper speed, exposure, density and colour filtration are virtually automatic.

There are a variety of methods by which the colour print may be processed. Dish, tank, rotary tank, and bench-top processor are all suitable, though I have to confess that the latter has numerous advantages when a large number of prints are required. Perhaps the best compromise is a motorised rotary tank such as that made by Jobo which incorporates a water-jacket in which exact quantities of chemicals can be immersed. For the occasional print, dishes or a standard film developing tank with at least 8x35mm film capacity is perfectly suitable. I have also used the Nova darkroom tank for the production of some prints reproduced here.

The humble dish is very convenient, provided solution temperature is maintained at the correct level. Virtually any size of print, test print or combinations may be processed rapidly without the need dry out a tank after each separate print has been made. A degree of consistency in colour balance between different test strips is easy to control; temperature can be controlled by the use of a water bath – facilitated by using a slightly larger dish into which the actual processing dish is immersed.

If you are already well equipped with dishes and tanks for black-and-white processing, no other equipment will be needed apart from a set of colour correction filters, if these are not already a feature of your enlarger. Gelatin filters come in a variety of sizes and are available as Colour Compensating (CC) or Colour Printing (CP) from Kodak. If you have a filter drawer below the lamphouse, use of the CP type will not affect the printed image sharpness. Another very useful item that occupies no more space than a strip of negatives is a colour control patch of the type used in graphic arts work and by professional studio photographers for checking colour balance on test shots. Its use will be explained a little later.

COLOUR FILTRATION

Most of the confusion for beginners in colour photography seems to stem from the fact that the correction of colour casts in prints relies upon the 'subtractive' principles of colour synthesis. When the three primary colours, (red, green and blue) are mixed together in equal proportions and viewed by transmitted light, the mixed colours produce a white light. This is known as the 'additive' principle of colour theory. Early colour photography was based on this, but required complex tri-pack plates which were mechanically criss-crossed with printed filters in the primary colours. Subject-matter was exposed three times, once each through red, green and blue filters, but could only be used in conjunction with still-life subjects. Newton had discovered much earlier that, when white light passed through a prism, it effectively split into seven separate colours. If one or more of these colours were blocked, the remaining colours combined to form a new colour when re-transmitted through a converging lens. This new colour was complementary to the blocked colour.

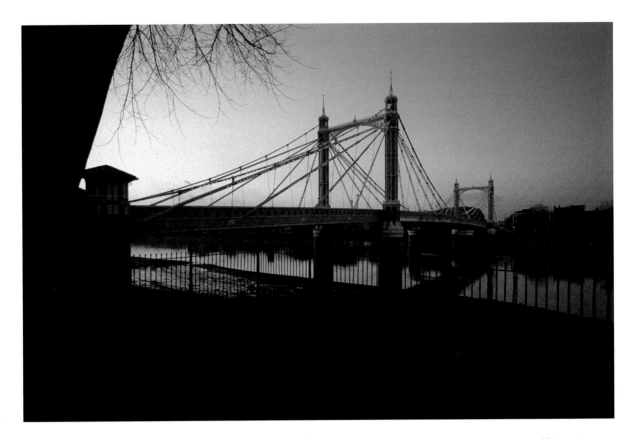

Many technicians and photo-scientists worked for years to produce a colour process suitable for general use which required only a single exposure through the camera lens. One-shot colour cameras simultaneously split the colour image through primary colour filters to produce three separate black-and-white plates, each one of a comparable density to the value of the filter through which it was exposed. To view the result, three similar primary filters were used through which to expose the plates on to paper. And so it went on until two Kodak technicians called Leopold Godowsky and Leopold Mannes invented Kodachrome film in 1935. This material used the subtractive principles of colour photography which had first been investigated by de Hauron as far back as 1862. The primary colours as we know them would be more accurately described as the 'additive' primary colours which, when projected on to a screen in equal proportions, not only give white light where those portions overlap, but other colours where only two of the primaries overlap.

These other colours are the complementary colours or 'subtractive' primaries, each transmitting two-thirds of the spectrum. Each one of these colours represents white light minus one of the three 'additive' primaries. For example, yellow (red and green primary) is white light without blue; magenta, formed primarily by the mixing of blue and red, is white light without green; and cyan (green and blue primary) is white light without red.

Filters which transmit the subtractive primary colours each transmit two-thirds of the spectrum; in other words, only two thirds of the colours forming white light. Any two filters combined together transmit one of the additive primary colours while absorbing the rest. When two additive primary filters are combined, total absorption of the complementary colour takes place. The Mannes and Godowsky invention used these subtractive principles for the production of amateur ciné film and, a year later, for 35mm still photography. All additive processes became redundant from that time on, with the exception of the Dufay process, later

Use of filters when exposing film will help to eliminate unwanted casts and effects caused by atmospheric conditions. The left-hand picture was exposed without any filter. The right-hand one employed a UV absorption filter which improves red tones and reduces the overall blue cast.

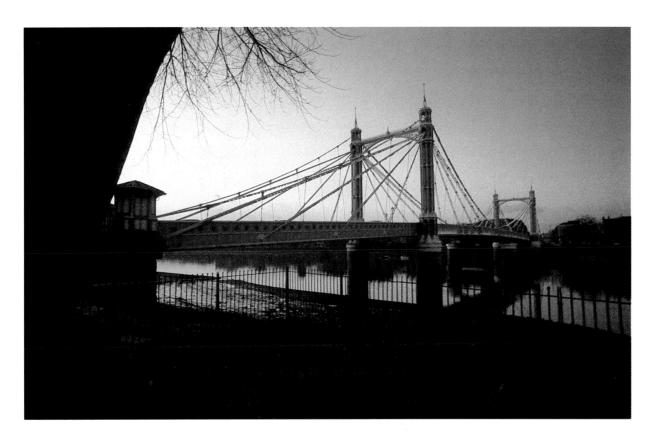

used as a basis for the exploration of instant photography by Dr Edwin Land and his later successful introduction of Polacolor (see Chapter 14). The confusion between reality, i.e. what we see and think of as real colours, and photographic colour, which is a synthetic mixture of unreal colours able to produce those real colours, is undoubtedly the cause of many an unsatisfactory print. In black-and-white photography, contrast between a variety of similar tones causes no such problem; the brain sorts tone and contrast into shape and form and gives it meaning. In colour, this simple process of rationalization no longer works; the introduction of colour suddenly inhibits and confuses the process of assimilation, although, in due course, the brain is able to fit the jigsaw together and recognize the image.

In producing a colour print from a colour negative the photographer is first of all faced with the problem of how to recognize the complementary colours – the subtractive primary colours of the negative image – in terms of real colour. Once a test print is made,

any imbalance in real colour, any apparent real colour cast, can only be altered by changing the subtractive primary colours, using similarly coloured filters of differing density.

The problems created by this kind of confusion appear at first hand fairly easy to remedy. Instead of thinking of colour as it is, think of it only in terms of subtractive primaries which, when combined in varying strengths, will produce the real colours of the world. This approach might work well if all colour photography were based on the negative to produce positives. Well, think about it. it is. Even the humble transparency begins life as a negative and then, through chemical fogging, is reversed to form a positive. If you were to process a colour reversal film first in black-and-white developer, fix it, and then by using a ferric bleaching process re-halogenise and develop normally as a colour negative, the result would be a highly saturated negative of complementary colours. In duplicating a transparency, the same principles of filtration are applied as with a negative.

COLOUR PRINTING

ew figurative examples exist which, in my view, adequately show how one may easily remember how white light is divided into the complementary colours of the additive primary colours, red, green and blue. If anything, a colour chart showing exactly how the complementary or subtractive colours are obtained tends to add to the confusion. How this can happen can be easily seen in Table 14, which identifies the colours in relation to each other.

COLOUR PRINTING FILTERS

For the benefit of those who do not have a dial-in filter facility (colour mixing head), or who prefer to control filtration by manual means, Table 15 lists the Kodak Colour Printing filters and their various denominations. Filters used in some colour mixing heads may not give the same balancing effect as the Kodak filters listed, and practical tests will have to be completed before a true assessment of their values can be established.

The Kodak CP filters are available in 5in (25mm), 6in (150mm), 12in (300mm) square sizes and 8x10in (200x250mm) size. Kodak colour compensating filters are also available, but in a much wider variety and for many different applications. They were originally designed for colour printing for use in front of the lens. However, no more than three should be used at any one time. Their greatest practical use is in photographic origination, where the colour balance of the subject matter is changed during exposure. They can also be used for black-and-white photography to make subtle changes in tonal values and are also useful for correcting casts when duplicating transparencies using tungsten and electronic flash light sources. A full description of

the uses and values of CC filters can be found in any current edition of the Kodak Photographic catalogue.

Each filter allows its own colour to pass, but filters out the remaining colours by subtraction. When two filters are used in correct proportions, the primary colours are obtained. If all three filters are used, the combination forms varying degrees of grey through to black, so in colour printing only two of these filters are used at any time in varying values to subtract or add colour to the print except, when for reasons of convenience, it is easier to add a value of a different colour when the colour shift required is minute. You will see how this works as we go along.

Modern colour emulsions of both negative and papers are far more stable than they used to be, and invariably need only fairly small adjustments in filtration, once the basic filter pack values for a particular batch of paper

TABLE 14: SUBTRACTIVE AND ADDITIVE PRIMARY COLOURS

SUBTRACTIVE PRIMARY COLOURS	ADDITIVE PRIMARY COLOURS	
	MIXED FROM	OMITTED
Cyan	blue+green	red
Magenta	red+blue	green
Yellow	red+green	blue

TABLE 15: KODAK COLOUR PRINTING FILTERS FOR USE IN ENLARGER LIGHT SOURCE

CYAN	MAGENTA	YELLOW
CP05C	CP05M	CP05Y
CP10C	CP10M	CP10Y
CP20C	CP20M	CP20Y
CP40C	CP40M	CP40Y

+ Ultraviolet absorber CP2B

have been established. On the back of a packet of paper you will find an emulsion batch number, much the same as you find on a box of film. Underneath this figure is another set of figures which may read 'filter correction 20Y'. This means that the standard filter pack for that type of paper needs a filtration adjustment of minus CP20Y before printing commences. Using a well-exposed and fairly contrasty negative, test prints using this filter pack should produce a first print of almost acceptable colour balance. If there is a dramatic shift in colour away from what you feel is right, first look to causes other than the basic filter pack.

Make sure that the ultra-violet absorbing filter, CP2B, is in place in the filter drawer. Check that the negative you are attempting to print has no obvious cast to it, other than those normally associated with colour negatives. Check the temperature and freshness of working chemicals. Ensure as far as possible that the developer has not been contaminated by the blix. Is the correct safelight in use? Are all light-emitting diodes around the enlarger extinguished or covered?

If all of these items are found to be in order, then you can begin adjusting the basic filter pack. First of all, check that this pack was made up from the correct values as advised in the paper manufacturer's instructions. Check that you have correctly adjusted the pack with the value given on the reverse label of the paper packet.

As with test exposures in black-and-white printing, colour printing requires the same dedicated effort to establish the basic parameters within which to work. As I have already mentioned, the filters in enlarger mixing heads will vary in value and type so, if you have one of these, you must first of all establish their accuracy in relation to Kodak values. Ideally, test strips from negatives exposed of a well-lit subject which incorporate a Kodak Colour Control patch are most suitable.

Process the film in the normal way, using the chemistry described in the previous chapter. Select a negative for printing. This will provide test prints which you can then match visually under normal daylight or a 40-watt daylight balanced fluorescent tube against the original Kodak Colour Patch. Adjust the filter pack to correct for casts which are not compatible with the original colours in the control patch. When a print of the closest acceptable match to the control patch is available, make a note of the filter pack values, exposure time and development used and compare this with the values given by the paper manufacturer for a basic filter pack using Kodak values.

The difference between the two sets of figures is noted and used as the standard bias for your enlarger whenever a new batch of paper, or batch from a different manufacturer, is used. If the new values are more or less than those established for your instrument, simply add or subtract the amount of bias from each filter required to form the basic filter pack.

Colour analysers and other measuring instruments can be purchased which will assist the photographer in making acceptable colour prints. However, all of these instruments will need to be calibrated for individual darkrooms and the conditions which exist; paper type and speed, light source type, filter type and chemistry must all be taken into consideration: Only when calibration has been accurately established for one printing session can there be any guarantee of success, which is why, if you aim to learn the basics of colour printing, the manual approach using individual filters will teach you more, a lot faster, than any gadget.

CORRECTING COLOUR CASTS
Exactly how filters behave in printing will soon become clear once several test strips have been made. Think of each filter in terms of the colour that it absorbs, rather than the colour it will transmit: magenta absorbs green; cyan absorbs red; yellow absorbs blue. In attempting to reduce a particular colour cast, increase the value of that same filter colour or filter combination required to give that colour. Remember, the colour of the filter will subtract the same colour from the print; the higher the filter value, or combination of values, the less of that colour appears in the final print. Alternatively, you may reduce the

The Paterson Orbital colour print processor using a unique agitation method is ideal for print-making and uses very little liquid. (By kind permission of Paterson Products Ltd.)

amount of filtration of filters of the complementary colour.

In practice, a print with an overall magenta cast will benefit by an increase in the magenta filter value of the pack. If the increase is too much, the complementary of that colour will be visible in the print, i.e. green. To remove it, increase yellow and cyan together, or reduce magenta. Most modern papers and emulsions are balanced for correction using only two of the three subtractive primaries, yellow + magenta. Cyan is more often used in printing positives from colour transparencies, about which more later. Whenever possible, it will pay to control filtration using only the yellow + magenta by adding or subtracting various values from the standard filter pack as and when required. On the odd occasions that cyan must be added or subtracted, values of the other two, magenta + yellow must be reduced. If they are already at zero or close to it, further reduction will not be possible, in which case correction of the cast is achieved by a combination of filters which gives the same colour as that which it is required to remove. For example, the print colour cast is *green*; magenta cannot be reduced further because it is already

TABLE 16: CORRECTING COLOUR CASTS ON COLOUR NEGATIVES

COLOUR CAST	INCREASE	REDUCE
Red	magenta + yellow	cyan
Green	cyan + yellow	magenta
Blue	cyan + magenta	yellow
Cyan	cyan	magenta + yellow
Magenta	magenta	cyan + yellow
Yellow	yellow	cyan + magenta

TABLE 17: CORRECTING COLOUR CASTS ON COLOUR SLIDES

COLOUR CAST	INCREASE	REDUCE
Red	magenta + yellow	cyan
Green	cyan + yellow	magenta
Blue	cyan + magenta	yellow
Cyan	cyan	magenta + yellow
Magenta	magenta	cyan + yellow
Yellow	yellow	cyan + magenta

at zero or at least a very low value; combine yellow and cyan (=*green*) and increase in value until the cast is removed.

Table 16 identifies the various colour casts and shows how to correct them. Note that it is

These two pictures make use of one colour which has been effectively isolated and emphasized by the use of neutral colours in the background. A print from any of these may need substantial correction to keep the surrounding colours neutral.

a simple matter to cross-reference both the 'subtractive' primaries and the 'additive' primaries so that, in order to facilitate the addition of colours, we only need reverse the procedure. Table 16 is for use when printing from colour negatives. Use Table 17 when printing positives from colour slides.

Reading the theory behind colour practice is essential if you are a complete novice. However, it is often possible to read too much too quickly. A mountain of information seems to have been swallowed, but very little actually comprehended, which is why I have assumed from the outset of this chapter that you will want to begin printing as soon as possible. There is always the risk, of course, that a mountain of wasted paper will accumulate in the process of discovery. The possibility that this mountain might be marginally reduced in size as a result of reading the theory first is, however, fairly small.

THE DURST COLORTRAINER

Start printing as soon as you can. I used Photocolor II and Photocolor RT printmaker

for most of the prints reproduced here, in combination with one of the best manual gadgets to be produced since colour chemistry became available in a two-shot liquid format; the Durst Colortrainer is about the size of a Scrabble board and divided into squares corresponding to both sets of primary colours in varying densities and strengths. In addition, there are 18 squares of varying density from white through to black.

The Colortrainer serves several purposes, and even for those who know, or are supposed to know, it is a simple but effective teaching aid as well as a reminder that even the most experienced hands are fallible.

A collection of coloured chips whose hue and density matches the coloured and black-and-white squares on the board are scattered at random on a suitable desk or bench top. The colour student is then invited to try and match each and every one of the 72 coloured chips to its relevant square; the 18 black-and-white chips and white strip are also matched. When you think you have accomplished this task successfully, transparent trays are laid over the board's coloured squares and the procedure repeated by laying the chips in order in the trays, which have lids. When the task is completed, the lids are affixed and the trays turned over to reveal a picture. This elementary jig-saw is easily recognized and one can soon see where the mistakes in matching the squares have been made!

When I first unpacked the kit, I had the uneasy feeling that someone might be making fun of me. None of the colours, except perhaps the brightest ones, could be considered as a near match for the sort of colours that one experiences in photography. This was my first mistake, because on pulling out a random colour print from the files, I soon discovered that one could easily match any colour and colour density in the print very easily using the chips. On the reverse of the chip are printed the filter values required to remove the cast or colour, and these correspond to the values given on the board.

Rather than make another mistake, I read the simple instructions and spent another hour testing my skills at judging colour. In the past,

assessing the colour balance of a print and trying to correct any casts that might be visible had always been done by overlaying the various filters on the print, or by viewing the print through the filter. Using a solid colour actually makes this task easier, because the colours seen in a print are viewed by reflected light, not by transmitted light. The chips were beginning to make a lot of sense.

To make full use of the Colortrainer, the student is advised to photograph the board in its entirety, using diffuse daylight or suitably controlled flashlight on the first few frames of a colour-negative film. After development, the best of these negatives is selected and four trial test prints made, using varied exposures combined with a standard filter pack. From the dried prints, the best level of density and contrast is selected and the 0.70 grey density square on the print cut out. This is then matched with an equivalent square amongst the 18 density squares on the board, from which a new exposure is then calculated, using a factoring table provided with the kit.

The new exposure is designed to give the correct density level for a standard print – **not** the correct colour. This is achieved by matching the cut-out density square with the nearest colour tone elsewhere on the board. If you are certain the colour match is correct, use the filter modification value to adjust your enlarger pack. You can make a note of these adjustments in your notebook or on the very comprehensive special trainer work sheets.

You should now have the correct exposure and correct filter pack to give you a starting point for making any other prints, provided you use the same film type, chemistry and light source. To my mind, this process makes the usual ring-around system of prints totally redundant. Use the standardized filter pack to make a trial exposure of the next negative, say a portrait shot. Using a subject in which skin tones are a major feature will soon establish whether you are making any progress.

Keep all the colour prints you make and write on the back of each one with a felt-tip pen the filter pack, exposure, f-stop, development + temperature and chemistry used, as soon as you have decided that the print is

unacceptable. When you have made an acceptable print, write the same information used to make that print on the back of the unacceptable one as well. You will soon begin to collect an assortment of prints with useful filter information written down, so should the time come when a repeat print is required, say a year later, you will have relevant information to hand. Any slight shifts in colour balance can soon be corrected using the Colortrainer.

N.B. The Durst Colortrainer is now discontinued. They were often sold with new enlargers, and since these tend to change hands frequently in the used market, quite a number of Colortrainers are still in circulation. Colour film and paper manufacturers often produce instruction booklets which incorporate easy-to-use colour correction techniques. Using a Macbeth ColorChecker, or Kodak Colour chart, simplified colour trainers can easily be produced by the student.

THE RING-AROUND PRINT SYSTEM

This is a system devised for both colour-negative and colour-slide printing techniques which is designed to show at a glance how the most likely cause of trouble in terms of exposure and colour filtration can be corrected. From a colour negative (or slide) known to be of correct exposure, colour saturation and density, a variety of prints are made; at least 9 and as many as 17 can be required for a full set. Included is one print which, to all intents and purposes, is accurate in terms of colour rendition, exposure and density. The other prints in the series are variations of exposure, plus or minus one full stop and plus or minus varying degrees of colour balance, using the three additive and subtractive primaries. For good measure, several prints exhibit strong casts using each one of these colours. In my experience, this kind of system only has any value if it is possible to make the prints large enough for further comparative purposes. In other words, anything less than a 10x8 is virtually useless. So to begin with, some considerable investment is required for materials and

chemistry. Furthermore, these prints will become the standard against which all other work is compared and adjusted. If, instead of using a real subject photographed under variable lighting conditions, a standard colour chart were to be photographed, some sense of a ring-around might be made possible. This is in fact what Durst have done with their Colortrainer, and it seems to me that the investment necessary to purchase this kit far outweighs the time and cost of materials involved in trying to make your own.

CHEMISTRY

The Paterson Photocolour FP processing instructions are very explicit. Liquids are available in a standard pack size of 1500 ml and a Professional outfit, which will make 6 litres of chemistry. The contents comprise colour developer concentrate, parts A and B, a special conditioner for Fuji film (C-41 process), and bleach-fix concentrate. The larger volumes are available as separate items, and include colour developer for negatives and prints, colour developer replenisher, colour developer for negatives only concentrates to make the Universal bleach-fix. A photo-stabilizer for films is also available.

As all the concentrates are in liquid form, little difficulty is experienced in mixing solutions to the right dilutions. Use polythene or glassware containers, not clear plastics, as some grades are easily damaged by agents in the chemicals. Photocolour chemicals have excellent keeping properties and, when used in diluted form with increased times, can be used to process large quantities of paper. The chemistry is ideally suited to processing Kodak RA4 type papers. It can also be used to process most other RA4 branded papers as well as C-41 process type film.

PRINTS FROM SLIDES

Nearly all of the foregoing information is applicable to making positive prints from slides. However, you must remember that this

is a reversal process and, therefore, all filter corrections are reversed (see Table 17). Processing is carried out in the same way as print making from colour negatives, using different print reversal chemistry. For the production of prints from slides in this book, various methods were used, including Cibachrome and Photocolor Chrome R. Both produce different results, but for the home-worker intent on producing a record of slides in print form and the occasional larger print which may be required for wall-hanging or a gift, Chrome R is to be recommended. Cibachrome (now Ilfochrome) has less temperature latitude and requires a fairly expert touch to obtain the superb results which this process is capable of giving.

It is suggested that, in the first instance, Ilfochrome process P30P available in Classic kit form in 1-, 2- and 6-litre sizes is used while some knowledge is gained in the handling characteristics of reversal print materials. Although filter corrections can become progressively minimised, finding the right exposure balance to produce a print without the burned-out highlights and dense shadows characteristic of the reversal print can take a little time.

Ilfochrome Classic kits contain only developer + bleach and fixer solutions. They should be used as directed by the comprehensive instructions contained in each kit. I use my stainless black-and-white developing tank when developing prints on a one-off basis. Dish processing is quite feasible, but complete darkness is required for the developer and first wash stage. The most likely problems associated with print casts are sure to come from exposed LEDs on things like timers and tank thermostat controls. Mechanical clocks do not have light emitting diodes. They just make a loud noise when time is up. Temperatures can be maintained easily, utilizing previously described methods employing a water bath or immersion heater stat, that once set, will keep solutions at correct levels for as long as the power is switched on. Temperatures may be checked every so often using a conventional alcohol or digital type thermometer with wandering probe.

Use the tank for the developer cycle which, once the paper has been loaded in total darkness, can be continued under room lighting. A few seconds before the end of development, turn out the room lights, remove tank lid and carefully remove the print as soon as the timer rings. The remainder of the process may be carried out using dishes. Transfer the print immediately to a stop bath dish and agitate fairly vigorously for about 15 seconds. Bleach/fix temperature is not critical; this stage may be carried out at the ambient room temperature. Temperatures should not, however, be allowed to fall below 20°C (68°F). There is an advantage in using this method if more than one print is to be made and you want to get on with the second one which can be tank-loaded and developed while the first is coming out of the fix.

TABLE 18:
ENLARGER FILTER EQUIVALENTS

ILFORD/KODAK/ CHROMEGA VALUES	AGFA VALUES	DURST VALUES
5	7	3.5
10	14	7
15	20	10
20	28	14
25	36	18
30	42	21.5
35	50	25
40	57	28.5
45	64	32
50	71	35.5
55	78	39
60	86	43
65	91	45.5
70	100	50
75	107	53.5
80	114	57
90	128	64
95	136	68
100	143	1.5

N.B. Different enlarger brands use different filter values. Using Kodak values in the left-hand column, read off the value equivalents for machines calibrated under other values in the centre and right-hand columns.

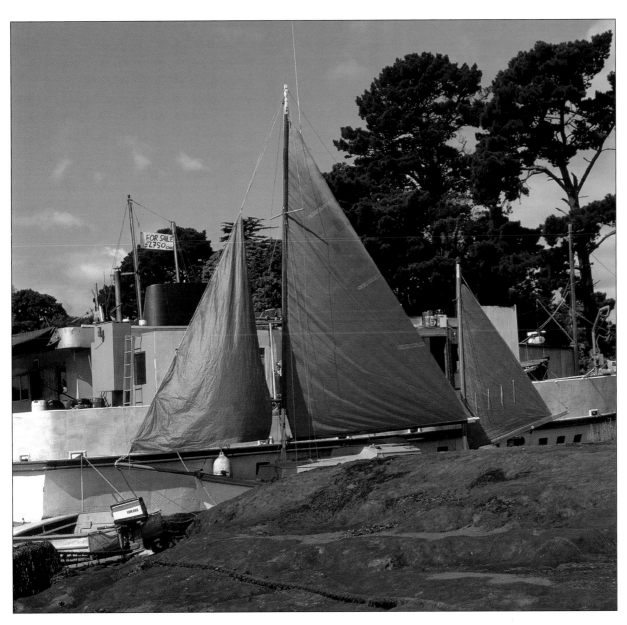

Red, green and blue – all the primary colours you need: to obtain an impression of how the colours influence each other, try covering each large area with a finger. By covering green only, red and blue are apparently more saturated. By covering blue, the red and green become less effective.

As with black-and-white printing, most problems encountered in producing satisfactory prints from slides will be met when endeavouring to print scenes of high contrast, i.e. when the brightness range of a slide is far in excess of the acceptable brightness range of the paper. With modern papers such as Ilfochrome, excellent differentiation in colour is possible, boosting both apparent sharpness as well as brilliance. This paper is particularly effective for printing slides with large areas which are highly colour-saturated. Some

sacrifice in tonal rendition may have to be made where large areas of highlight and large areas of deep shadow detail are present in the slide with fewer middle tones. It is much better to select a picture in which one or the other, but not both, of these areas may be sacrificed.

It is possible to reduce the first development, much in the same way as one might when processing transparency films, to 'pull' the contrast level down, but some compensation for this procedure must be given in the

exposure. Initially, try an increase in exposure of one stop and reduce the first development time by 20 per cent. A series of stepped exposures should be made to establish the correct density level and new development time. Remember that, in reversal printing, an increase in exposure will produce a lighter print; decrease exposure for a darker print. Expressed like this, it is easy to remember: **increase light, decrease dark**.

COLOUR BALANCE

Reversal prints hardly ever need the same amounts of filtration which are required in making prints from negatives. Nearly all films have a slight colour bias, but if slides are first of all inspected closely, using a Lupe over a good light-box with daylight balanced fluorescent tubes, dominant casts are easy to detect.

To start with, make your test strip exposure using the paper pack filtration. Slides of scenes shot under adverse conditions, such as sunset and sunrise, or in hot and very cold climates, may show an overall cast if no correction filter has been used at the time of exposure. It is often difficult to assess what cast, if any, may be present in early morning or sunset pictures, such is man's taste for 'romantic' scenes. However, early evening shots during twilight, which have necessitated longish exposures, may show decided colour imbalance due to reciprocity failure (see illustration on page 94) When desirable, this can be corrected in printing the slide. Quite often, especially in the northern hemisphere, I find that reversal material exposed at this time of day for more that a second or two produces a result which is actually better than the original scene.

When filtration is required, it is unlikely to be much more than in units of 05–15. Transparencies which have faded with time or taken on a cast through chemical change of the dye couplers may need considerably more filtration. There are no standard filter pack settings for these occasions for obvious reasons. As with colour negative printing, the final result is always very much in keeping with personal taste. Use Table 17 (page 150) as a guide to correction.

COLOUR REVERSAL PROCESSING

The current process used for developing the majority of colour slide films is known as 'E-6'. You will find this designation on the packaging of films. Slide films which require special processing – such as Kodachrome – cannot be E-6 processed and must be returned to the manufacturer after exposure. A wide variety of chemistry kits, as well as professional quantities of E-6 processing chemicals, are available off-the-shelf.

The standard E-6 process cycle is as follows:

1 First developer.

2 Wash.

3 Reversal bath.

4 Colour developer.

5 Conditioner.

6 Bleach.

7 Fix.

8 Final wash.

9 Stabilizer.

A shorter cycle is also available which omits the separate reversal, bleach and fix baths. Instead, reversal takes place during the colour development stage while the bleach and fix baths are combined. Some small chemistry kits use this system – known as a 3-bath cycle. Tetenal UK-6 is to be recommended. Success in home processing of E-6 materials is usually consistent with technique. Use a lower than recommended temperature and you will obtain what appear to be under-exposed slides. Working temperatures for the majority of E-6 chemistry falls between 37 and 38°C for times of between 6 and 8 minutes. Once you have established a temperature which is easily

maintained, fluctuations of between +/- 0.3°C and times of +/- 5 seconds are permissible. First development is critical and should always be preceded by a pre-heat bath which brings the film up to the required first development level.

Lower temperatures may also give processed slides a slight yellow tint, while higher ones tend to yield a blue cast. In practice, I have found that a working temperature of between 34 and 35°C (93-95°F) gives results with a very faint warm bias. The reds and oranges are noticeably enhanced. Where these colours predominate in the picture, the overall effect is quite pleasing, and where blues predominate any enhanced red values tend to take the coldness out of the scene. Some tests may be necessary to establish a colour-bias preference.

Using small amounts of chemistry in one-shot processing, obtaining consistency can be difficult, and there is now such a wonderful range of E-6 type film available that it hardly seems worth while to modify the standard technique. For example, Kodak's Ektachrome Panther 100 and Panther 100X give the photographer the best possible combination of choices previously only obtainable using film brands of different types. These have unique properties, boasting the finest grain/speed ratio of any film in their class. Standard Panther 100 has a 5 per cent higher contrast rating than normal Ektachrome EPP, and is balanced for the same colour temperature. Panther 100X has the same contrast level as 100, but has a built-in warm-up filter equivalent to the value of an 81C lens filter. This gives the photographer a great advantage when shooting under a variety of weather conditions, in particular under overcast skies, when use of a camera filter was often necessary in combination with a modified processing technique. The advent of Panther has obviated the need for either device.

A Skylight 1B filter will absorb much of the ultra-violet but, even though it does have a slight warming effect on flesh tones and some other subjects taken in close proximity, those wide-open scenes still seem to suffer. If you had previously conducted several tests using, say, Fujichrome 100, processed at varying temperatures, the noted record would give a very good indication of how colour balance could be shifted during processing to give a more pleasing result. The same applies to scenes of sunsets. Many of these are predominantly red or orange in colour, but where high-pressure weather patterns exist locally, upper regions of the sky may still be blue, or purple. Such subtle differences in hues are often difficult to expose predictably.

In reversal processing, the key to success in obtaining a correct level of apparently well-exposed images lies with the first developer. It is important to maintain the chemistry to within at least plus or minus 1°C (1.8°F) but less if possible, and to adhere rigidly to timing. In practice, there are several points to check before you even start exposing reversal film, especially if you have an in-camera though-the-lens (TTL) metering system.

The ISO indexing ring, which on most cameras is fitted with TTL metering, is designed to give exposures which will produce an averagely acceptable result. I do not recall an occasion when I have ever been able to use one of these meters and rely on the film manufacturer's rated ISO and my camera meter being in exact agreement on the correct speed. When you purchase a new camera, always run a film through it and make exposures, using a range of ISO settings. Keep a note of the frame numbers, exposures used and ISO settings, so that you can check as soon as the film is processed whether your TTL meter is graded up or down from the actual indicated speed.

Nine times out of ten, one can be fairly certain that camera meters set to the manufactured film ISO will produce transparencies that are slightly over-exposed by between half and one stop. Shaded details look fine, but highlight areas will invariably have that washed-out appearance, lacking contrast, colour intensity and brilliance. However, the camera manufacturer may well argue the point that the film maker is to blame, having rated the film at a slightly slower speed than it should be. All types of reversal film tend to vary in this respect, which is why it is well

worth investing time, a little money and effort into finding the 'right' emulsion.

In recent years, Fuji RDP 100 became my main E-6 stock, but once Kodak introduced Kodachrome in the larger medium format the bulk of work was exposed on that. The film in this format was short lived – apparently insufficient demand – and I had to revert to using Fuji, until the advent of Ektachrome Panther 100X. These new emulsions seem to expose more accurately with in-camera meters, although older Kodachrome emulsions curiously never exhibited these peculiarities of exposure. Certainly, there is much to be said for fully evaluating your camera/hand meter, ensuring that the correct batteries are fitted and that the power levels are good.

Once you have fully investigated emulsions and matched the chosen one with an easy-to-use chemistry, you will soon begin to understand just how flexible reversal materials can be. By pulling back the time on the first development, varying degrees of under-exposure are obtained; by giving extra time, an effective increase in film speed is gained and it is quite surprising just how far some reversal emulsions can be pushed (see illustration on page 166)

If you follow the manufacturer's step-by-step guide carefully, there is no real reason why any competent darkroom worker should not be able to produce a set of superbly processed transparencies at the first attempt. You will need a large basin for the water-jacket if your darkroom is not equipped with a rotary processor with built-in water-jacket. But, other than that, a normal cylindrical film developing tank in stainless steel or plastic, thermometer(s) – more than one to avoid contamination of chemicals – and a clock are all the equipment you will need to begin.

PUSH-PULL REVERSAL PROCESSING

Professional newspaper, freelance and agency photographers have been force-developing reversal colour emulsions for years – a habit largely induced by the lack of effective

film speed for low-light-level photography. Modern emulsions are available in a variety of ISO values with some very high manufactured emulsion speeds; Kodak Ektachrome P800/ l600-Professional film is a fine-grained transparency film with excellent colour rendition and colour balance adjusted for forced processing. It gives best results rated at the box speed, but can be pulled back to E1400 or pushed up to E13200. Fujichrome 400 Professional D RHP is another film designed to be push-processed when required. Up-rating lower-speed materials to a point where it is still necessary to use relatively long exposures – over one second – usually results in some interesting colours caused by reciprocity failure. High-speed emulsions do not have this problem.

It makes sense to use such high-speed emulsions where light conditions warrant it. Sports photographers equipped with fast telephoto lenses of the dinner plate variety (f2.8 or faster) will find that not having to up-rate 200 or 400 ISO emulsions is a valuable asset. As there now seems to be an ISO value available off-the-shelf to cater for almost every demand, it seems only reasonable to ask why one would ever want to resort to push-processing.

Well, there are still many photographers who enjoy manipulating the characteristics of some colour reversal films. Depending on the application of the technique and on the type of emulsion, a variety of effects can be obtained: increased grain, increased colour saturation, increased contrast and others are all possible. For example, Ektachrome 400 (daylight) is usually only pushed to EI800. Beyond this, weird things begin to happen with colours. Try exposing a roll under fairly low-light conditions at EI3200, an effective increase of 4 stops.

Nearly all push-processing is a matter of experiment until the right results are produced. Keeping notes of new times and any changes in temperature and chemistry make-up will be useful for future occasions.

Begin by carrying out a clip test. Load a few frames of a fully exposed roll into the tank and, using the same temperatures as you

Polachrome's brilliant colours and contrast range can be used effectively to create special effects. This still-life was shot through a malleable acrylic filter to distort parts of the image.

would for standard development, increase the first development by 50 per cent to give an effective increase in film speed of one stop. Progressive increases in exposure values will not necessarily mean that the increased time of the first development should follow in exact increments. For example, an 8-stop increase in film speed should theoretically require a 400 per cent increase in first development time. So if the normal first development time was 4 minutes, the new time will be 16 minutes. However, increased first development on this basis does not produce a sufficient increase in density levels, resulting in processed transparencies with a somewhat muddy appearance. Some adjustment is necessary to get the latent image held in the shadows properly developed. How much extra time is given will largely depend upon the subject matter and whether this was predominantly in shadow with few bright highlights or whether it was evenly lit with few shadow areas. Start by adding 25 per cent to the newly calculated time. In addition, to help build up the maximum density (black), dilute the mixed colour developer with water at the rate of 1+2 and increase the colour development time by approximately 135 per cent. The original transparency of the stoker (see illustration on page 166) was shot many years ago before the very high-speed films of today had been invented. I had made several attempts to shoot this picture by using the light from the furnace only, using Ektachrome-X, the old version of Ektachrome 64.

Using exposures of between 1/15 and 1/30 second on a 28mm lens wide open at f2.8, the first results of forced processing were hopeless. I had a picture, but no detail existed in the shadow areas or in the face, which was precisely where I wanted maximum detail. I went back to the scene several times over a period of a few days. After gradually increasing the first development on consecutive occasions by employing calculated figures, I finally decided to double my original estimations, on the grounds that nothing more could be lost. The E-3 process at that time required a first development of 10 minutes at 24°C (75°F). I had already pushed that time way beyond what might have been considered reasonable limits – 30 minutes – with no effect. In exasperation, I put the last roll of exposed film in the tank and left it for an hour!

I gave a good healthy re-exposure to a photoflood and then three times the normal colour development. Out of 36 exposures, I salvaged half a dozen that were more or less perfect. Later I tried to work out what the effective speed of the film was, having pushed it beyond what I would have normally considered an acceptable level. As there were no accurate figures to go on, other than a rough estimation of exposure value from my Weston light meter with which I had taken a fairly close reading of the furnace, I could only hazard an approximate guess, taking into consideration development time and the brightness range of the subject-matter from highlight to deepest (black) shadow. At the furnace door, the Weston had given an EV of 6.5 which approximated my 1/15 second at f2.8 exposure. Light from the furnace reflected on the stoker's visage was EV 1 or less, though it could not be accurately measured because of the intense heat at the final close proximity to which I encouraged the man to go. So, on the basis of that alone, the film was up-rated at least 8 stops and, if the development time is considered, allowing for a large percentage of time to develop the latent shadow image, the effective EI is close to 650.

Some reversal emulsions requiring E-6 chemistry for development, when exposed under certain inclement weather or lighting conditions, can be made to produce marginally better results if a small increase in film speed is assumed from the outset. A one-stop increase in speed when exposing under overcast, dull conditions, with consequent increase in first development time, will produce slightly contrastier transparencies with improved colour rendition. Best results are obtained by using medium-speed films of between 100 and 200 ISO. When conditions deteriorate so much that practically useful exposures can no longer be employed, better results will be obtained using a higher-speed film.

DUPLICATION OF COLOUR TRANSPARENCIES

The photographer wishing to duplicate slides for projection, or display, reproduction and occasional audio-visual usage, can employ numerous methods, the most common and popular of which is a slide-copying attachment which fits on to the standard lens of the camera. The latter is then attached to the camera via a set of focusing bellows or extension rings. A flash-gun or tungsten light is used as the light source behind the flashed opal screen of the duplicating accessory. Special professional duplicating machines, like the Bowens Ilumitran or Elinchrom Diaduplicator may also be used. When this equipment is not available, the only alternative may be a north-facing window, a roll of adhesive tape, a sheet of tracing paper and camera with macro lens or macro supplementary lens. This is not a very efficient answer to the problem, but surprisingly good duplicates can be made in this way with a little care.

Probably the best answer is the enlarger. Some, like the Kaiser models, permit the colour head to be inverted and used as a light-projection box incorporating the filter head. The copy camera is mounted on the enlarger column complete with macro bellows and can be used in much the same way as a professional duplicating machine. This system is best employed using tungsten balanced duplicating film. Duplicating or tungsten balanced sheet film may also be used under the enlarger to produce excellent 1:1 or enlarged transparencies. A Hasselblad fitted with a 70mm film back and double extension bellows and duplicating film holder is another method permitting long duplicating runs of the same or different originals without the need to keep changing film. Most duplicating film stock can be purchased in bulk.

One of the biggest problems in duplicating originals is that the contrast range in the duplicate is increased when no black-and-white mask is used. Making a mask is not difficult but is not always necessary, particularly when the end result is used for reproduction and the format size of the duplicate remains the same as that of the original.

Kodak Ektachome Slide Duplicating Film 5071 (process E-6) 5072 (process C-41) is used for making transparencies from colour negatives; the procedure (basically the same as that described below, with filtering principles reversed) is recommended for duplicating 35mm originals. It is a specially formulated emulsion with low-contrast characteristics. The film is designed for use with Argaphoto or Photopearl lamps of 3200k. The emulsion speed is low, effectively ISO 6. This film is available in 36-exposure cassettes and the filtration details are marked on the side. If you use a zoom type copier with electronic flash, use Kodak's SO-366 (or Fuji Duplicating Film equivalent) which is balanced for daylight or electronic flash.

Kodak Ektachrome Duplicating Film 6121 can be used for same-size or enlarged duplicates; it has excellent colour reproduction characteristics and does not require originals to be masked. Both film types are designed to be used with tungsten light source and are processed in E-6.

To make duplicates from any size original up to 16x20in use Ektachrome 6121. I would normally use the 5x4in format. Two strips of three 35mm format originals will cover the format with a little to spare at top and bottom edge. I use a standard clear-glass, foam-backed contact printer which is positioned under the enlarger light beam so that the whole 10x8in area of the print frame is adequately covered.

When you have selected the transparencies for duplication, carefully tape these

together horizontally. Use a light-box and thin strips of transparent sticky tape (Scotch) to make the joins. Ensure the tape does not overrun the frame edge of the picture. In the darkroom, with the safelight on, position the printer frame under the enlarger light beam. Make this slightly out of focus so that any dust particles inside the enlarger are not sharply focused on the contact printer. Now open the frame so that the glass lies on the left-hand side. Lay the transparencies to be copied on the glass so that the top edge of the top three protrudes slightly over the glass edge. Lay the transparency originals so that the emulsion side faces up. Have the box of sheet duplicating film handy on the right-hand side of the bench. Insert the CP2B ultra-violet filter into the filter drawer and, if you think there is a colour cast that would be better removed from the original, insert the appropriate correction filters. You can use Table 17 (page 150) as a guide, but remember that reversal materials require very little filtration and it may well be better to begin with none at all apart from the correction pack printed on the film stock box. Colour printing (CP) filters will also be useful. Using the primary filters (red, green and blue) facilitates easy identification of colour casts present in the original when this is viewed through one filter or a combination of filters.

Next, set your enlarger timer to the 'seconds' mode. Select 5 seconds for average well-lit, but not too contrasty, scenes. The f-stop on the enlarger lens should be at f8-11, midway between the two. Briefly turn out the darkroom safelight and ensure that all other lights on machinery and instruments are extinguished or taped over. Turn the light back on and take a light-tight box in which to place the exposed film. Keep this handy by the enlarger. Turn out the darkroom lights. Open the box of duplicating film. You will find that all sheet film is code-notched in one corner. Place the notch in the top right-hand corner; the emulsion is now facing you. Carefully feel for the raised edge of the foam back of the contact printer in the top right corner. Place the film sheet emulsion-side-up in this corner, so that both its top edge and outer edge are

aligned with the foam back. Now take the transparencies to be duplicated and align the top edge with the top outer edge of the sheet film. The transparencies should also be emulsion-side-up. Carefully close the glass cover of the printer. Make the 5-second exposure. Open the glass cover and remove the exposed film sheet and place it in the light-tight box. As soon as you have prepared the chemistry, process the sheet of film. Dishes or tanks can be used for this purpose as described in Chapter 2. If you plan to make a regular habit of processing 5x4in sheet film, a tank designed for the job is a good investment. Sheet film can be processed in a cylindrical tank, but with some difficulty, although Jobo do make a 5x4in sheet film loader for their tank spirals.

Once you have developed the first sheet of film following the chemistry instructions to the letter, you will be able to see exactly where, if at all, any errors have been made. These are most likely to be in the exposure, which is why it is important to choose an original transparency of normal brightness and fairly low contrast. First results from this will provide a duplicate master from which subsequent exposures can be adjusted. To make enlarged duplicates, first strip the original of any mount, clean by dusting with a squirrel-hair brush or compressed air. Tetenal Film Cleaner cleans off fungus or mould and inhibits its return. Carbon tetrachloride (CT) may also be used, but is now difficult to obtain over-the-counter. Hairdressing suppliers can usually supply CT in larger quantities. It is not advisable to touch the emulsion side of the slide, unless this is so badly marked and dirty that it cannot be duplicated without cleaning. When you have wiped over the back of the slide with CT, polish it gently with a clean area of cloth and then dust off loose matter. Flick the edge of the slide with a fingernail to discharge any static electricity. Now place the slide emulsion-side-down in the enlarger negative carrier. Make sure the CP2B filter is inserted in the filter drawer.

Normally, I make whole frame 5x4in dupes from the original, but I have also used a 6x9cm roll film back containing Ektachrome

Speed. Original was shot on Ektachrome 200 with an 80-200mm zoom Nikkor. Duplicates were then made to increase contrast and delete some shadow detail.

120 Tungsten film to make acceptable duplicates. The roll film back is fitted into a jig made up with small aluminium brackets on a sheet of plywood. This mounted back is held in position on the enlarger baseboard by using a pair of small wood-working clamps. When you make up the jig, remember that the end of the back into which the dark slide is inserted must be kept free. The slide has to be removed and replaced before and after each exposure. Any removable film back, for cameras such as Hassleblad or Bronica, can be utilized in the same way.

Load the film into the back in the normal way. Wind on a couple of turns, but not as far as the arrow markers on the film backing paper. Before closing the back cut a thin sheet of white paper 6x9cm (or 6x6) and attach it to the black backing of the loaded film where it will close inside the frame aperture. Close the film back and mount in the jig. Using a safelight only for general illumination, position the back on its mount exactly where required under the light beam. Size and focus the original on to the white sheet of paper in the film back. When you are happy with position and focus, gently remove the film back from the jig and wind on the film to its arrow marker position in the normal way. Now insert the dark slide and wind on to the first frame. Reposition the back in the jig and begin making exposures as soon as you are ready.

Using a 5x4in double dark slide film holder, the process is much simplified. First, in total darkness, load up as many sheets of film as you think will be required for a duplicating session. Keep one side of one holder empty and mark the side with a piece of coloured adhesive tape so that you know exactly where it is. Into this side, place a sheet of white paper of approximate film thickness cut to size. This is used as a printing frame to crop and accurately focus the original transparency. The dark slide should always be inserted after use; it keeps the paper clean and ensures that the slide does not get lost or scratched.

A special jig is not required for this process, though individuals may prefer working with one. A normal printing easel is quite sufficient, the two adjustable arms being used to keep the film holder in place. When exposures are being made, short lengths of masking tape are useful to fix the film holder more securely in place. From here on, the procedure is much the same as one might use for making prints from slides.

Crop and focus on the plain white sheet held in the marked holder. When you are satisfied, remove the focus film holder and insert a loaded double dark slide holder into the printing frame. Tape in place if necessary. Extinguish all lights, check for light-emitting diodes and other stray lights. Remove the dark slide and make the exposure. Replace the dark slide and mark the exposed side by placing a short length of masking tape over the centre of the slide. Continue making exposures as required.

If you are using tungsten-balanced film, you will find the exposures required for satisfactory density and contrast level in the duplicates are much shorter than for Ektachrome 6121 duplicating film which has an average time of 10 seconds. Shorter times may be required for contact duplicates. When making enlarged duplicates using tungsten-balanced film, start at 2 seconds with an f-stop of f11. An out-of-focus panchromatic mask is not normally required for 6121 film but, if contrast seems a little on the high side when duplicating without a mask, increase exposure marginally and cut the first development time. Start with an increase of half a stop and reduce the first development by 10 per cent. A similar procedure can be used with tungsten film, only more exposure and less first development may be required in some instances.

CONTRAST MASKS

The use of duplicating film may obviate the need for a contrast mask. However, normal to high contrast subjects on original material may duplicate more satisfactorily if a mask is used. The mask is made using high-speed panchromatic film: Tri-X or HP5 Plus are both suitable for this purpose. A wooden contact printing frame is the most suitable carrier for

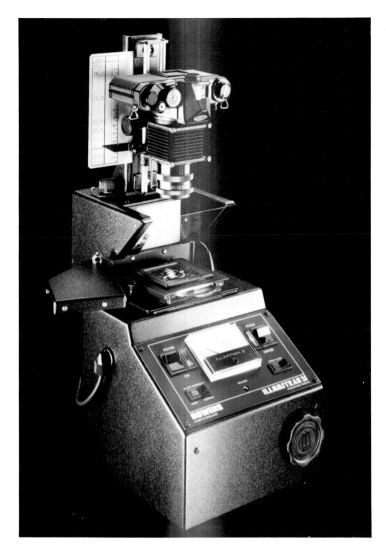

A professional duplicating machine such as the Bowens Illumitran means that contrast and filtration can easily be controlled.

place the sandwich, transparency at the top, under the frame. Make several exposures using different sheets of film and process normally in Kodak DK 50 diluted 1 + 2 for 4 minutes at 20°C (68°F).

The spacer provides a degree of unsharpness on the mask, but this in itself is often not sufficient and use should be made of a point source light of low wattage to expose the film. The light source should be at a distance of at least 4ft (1.2m) from the print frame. Alternatively, an enlarger source may be used if the light beam can be diffused by employing a sheet of etched plastic or opal glass. Ideally, masks should be developed to a *gamma* of about 0.7, but it will pay to make several exposures giving the same development in order to find the most suitable contrast.

Once you have selected a suitable mask, this must be registered with the original. This task is easily accomplished over a light-box with the aid of a high-powered optical magnifier. It should be easy to see where the original and mask are out of register. Once aligned, tape the two together and sandwich between two optical flats (pieces of glass). If a glass negative carrier is used, the sandwich will not be necessary and some newer enlargers, like the Durst, have a pin registration system in the negative carrier which is ideally suited for this purpose as well as for making montages.

Duplicating from low-contrast originals will normally produce very acceptable results using tungsten-balanced film of 50 ISO. Ektachrome 160 Tungsten is a trifle too contrasty for this purpose, although there will be subjects from time to time which will benefit from the increased contrast and apparent colour saturation this emulsion provides. The same principles apply in making copy transparencies from original flat colour prints or artwork. Begin by using the lowest ISO rated film rather than the highest. If necessary, increase exposure and reduce the first development by 30 seconds when using Ektachrome 160. The same procedure applies when using this material to make enlarged duplicate transparencies.

this purpose, but is not essential if you have an ordinary print-contacting frame.

Place the mask film material emulsion-side-up on a clean, flat surface. On top of this place a glass spacer. An old glass negative plate is ideal. This must first have the emulsion washed off, which is simply done by immersing the plate for a few minutes in warm water. Wash and dip in a solution of photo-flo and hang to dry. You will then have a clear piece of optically flat glass for the spacer.

When the spacer is positioned, place the original transparency on top of the spacer, emulsion-side-down. Make sure the glass cover of the printing frame is cleaned and

Duplication of 35mm originals to larger formats is usually only successful if the original is sharp and not too contrasty. This reproduction is from a 5x4in duplicate made on Ektachrome Type B sheet film. In cases where the original is valuable and unlikely ever to be repeated, duplicates should be made.

Of the many photographic processes available to the enthusiast, duplication is one of the easiest and possibly one of the most interesting.

Film and processing instructions followed to the letter may produce perfect results, but these may not always be the ones required. Keeping this in mind, there is plenty of scope here for experimentation using the simplest of materials.

FAULTS

The following is a list of faults which may become apparent after processing using Photocolor chemistry.

TRANSPARENCY PROCESS

Fault
Entire film black, no frame markings.
Cause
First developer oxidized or exhausted; colour developer and first developer used in the wrong order.

Fault
Transparencies appear black, with little or no image, frame numbers on film rebate appear to be normal.
Cause
Severe under-exposure in-camera; faulty shutter; film not transported through camera; faulty flash synchronization, etc.

Fault
Entire film, including film rebates transparent; little or no image.
Cause
Little or no colour development; chemistry oxidized or exhausted; film fogged by accidental exposure to light, as when camera back opened before film rewound.

Fault
Dark or light band entire length of one edge of film.
Cause
Insufficient coverage by solutions at one or all stages of processing; it may be possible to remedy this by repeating the blix stage if the film is properly developed.

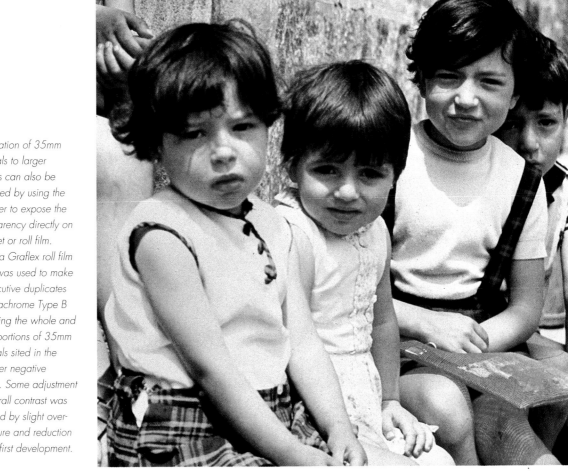

Duplication of 35mm originals to larger formats can also be achieved by using the enlarger to expose the transparency directly on to sheet or roll film. Here, a Graflex roll film back was used to make consecutive duplicates on Ektachrome Type B film using the whole and small portions of 35mm originals sited in the enlarger negative carrier. Some adjustment to overall contrast was effected by slight over-exposure and reduction of the first development.

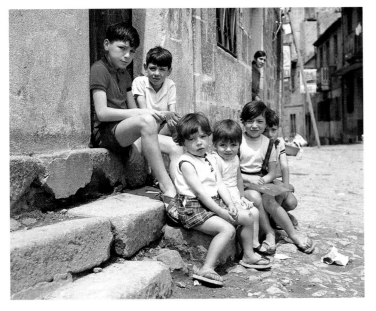

Fault

Very dense transparencies with blue/purple cast; exposed end of leader blue.

Cause

First developer severely exhausted and/or oxidized.

Fault

Transparencies too light, otherwise film normal.

Cause

Film over-exposed in camera; too much first development; wrong time/temperature; film force-processed inadvertently.

Fault

Mottled veil-like appearance; film leader grey.

Cause

Blix process incomplete; repeat blix with fresh solution and rewash.

167

Fault

Low density and contrast. Colour saturation is poor.

Cause

Insufficient colour developer; wrong time/temperature; oxidized/exhausted colour developer.

Fault

Dense transparencies, but edges and leader are normal.

Cause

Under-exposure; insufficient first development; time and/or temperature incorrect; exhausted first developer; no account of increased time necessary when employing used chemistry.

Fault

Shadow areas and frame divisions have low density with red/brown cast.

Cause

Colour developer exhausted/oxidized or made with insufficient Solution B.

Fault

Unprocessed areas of film, irregular patches.

Cause

Film not properly spooled; doubled up on some grooves, causing film to stick together at some points.

Fault

Small black spots, irregular pattern.

Cause

Air bubbles on emulsion during first development; remember to tap tank on bench top during first few seconds of first development; vigorous agitation required initially .

PRINTS FROM SLIDES

Fault

Prints too dark, no contrast.

Cause

Oxidized first developer.

Fault

Have poor blue blacks, colours washed out.

Cause

Oxidized colour developer.

Fault

Prints with greenish-grey blacks, contrast low, colours poor.

Cause

First developer contaminated with colour developer.

Fault

Prints with green blacks, low contrast, poor colours and yellow cast.

Cause

First developer contaminated with blix.

Fault

Prints with blue blacks, low contrast, poor colours and orange cast.

Cause

Colour developer contaminated with first developer.

Fault

Prints with blue or violet-blue blacks, severely degraded colours and strong overall blue or violet-blue cast.

Cause

Colour developer contaminated by blix.

COLOUR PRINTS FROM NEGATIVES

Fault

Streaks or uneven marks green and/or pink in colour from drum-processed prints.

Cause

Liquid retained in drum or lid which runs across dry paper.

Fault

Blue stain or fogged borders and highlights.

Cause

Contamination of the developer with blix; pre-heat water too hot; check that safelight is the correct type; possible over-exposure to safelight.

Fault

Yellow or orange streaks or patches at corners and edges of paper.

Cause

Stray light causing paper to fog while in partially opened packet; check darkroom for source.

Fault

Under-developed areas on corners and edges of print (white or pale areas).

Cause

Print not fully immersed in developer.

Fault

Red or yellow scratch marks.

Cause

Abrasion of wet emulsion surface.

Fault

Finger marks.

Cause

Paper handled with damp, contaminated fingers; wash and dry well under air dryer.

Fault

Prints too contrasty, possibly with a yellow cast.

Cause

Over-development; contamination of pre-heat water with blix.

Fault

Prints contrasty, possibly with violet cast, blue stain on borders and in highlights.

Cause

Developer contamination with blix.

CROSS-CONTAMINATION OF SOLUTIONS

The effect on film will depend largely on the degree of contamination. Severe contamination will produce low-density edges and pronounced colour casts.

Fault

Colour developer contaminated with blix.

Result

Severe cyan cast.

Fault

First developer contaminated with colour developer.

Result

Loss of density in shadows and unexposed areas of film. Marked colour changes.

Fault

First developer contaminated with bleach-fix.

Result

General appearance of over-exposure; cyan/green cast, loss of image density, green edges to film.

Fault

Colour developer contaminated with first developer.

Result

Strong green or yellow/green cast.

LIGHTING CASTS

Emulsions balanced for daylight will give strong yellow/orange casts when exposed under tungsten lighting and greenish casts when exposed under fluorescent light. Use a magenta filter to remove green (fluorescent light). Emulsions balanced for tungsten light give blue casts when exposed under daylight conditions. Use the correct conversion filter.

All of these possible faults and remedies apply equally when making duplicate transparencies from originals using E-6 chemistry. The biggest cause of all problems is usually cross-contamination of solutions. Wash out and dry tanks thoroughly before starting a fresh process. Where possible, use more than one thermometer and keep the same containers for use with the same chemicals. **Always** wash hands after immersing them in one solution.

POLAROID PHOTOGRAPHY

Standing by the roadside with a bucket in one hand and a half-cleared negative in its stainless cut film holder in the other, I began to ponder on the marvels of modern photographic technology, simultaneously wondering whether Fox Talbot had felt any of the emotion I was now experiencing as he carefully developed the wet collodion plates he had just exposed in a mobile field darkroom. I hoped that he had, reflecting ironically that, after nearly twenty years of freelancing in photo-journalism, I had at last found a process that made me feel the kind of things I had always thought conventional photography should have made me feel but never had. It has always seemed to me that the actual process of conventional development and print making was somehow not connected psychologically with the art of picture making.

The artist can watch a picture of his subject appear slowly in front of his eyes while viewing that same subject. The photographer is compelled to commit the picture to memory until such time as the exposed image can be developed in another place at another time. It is a procedure I often find a trifle frustrating. Combined with the anti-climax on discovering some time later that the developed pictures are not what one had either hoped for or expected, this has affected the way I have thought about image-making for some time.

Perhaps I should explain. I had been investigating the various possibilities of conventional colour emulsions and how they could be manipulated to achieve a particular effect. Much had been written in the trade press with regard to manipulative processes to produce results that were far removed from those intended by the companies which had spent years perfecting those emulsions. I liked the ideas, but not the results. What I really wanted was a process that would give me a colour more suited to the very intangible ideas I had been nursing.

To this end, I had purchased a plastic Polaroid 1000 camera on the simple theory that instant photography was something I had never seriously dabbled in, nor had any need for. In fact, in the past, viewing the results of Polaroid Instant colour had only confirmed my suspicions about the apparently awful quality of colours reproduced. But, armed with a pack of SX70 colour film, I began making a few simple exposures. A pillar-box red garden swing on a green lawn had caught my eye.

Not knowing precisely how the film was balanced (except for daylight) I could not have known how it would react to the bright backlighting of a cold December morning. The first print was rushed indoors and held over a radiator for the recommended developing period: the print developed with a ghastly blue cast over everything. My bright pillar-box red was a soggy pink and the green lawn had turned to sea water.

What if the film, like conventional reversal materials, was balanced for a very high

This is a magnified image of part of one eye, and clearly shows the linear colour grid which at normal 10 x magnification in print form is not noticeable.

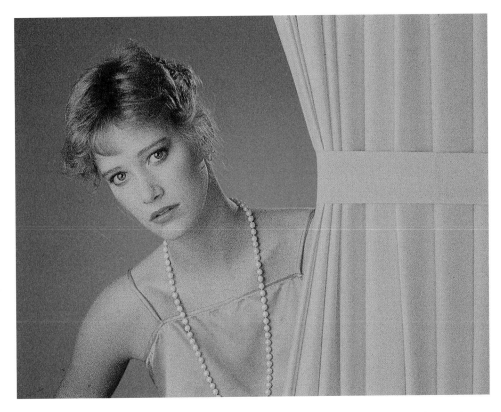

Polaroid film has long been used by many professionals as a medium for checking exposure and colour balance, set design and picture composition, before the final picture is committed to conventional emulsions. But Polaroid materials have their very own distinctive character and, in some instances, use of these emulsions might be better suited to the end product requirement than conventional materials. Polachrome, which is available in 35mm format only, uses the additive linear grid screen to form colours, which when properly exposed give brilliantly saturated results. Notice that in this photograph, no large white areas are visible adjacent to other colours. This is a key to the successful use of the material. (By kind permission of Polaroid [UK] Ltd.)

Kelvin value? Any cast resulting from the actual colour of the light would be far more pronounced on a print than on a transparency. For the next exposure, I positioned a pale amber 81C filter over the lens and fired the magic button. The result was much better. There was a very pronounced improvement in both reds and greens, but I could have done better with a more powerful filter, which was not available. Yet, in spite of the simple nature of my new toy, Polaroid had stimulated my imagination and given me a renewed interest in many other photographic techniques I had long since forgotten.

And that, more or less, is how I came to be standing by the roadside holding a bucket in one hand and wet negative in the other. The gallon plastic bucket contained a dilute working solution of sodium sulphite, mixed earlier in the darkroom from 500g of anhydrous salts. This mixture was essential for the proper clearing of the negative I hoped to get from the Polaroid 665 black-and-white positive-negative film exposed in the Hasselblad. Unable to obtain sodium sulphite the day

before, I had used plain water in my impatience to try out a few exposures. It certainly cleared the opaque backing from the emulsion, but prolonged overnight storage in the water had softened the emulsion so much that the negatives scratched too easily.

The beauty of this emulsion is that it provides the photographer with a usable negative, one from which prints can be made on conventional papers, in addition to a print, straight out of the camera. The type 665 Positive/Negative film is a film pack with an ISO of 75 and a development time of 30 seconds under ideal temperature conditions. However, it is not quite the plain sailing one might imagine, and how the film is exposed depends very much on the ultimate requirement.

In order to produce a fully exposed and developed negative, I found that the rated speed of the film was a trifle optimistic, especially when used outside in low temperatures. My first efforts were grossly underexposed, so I kept reducing the effective ISO until I had reached a point where the prints

were over-exposed by a full stop after development. Type 55 film has a rated ISO of 50, but this also needs considerable reduction in the field in cold conditions. Further, in both types, you will find the print material a little faster than the negative, a difference of probably EI 20.

Working in the open like this requires a little ingenuity in maintaining a fairly high temperature level for processing. I had been running the car for a while, so the radiator was quite warm. By holding the exposed film pack close to its surface, I was able to keep development within 90 seconds. The alternative would have been an 'under-the-arm' job, which I did not relish because of the risk of damaging both print and negative, or a portable heater of some description. An empty biscuit tin inverted over the car radiator and in which the film was held during the development time might have been more reliable.

You can use plain filtered water to remove the opaque backing from the negative but, as I found in my impatience, this produces a rather soggy negative from which not all of the developing agent is removed and which is easily scratched or abraded. It is better to have the right chemicals in the first place. The negative will clear after a few minutes of rapid agitation. To harden the negative, prepare a solution of 28 per cent acetic acid by mixing 250ml with 500ml of water at 21°C (70°F). Add to this solution 16g of potassium alum and top up the mix with water to make 1 litre. Immerse with gentle agitation for about 2 minutes in this solution. A thorough wash is then required before dipping in photo-flo solution and drying. The wash should be in running water for not less than 20 minutes.

The emulsion thickness of Polaroid negative material is very much less than conventional Estar-based sheet films, which makes it very floppy and prone to the slightest possibility of accidental damage. If you value your negatives, make sure that they are placed in a glassine bag as soon as they are dry.

Out in the field, negatives can be kept in a sodium sulphite solution for a period of up to 72 hours if it is not possible to return immediately to base, where running water and drying

facilities are available. The industrious photographer will no doubt arrange for a field kit to be made up which can be easily transported in the boot of a vehicle; one can- not travel far or very fast with buckets of solution slopping about.

Polaroid used to manufacture a field kit which comprised a plastic bucket with sealed lid and space on a rack for several negatives. These units are no longer available, but it may be possible to track one down through the classified columns of a trade magazine. The company also supplies sachets of pre-measured anhydrous sodium sulphite for mixing small quantities of the solution.

Polachrome must be used under carefully controlled conditions. It does not like harsh, contrasty general scenes or ultra-violet light. Large areas of white or near-white in close proximity to strong colours tend to reduce the colour effect.

Using the 'O and ER' Express enlarging easel under a conventional enlarger it is possible to make direct colour prints on to Polaroid materials, or to make black-and-white negatives and/or prints. This equipment is manufactured in the United States by Optical and Electronic Research Inc., and is available in the UK from distributors George Elliott. (Photo by kind permission of Optical and Electronic Research Inc.)

The Polaroid back for use on the Hasselblad has an optical flat over the frame aperture, and it is essential that this be cleaned before a film pack is inserted for use. Any foreign matter on the glass will show up as black specks on the negative when it is developed. Quite a number of medium-format cameras are available with off-the-shelf polaroid backs: apart from the Hasselblad just mentioned, the Kowa Super 66, (discontinued but still widely used); most Bronica, Mamiya and Rollei medium-format SLRs all offer a Polaroid facility.

A Polaroid back available for the Nikon F2, F3, and F4 is made by Marty Forscher of New York. It has a special fibre-optic block which allows the image at the normal film plane of the camera to be carried back to that of the Polaroid back. In addition, the back has a facility for exposing two frames independently on the same sheet of film. Naturally, because this piece of equipment is produced in fairly limited quantities, it is expensive and would hardly be considered as anything other than a professional aid to better pictures. If you want to know exactly what that 2,000mm lens is going to put on the frame before you shoot the Kodachrome, a Polaroid back could prove invaluable.

This is exactly what many professionals using larger formats use their Polaroid backs for: to check exposures, to check the studio set, to check the ability of a certain lens to produce the right result. But, for me, instant photography does not end here. It is just a beginning, and with a great deal of help from Polaroid (UK) Ltd I have been able to explore just a few of the possibilities.

One development to come from the Cambridge, Massachusetts, Corporation was the introduction of a range of 35mm emulsions in both colour and black-and-white. Polachrome, Polapan and Polagraph are all compatible with any camera employing the 35mm format, are packaged in distinctive white labelled cassettes with swaged-over end caps. The manufacturer thoughtfully provides an ingenious tin-plate device for extracting leaders which have been inadvertently wound-in after exposure. This device comes with the 'Darkroom in a Box', which provides all the equipment one needs to process a film within minutes of its exposure. Fox Talbot would have loved it and I cannot imagine anyone who has used the system who would not feel similarly disposed.

Each film is provided with its own cartridge of processing chemical which is released from a pod in the cartridge and is transferred to a 'vehicle' film of thin polyester sheet and mated with the exposed film via a set of lightly sprung rollers. Both cartridge and film are easily inserted into the magic 'box' and anchored on to a take-up drum. The box is closed and, by depressing a lever, the caustic jelly-like developing agent is released from its capsule inside the cartridge ready to be carried to mate with the exposed film on the 'vehicle'. A few quick turns of the winding

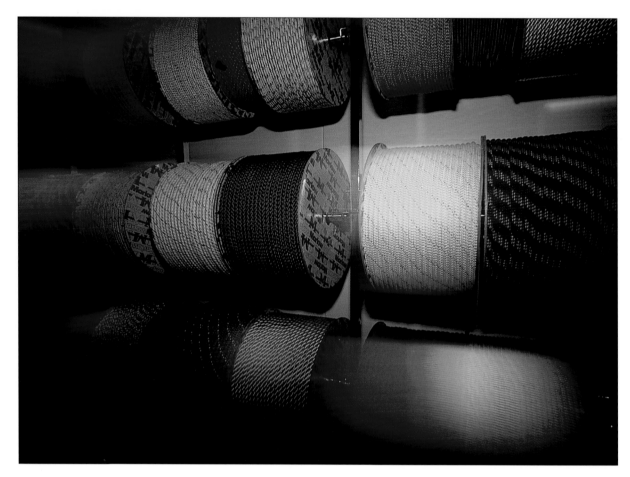

handle (there is also a motorised version) pulls the film and vehicle out of their respective cassettes and winds them on to the drum. After the relevant number of seconds has elapsed, development is complete, the lever released and each film wound back into cassette and cartridge. On opening the box, both vehicle film and exposed film are detached from the drum. Discard the developing cartridge. Over a light-box, gently pull out the processed film for inspection, et voilà!

POLACHROME

I have no 'formal' training in photography or art, but my instinct seems to tell me what is worth a second look. Black-and-white has been the mainstay of my photographic career, probably mainly because the end product fits most easily with my feelings for art, nostalgia,

adventure, human endeavour and the impact of disaster. Communicating any of those feelings through photography to the viewer is somehow easier without the complication of colour.

Colour in the conventional photographic form lacks immediacy. No matter what the subject, it is rarely capable of giving the viewer a sharp smack between the eyes which says, 'Wake up, look at me; I am doing something which should affect your senses.' Colour in photography has got to make me feel the same kind of things I feel when I look at a painting; admiration for the person who painted it because of the technique used; a feeling of the whole being acceptably right because subject and composition have been well chosen and balanced on the canvas in a way that my brain can easily digest; a feeling that the actual coloured pigments used are not artificial but closer to those created by nature.

Two examples of how a fairly ordinary Polaroid snapshot camera using 600 type film can be utilized to produce excellent quality on-the-spot portraits; 600 film needs to be used with electronic flash for really effective results. The original prints were copied on to tungsten film, which increased the contrast slightly.

By accident more than design, I have found a colour emulsion that makes me feel some of these things, even if there is room for mechanical improvement in the way in which that colour is reproduced on the emulsion. A good eye can easily pick out the filter rulings (see illustration on page 170) without the aid of a Lupe, though in web-offset reproduction the effect is largely lost in the screening process (see illustration below). Polachrome has the ability to render most colours in a highly saturated form. Reds, orange, blues, browns, blacks, yellows and pinks are rich, vividly bright. It definitely does not like the presence of ultra-violet light, nor subjects which reflect white or near-white. It has a low ISO (40) and very little latitude in exposure, having characteristics similar to the original Kodachrome where exposure was critical. Ambient temperature makes no apparent difference to either contrast or colour rendering when exposures are being made, but development temperature must be within the range recommended by the manufacturer. Best results are obtained at 21°C (70°F).

What are rulings? Polachrome colours are achieved by the additive process of combining very fine rulings of the three 'additive' primary colours, red, green and blue, in a grid pattern layed over the emulsion. When viewed by a very strong white light, the combining effect of minute specks of these colours on the eye and brain is such that we see colours of the image in much the same way as when looking at the printed colour picture on a page. Colour television works on the same principle. When viewed against a point source light with a magnifying glass, Polachrome transparencies appear to defract the light into its spectral sources and this gives a very clear indication of how the additive screen process works.

Polachrome is certainly unique, even if its development is somewhat loosely based on the findings of a certain Dr John Joly of Dublin who, as far back as 1893, had devised a

In a conventional darkroom, negatives are washed and dried and can then be printed in the normal way on bromide or RC papers. The first picture shows the full negative area. The second is a print on original Polaroid material. The third is a print on conventional resin-coated paper.

three-colour linear-ruled plate. Louis Dufay also produced an additive-based colour motion picture film in the nineteen-thirties known as Dufaycolor. There was also a Dufaycolor reversal processed still format film, which sank into oblivion when Godowsky and Mannes produced the first subtractive-based Kodachrome.

Polachrome's main attraction for me is its richness of colour and, when transparencies are viewed on a white beaded screen with the full power of a projector bulb, those colours are stunning. There is little evidence of the

'television' type line effect. From colour prints produced with an 8x10in Polaprinter using Polachrome originals, the richness of colour is retained, but because prints are viewed by reflected light, some of the original transparency brilliance is lost. In reproduction, I imagine that the finest mechanical processes available would produce impeccable results.

I am not certain, however, that what I have seen in the way of printed reproductions using standard web-offset printing, such as is used for the printing of many of the world's magazines, is capable of doing the product

justice. I shall be as interested as the reader to see just how well or indifferently the illustrations in this chapter have fared in the photo-mechanical process.

Because of the fragile nature of 35mm Polaroid it is important to observe one or two conventions. When developed film is extracted from the cassette, scratches and abrasions are more easily avoided if the film is pulled with one felt flap against the anti-halation backing. Hold the cassette in the right hand so that the exit gate of the cassette is turned slightly upward from the horizontal; pull the film in a downward fashion against the lower felt pad. Use the special cutter/ mounter first of all to mount processed transparencies before viewing. This helps to avoid unnecessary scratches caused by a Lupe being held on the metallic silver image. Use masking or transparent adhesive tape to remove ragged edges of the black developer layer which is not completely separated from the film during processing. Lay the processed film emulsion-side-up on a cleaned light box. Place adhesive tape on the film edge and, while holding one end of the processed film securely, rapidly peel off the tape. The black layer will come away easily and cause no damage to the film base or exposed frames. An excessive amount of developer layer remaining on the processed film is usually caused by not rewinding the film fast enough after the development time has elapsed.

The 'Darkroom in a Box' is small, lightweight and could be taken on any assignment into the field where transportation is available or, for that matter, in a backpack. Aviation specialist Richard Cooke has used Polachrome successfully while airborne to establish formation patterns while working with acrobatic teams. Polachrome gives more or less instant access to information, often much needed by the roving photo-journalist, and I think I would be wary now of going off on a major project without having a few rolls of film and the processor handy.

A Polaroid film pack back for medium-format work and the Polaroid 405 back for use with the 5x4in format have established themselves in my camera cases as standard equip-

ment. Use of the various materials available has already helped to broaden the scope of my photography and encouraged me to attempt assignments I probably would have found dull or uninteresting before because I did not have the means or access to an instant result.

POLAROID MATERIALS AND EQUIPMENT

Listed in Table 18 are the main specifications of the three 35mm format emulsions available, followed by a general list of materials

The colours in this photo are greatly enhanced by the use of a strong daylight source which was focused to backlight the utensils in the pot. Polachrome colours lend themselves to creative advertising work.

Polachrome's best asset is its ability to reproduce vibrant and brilliantly saturated colours. In the example above, which was processed normally using the Polachrome pod, exposure was made using daylight and fill-in reflectors.

Film pack producing instantly processed highly saturated colour prints are available for SX70 and 600 series polaroid cameras. These two are reproduced from original prints copied to Ektachrome type B reversal film

and equipment produced by the Polaroid Corporation.

FILMS

Polaroid instant films are available in six formats. They may be used in a variety of Polaroid film holders sold through professional photographic dealers, or in Polaroid camera backs sold by over 150 other manufacturers of photographic and scientific equipment.

8x10in Individual positive sheets and negatives, 15 to a box. For use with 8x10in view cameras, graphic arts reproduction cameras, computer graphic cameras, etc. There are two colour films, including Polacolor type 809, Polacolor type 891, Colorgraph 891 for over-

head projection quality transparencies. Other films include Polaroid 803 black-and-white medium-contrast print film (800 ISO), Polapan 100 black and white medium-contrast (100 ISO) and Polaroid TPX negative transparency.

4x5in Individual film packets, 20 to a box. For use with 4x5in cameras and instruments which accept Polaroid's Model 545 film holder. There are nine film types: Polacolour PRO 100 in silk and gloss finish; type 59 (ISO 80) medium/high-contrast colour; Polacolour PRO type 64 especially balanced for tungsten light; black-and-white; type 57 High Speed Film ISO 3000; type 55 Positive/Negative ISO 50; Polapan type 52 ISO 400; type 51 High

Polaroid High Definition slide film (E-6 compatible) exhibits superb quality in capturing the brilliance of well-lit colours, while retaining detail in the whites.

Contrast ISO 320 daylight/l2s tungsten; type 53 ISO 800; Polapan 100 ISO 100 (both medium-contrast) and type 57 ISO 3000 medium/high-contrast.

Polaroid Professional Chrome, balanced for Daylight and Tungsten (ISO 100 and ISO 64) is a single shot E-6 compatible film packaged in its own dark slide envelope in the same way as other Polaroid products suitable for use in the 545 back. Characteristics are very similar to those of Fuji RDP 100. Photographers already equipped with these backs will find this film very useful as it can be shot alongside proofing shots in the same back. Conventional dark slide backs are not usable with this stock.

4x5in Eight-exposure film pack. For use with 4x5in cameras and instruments that accept Polaroid's Model 550 film holder. There are four film types including Polacolor ER type 559 ISO 80, Polapan type 552 ISO 400, and two medium-contrast films, types 553 and 554 of ISO 800 and 100 respectively for black-and-white. 3.25x4.25in series 100 or 600 professional film, eight-exposure film pack; for use with cameras and instruments equipped with Model CB10l or CB102 camera backs or 4x5in cameras and instruments that accept the Model 40s film holder; also for use with Polaroid 3.25x4.25in pack film format cameras. There are nine film types including Polacolor ER type 669 and Polacolor type 691 (for overhead transparencies), both with ISO 80. Recently added to this range were Polacolor PRO 100 print film and Polacolor 64 Tungsten. There are five instant black-and-white films, including type 667 High Speed ISO 3000; type 665 Positive/Negative Film ISO 70; type 612 Ultra High Speed Instrument Recording Film ISO 20,000, type 611 Video Image Recording Film and Polapan 100 High Speed CRT Recording Film ISO 3000. The general purpose high-speed print film (ISO 3000) has medium to high contrast. A recent introduction to this range is the Polaroid Sepia, which gives a 'vintage' look to portraits (ISO 200).

3.25x4.25in Eight-exposure film rolls. For use with cameras and instruments equipped with CB40 camera backs (no longer manufactured). Also for Polaroid 3.25x 4.25in roll film format cameras (no longer manufactured).

3x3in Series 80 film. Eight-exposure film pack. For use with cameras and instruments equipped with the Model CB80 camera back; also for use with Polaroid 3.24x4.25in pack-film format cameras.

SX-70 Ten-exposure film pack. For use with cameras and instruments equipped with the CB71 camera back; also for use with Polaroid cameras that accept SX-70 film.

Other types of Polaroid film include the Polaroid Image, 600 Plus and Polaroid Vision 95 films for a whole range of instant cameras. These films use Hybrid 4 chemistry and exhibit sharper images with amazingly rich colours when exposed properly. This film also has very fine grain qualities which permit excellent reproductions and enlargements to be made from originals.

CAMERAS AND SLIDE PRINTERS

A complete range of products is available from the Polaroid Corporation in Cambridge, Massachusetts, and from Polaroid (UK) Ltd in St Albans, Hertfordshire. In addition to a range of automatic instant cameras, Polaroid markets the Polaroid 600 and 600SE cameras. These two cameras are based on the Mamiya Universal Press camera; lenses for both models are made by Mamiya, as is, I suspect, the rest of the camera. The 600SE has interchangeable lenses with a full range of shutter speeds from B and 1 second to 1/500 second. The camera accepts an interchangeable Polaroid film back. The 600 model has a fixed 127mm lens with the same shutter speeds as the 600SE. The film back is interchangeable and both cameras accept 665, 107C and type 108 film packs. Another interesting piece of equipment is the Polaprinter 8x10 Instant Slide Printer which is used for making prints from slides, either full frame or cropped on Polacolor ER type 809 film. The printer can also be used for making overhead projection transparencies from original or duplicate

Printing slides from Polachrome or conventional transparencies using Polaroid print materials requires more skill than normal because of the inherently low brightness range of the material. The original shot on Fujichrome (left) produces an acceptable print using the 8x10 Polaprinter technique, but with marked loss of greens, reds and shadow detail. Low-contrast originals will make better prints. Right: nearly all texture detail in the suit of HRH Princess Michael of Kent has had to be sacrificed in order to retain detail in the hair and visage.

35mm transparencies on Polaroid Colorgraph type 891 film.

The Polaprinter 8x10 System consists of the Polaprinter Model 3580 for previewing the slide and making the exposure, the Polaroid 8x10in film holder, the loading tray and the Polaroid universal 8x10in film processor. The system is powered by a 220/240 volt AC power source and can be used in normal room lighting. The Polaprinter slide printer is a much smaller version of the 8x10in Polaprinter and is

designed primarily for making instant prints from 35mm slides in black-and-white or colour using standard 3.25x4.25in film packs. Slides are previewed on the built-in editing screen, and contrast and exposure controls are adjustable. Vivitar and Hanimex also manufacture and market an instant slide printer which utilizes Polaroid materials. Both of these machines are ideal for the photographer interested in providing a rapid proofing service to customers in a hurry. Picture libraries who need

to supply potential clients with a good positive image of the original slide, and anyone with a large collection of black-and-white or colour slide originals who needs to keep a handy record of important work to hand for easy viewing will find the Polaprinter invaluable.

NEW DEVELOPMENTS

Polaroid are constantly working on improvements and new inventions in instant photography. When the late Dr Edwin H. Land retired in 1982, he held more than 500 patents. Critics of the first Polaroid instant black-and-white film launched in 1947 firmly believed that Land's attempts to create a professional quality film capable of instant development would not only fail but would never capture the public imagination.

Polaroid's instant range of 35mm emulsions has been extended to include two new 35mm formats: Polablue and Polalith. There has also been an interesting departure into the realms of conventional silver-image photography with the introduction of a new professional-quality colour reversal material in sheet form (see above) which is processed in E-6 chemistry. The new Polachrome is made by Fuji and is packed in individual sheets for use in 5/4 Polaroid backs.

A new fully automated autoprocessor for the 35mm emulsions, an illuminated slide mounter and viewer and a palette for use in conjunction with desk-top computers have been other developments. This device enables screen graphics to be photographed directly on to 35mm formats for the production of audio-visual slides. Polaroid's demonstration of the then new Polacolor process in 1960 was a unique and outstanding contribution to modern photography, and probably the most significant advance in photographic science that this century has seen until the more recent introduction of Kodak's CD image system. Early peel apart, instant pictures have steadily improved in quality to a point where, now, there cannot be much further to go. As the popularity of 35mm instant photography grows, so too will the demands for improved quality and faster ISO speeds. With this in mind, Polaroid developed their own software and hardware for desk-top electronic imaging where images are produced digitally, manipulated on screen then copied to conventional polaroid materials for overhead transparency projection, instant print or conventional silver halide film emulsions which the company has been marketing for several years.

These 35mm format emulsions comprise a range of high-definition colour negative and E-6 compatible chrome film ranging in ISO speeds from 100, through 200 to 400. Just prior to the launch of this film, I was involved with Polaroid (UK) Ltd in testing the various emulsions. They display excellent colour saturation and sharpness throughout the ISO range and I have long since been a user of Polaroid slide film for a wide variety of subjects.

TABLE 19: CHARACTERISTICS OF POLAROID EMULSIONS

CHARACTERISTICS	POLACHROME CS (COLOUR TRANSPARENCY FILM)	POLAPAN CT (CONTINUOUS TONE BLACK-AND-WHITE TRANSPARENCY FILM)	POLAGRAPH HC (HIGH-CONTRAST TRANSPARENCY FILM)
Balance	daylight	panchromatic	panchromatic
Speed: ISO	40	125	400
Exposure latitude	+$1\frac{1}{2}$ stop	±1 stop	±$\frac{1}{3}$ stop
Reciprocity behaviour:			
1-second exposure	+$\frac{2}{3}$ stop	+$\frac{2}{3}$ stop	+$\frac{2}{3}$ stop
10-second exposure	+1 stop	+1 stop	+1 stop
Contrast (gamma)	2.0	2.0	4.0
Emulsion resolution			
(lines pairs/mm)	90	90	90
Grain	medium	fine	fine
Colour fidelity	high	—	—
Colour saturation	high	—	—
Processing time*	5 minutes	5 minutes	5 minutes
Developing time	60 seconds	60 seconds	120 seconds
Processing temperature			
latitude	15-19°C	15-19°C	15-19°C
	(60-85°F)	(60-85°F)	(60-85°F)
Projected brightness			
base density	0.7	0.2	0.05
Frames per cassette	12 and 36	36	12

Includes loading, development and unloading of autoprocessor.

OTHER PROCESSES AND TECHNIQUES

The knowledgeable amateur may find that this book does not include discussion of some common manipulative techniques. In my opinion, techniques which are used to produce *Sabattier, Posterisation, Bromoil, Gum bichromate* and other effects based on fairly vintage recipes are not essential darkroom techniques. That is not to say that they may not produce effective results or that they may not be essential to some technicians. One or two of these devices for the enhancement of what would otherwise be fairly boring pictures are time-consuming and quite complicated to prepare; others are relatively simple, requiring only as much as the striking of a match during print or film development. Other books by other authors are available which describe the various processes in detail and they are nearly all contained in the earlier-mentioned book published by Kodak, *Creative Darkroom Techniques*.

This last chapter is used more as a listing for the odd items which I do consider essential, and a brief description of each process and its purpose follows.

COLOUR TO BLACK-AND-WHITE

There are various reasons for wanting to make black-and-white prints from colour materials. The most usual is for purposes of reproduction in newsprint or a magazine.

Colour negatives are the most common source of original material and these will normally print acceptably on a grade 3 or 4 paper. There may, however, be some change in tonal rendition of original colours due to the way in which colours are recorded on colour-negative materials. The complementary colours contained in the negative tend to absorb the blue component of white light, to which most conventional black-and-white materials are most sensitive. Consequently, items of the subject which would normally be rendered blue are yellow in the negative and, as the yellow acts as a safelight, these tones in the print will be lighter than normal. Lighter colours of the subject will print darker and so on. To correct these tonal differences, use a panchromatic paper which is specially designed to overcome the problem, such as Kodak's Panalure Select RC paper. It should be used in conjunction with a No.13 (amber) safelight.

Panalure is a fast paper easily processed in the tray or machine using Polymax or other suitable RC paper developers. Stop bath, fixing and washing are compatible with conventional black-and-white paper processing. Colour negatives may be filtered using CP or CC acetate and gelatin filters to produce just the right tonal effect and contrast.

BLACK-AND-WHITE FROM TRANSPARENCIES

There are several ways in which black-and-white prints are obtained from slides. Prints can be made directly from the slide using a panchromatic reversal paper. Tetenal paper and chemistry are available from professional photographic dealers.

The most commonly used method is to make a black-and-white internegative from the original slide, using a medium-speed panchromatic film such as FP4 Plus. Slower emulsions like Pan F Plus, Agfapan APX 25 or Kodak Technical Pan 2415 may be more useful when making contact internegatives. Faster ISO speeds may be necessary when enlargements of a segment of the original slide is to be made. Use the same procedures as for slide duplication with sheet film or a

roll-film back. With FP4 Plus, which is a good all-rounder for this purpose, an enlarger light source of 75w and an aperture of f5.6 give an exposure of 2 seconds for an E160. FP4 Plus is normally rated at 125 ASA, but because of the increase in contrast which would result if the film were exposed and processed normally a fairly big cut in development is necessary to compensate for the over-exposure. Make several trial exposures and begin by reducing normal development by 30 per cent.

With contrasty original transparencies in which large areas of blue sky predominate, use filters to correct the tonal rendition in the internegative in the same way as when black-and-white film is exposed in camera.

If your enlarger column and head bracket can be converted for use as a copying stand, black-and-white internegatives can be easily made using a bellows focusing unit and the standard lens for 1:1 reproduction. A simple diffused light source is all that is required to light the transparency. A sheet of opal per-spex, an electronic flash gun or photoflood light source in reflector, plus two empty shoe boxes, are all that is required.

Use the shoe boxes, standing them on edge on the enlarger baseboard, as pillars for the perspex sheet. Place the electronic flash in the space under the perspex (or photoflood). Lay the transparency to be copied on the perspex sheet. Adjust the column height of the copying camera and fine-focus the image. Cameras with TTL metering will be useful when the photoflood is the preferred light source. To establish the correct exposure with flash, set the ISO speed on the 'auto' mode dial and select the smallest aperture setting. Make a series of bracketed exposures on a short length of film and process using Table l.

The person with some handicraft skills will not find it difficult to construct a small reflex light source with flashed opal perspex top.

MOUNTING

There are several methods and different types of materials available for the photographer who wishes to mount pictures for exhibition, copying or framing. Resin-coated papers do not adhere well to mounting boards when a liquid paste is employed. The paper base is waterproof and little or no adhesion will form when the material is brought into contact with the mount.

For general-purpose use, where archival properties of the mounted picture are not considered, double-sided self-adhesive tape is as good as anything. Simply apply the tape to the four sides of the trimmed print to be mounted, align one edge with relevant marks on the card and then peel off the outer tape protector on the side of the print to be fixed in place by gently holding the print in position on the card with a cloth wad. When one edge is secured, hold the print off the mount by the opposite edge and peel off the remaining three tape protectors. Gently lay the print out from the edge already secured.

A more convenient adhesive, if the print is required to lie completely flat on its mount, is made by 3M Scotch. Several types of this adhesive are made; one allows for reposition-ing, another is formulated for more permanent requirements. Lay the print to be mounted face down on sheets of newspaper. Shake the can contents well and then, with the nozzle at a distance of approximately 9–12in (23–30cm), begin spraying in parallel bars across the picture from left to right. Repeat the action from top to bottom to give an even spread of adhesive, but do not move the print off the newspaper until both directions are complete and the adhesive has dried.

To mount, hold the print by its top right-hand corner and gently align the lower left and bottom edge at the corner. Apply light pressure at this point and then secure the bottom right-hand corner in the same way. Using a cloth wad, gently curl the print down, while simultaneously applying a light pressure with the cloth wad to remove any air bubbles which may form. Quite large prints can be successfully mounted in this way but you must take care at every stage to ensure absolute cleanliness, otherwise foreign matter may be deposited on the adhesive side of the print, which will cause unsightly marks in the finished product.

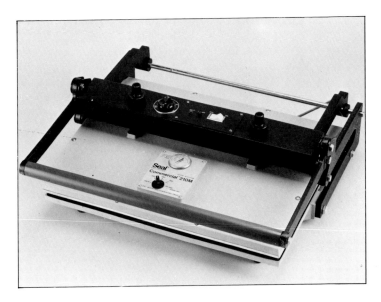

Seal commercial dry-mounting press for the proper mounting of all photographs and artwork. (Photo by kind permission of Pelling & Cross)

Spray-on adhesives are fairly expensive. However, I have found that this is the most convenient mounting method for photographers who only have an occasional need for this. Prints can be mounted quickly on to virtually any surface once the mount area has been marked out and there is little or no mess. Newspapers can be discarded as soon as the sprayed print has dried ready for mounting. I still have prints I mounted using this method well over a decade ago and they are as good today as others which were dry-mounted using tissue and a hot press on the same occasion. There is no noticeable deterioration in print colour or tone.

Fibre-based prints can be mounted using conventional pastes, such as those made from rice starch. These should be of low or neutral acidity to prevent 'foxing' and other unsightly stains caused by chemical reactions with residues of chemistry left in the print or contained in the mount board. Atlantis conservation board is an acid-free archival mounting board which is available in a variety of textures and colours. (See also the black-and-white section under paper listings on page 110.) Wet-mounting can be a messy and tedious business and does not work well with prints that have been hot-dried on a glazing machine or flat-bed dryer. Prints should be completely flat and undistorted – no curl. Use a lint-free cloth lightly damped to prepare the

back of the print ready to accept the paste. Apply the paste with a soft-haired brush in an even pattern. Carefully align the edges to the mount and squeeze out air bubbles using another cloth, working from the centre of the print outward. Be very careful when you get to the edges to ensure that no paste is brought back on to the print. Unless your prints are for important exhibition purposes and are expected to remain in service for many years, the use of self-adhesive tapes or sprays is to be recommended. Paper and linen archival tapes are also available.

The most common method of mounting prints on board employs a 'dry-mount' tissue adhesive. This requires a heated press to effect a professional finish. An ordinary domestic iron can be used, but I have never found the use of such implements very successful.

Lay the mount tissue (Lamatec) on the back of the print and gently tack in place with the tip of a medium/hot iron. About nine different tack spots is the ideal number in a three-up/three-down pattern. Cut off excess tissue around the edge of the print. I usually do this before tacking in place, using a sharp knife on a cutting board of thick card with a metal rule. Cut the tissue about an eighth of an inch smaller than the print to be mounted. That way there is no risk of a 'spread' from under the print as it is mounted. When you have tacked the tissue to the back of the print, align on the mount marks. Cover the print with a sheet of heavy-gauge brown wrapping paper. This is used to protect the print from the iron. Tack each corner in place with the nose of the iron, using gentle pressure for about 10 seconds. Remove the protective brown paper and check that the print is correctly positioned. Replace the paper if all is well and begin ironing from the centre of the print outward with a widening circular motion. Twenty seconds should be sufficient to get proper adhesion with a fibre-based print. Resin-coated papers will need a very low temperature and mount tissue of low melting temperature.

A high throughput of mounting will best be served by the installation of a custom-built

press such as the Commercial 210M or Jumbo 160M made by Seal.

With the use of Daler picture mount board, a sharp cutting knife such as an adjustable model-making type, or a scalpel, prints can be effectively mounted on the kitchen table. It is better if you have a large work bench on the 'dry' side of the darkroom, so that all tools and materials are easily to hand when needed. Small prints will benefit from having a window mount which is cut from a second piece of card with a picture framer's 45°-angled cutting knife. These gadgets are usually obtainable at little cost from good artists' supply stores. The 45° edge to the window mount helps add a little depth to any photograph and gives a more professional finish than the usual straight edge cut (see 'Alto Bevel Cutter', below).

Alto bevel edge mount cutter gives a neater finish to picture surround when framed for hanging.

PROFESSIONAL PHOTO-MOUNTING MATERIALS AND EQUIPMENT

PERMA-MOUNT

Water-based spray adhesive suitable for all paper base types. It is non-flammable and allows re-positioning on the mount board. It is available in an aerosol 12.2oz can.

PROTECT-ALL

Gloss print lacquer with built-in ultra-violet protection which absorbs harmful light rays. It increases light fastness and seals print from foreign matter.

PHOTO-FINISH

Matt finish print lacquer similar to the above. It incorporates UV protection. It is ideal for spraying on to glossy prints which need camera copying. Excellent results can be obtained from sprayed colour print originals copied on to Ektachrome 160 Tungsten. be re-used.

TEMPERATURE INDICATOR STRIPS

These are impregnated with coloured heat-sensitive wax patches. One will melt at 93°C (200°F), the other at 99°C (212°F). They are ideal for accurate control of platen temperatures.

SEAL PLATE CLEANER COMPOUND

Specially formulated for cleaning the platen on a dry mounting press to which bits of print and dry mounting tissue have adhered.

FUSION 4000

One hundred per cent thermoplastic adhesive without paper support. It flows freely when heat is applied. It has a very tough adhesion; ideal for mounting prints to metals and laminated plastics.

RELEASE PAPER AND RELEASE FOLDER

Silicone treated materials which prevent thermoplastic adhesives from adhering to print materials or mounting platen. The folder is single-sided and has a longer life-span. It can be re-used.

SELECTOR TACKING IRON

This has a built-in adjustable thermostat. It is Teflon-coated. It is used for tacking adhesive in place on print.

PRINT MOUNTING POSITIONER

A calibrated 'T' square specially designed for print mounting. There is no need for pencil marks or lines, and it comes with comprehensive instructions.

Seal tacking iron for use in dry-mounting.

ALTO BEVEL CUTTER

This device comprises a cutting jig which is adjustable to give frame borders of between 1.5 and 6.5in (3.8–16.5cm) in steps of 1/8in (3mm) and a special cutter which produces a 60° bevel. It cuts up to 31in (79cm) long, and materials up to 1/8in thick are accommodated.

TONING

Sepia toning has always been the most popular method of reducing the harsh impact of pure black-and-white in prints. Before the advent of colour negative materials for general use, and particularly in studio portraiture, the high-street photographer automatically toned every print that came out of the wash, a process also used as a preliminary stage to hand-colouring. Sepia colours vary from a reddish-brown to pale brown and are achieved by converting the black areas of the print using a ferricyanide bleach followed by redevelopment in a dilute solution of sodium sulphide. The latter should **not** be used in an unventilated space and preferably **not** in the darkroom, where its vile-smelling vapours will fog any unprotected light-sensitive materials. Mix the solutions A and B in a well- ventilated space. The bleach can be re-used if kept in stoppered Winchester-type bottles. The dilute sodium sulphide should be discarded after use well diluted.

Mix chemicals in the following proportions:

1 Solution A (bleach): potassium ferri-cyanide 100 g + potassium bromide 100g dissolved in 1 litre of filtered water.
2 Solution B (tone developer): sodium sulphide 50g dissolved in 1 litre of filtered water.

Then, to make working solutions:

1 Dilute 1 part of A with 10 parts filtered water and pour into first dish.
2 Dilute 1 part of B with 10 parts filtered water and pour into second dish.

METHOD

Prints which are to be toned should have received more than the normal amount of washing; a minimum of 50 per cent longer is usual and wet prints are easier to tone than dry ones.

Immerse the print in the bleaching solution A and begin a process of gentle agitation, continuing until the deep shadows are only just visible. Mid tones and highlights should have disappeared, but different tonal effects can be obtained, depending on the strength of tone of the original and how much new tone is required.

When the correct level of bleaching has been obtained, remove the print from solution A and wash thoroughly in running water for a minute. A ragged-ended sponge dish-washing utensil is ideally suited to removing excess ferricyanide.

Drain the print from the wash and immerse in solution B. After a few minutes of gentle agitation, the print will have been re-developed and stained. Wash and dry in the normal way.

STAINING SOLUTIONS

Various proprietary staining solutions prepared in liquid form are available from most

photographic dealers. If you cannot easily obtain the dry chemicals required for this process, Kodak manufacture and supply the following.

KODAK RAPID SELENIUM

Effect: cold brown tones; slight increase in print contrast. Dilute stock 1+3; wash for hour.

KODAK POLY-TONER

Effect: warm to cold sepia tones. Dilute stock 1+4 or 1+24; wash for 30 minutes.

KODAK SEPIA

Effect: sepia tone; use with most papers. Follow maker's instructions using 'A'+'B' solutions; wash RC papers for 4 minutes, others for 30 minutes.

KODAK BROWN

Effect: sepia tone. Use with most papers. Toner contains **poisonous** fumes, so use only in a well-ventilated space; immersion normally 15-20 minutes at 20°C (68°F); wash: same as for Kodak Sepia toner.

FARMER'S REDUCER

This is a bleaching bath which was invented by the English chemist E.H. Farmer in 1883 and which has long been used for reducing the silver-image content of highlights and shadows. The action on negatives is quite rapid and needs careful application. Prints can be more easily controlled depending on the dilution of chemicals.

The formula for solution A is: potassium ferricyanide 20g + 250ml water.

The formula for solution B is: sodium thiosulphate (hypo) 250g + water to make litre.

METHOD

Thirty ml of solution A+120ml of solution B mixed with 1 litre of water is used for negative reductions. Three ml of solution A+12ml of solution B mixed with 1 litre of water is used for print reduction. For example, prints in which the highlight areas need 'whitening' are immersed in a working solution and agitated gently for several minutes. The tray should be placed in a good light where the action of the reducing agent can be seen. As soon as the brightest highlights begin to lose their greyish tones, remove the print and wash for 30 minutes and then dry.

Negatives to be reduced should ideally be immersed in a small dish which is placed over a strong light source. A sheet of flashed opal perspex let into a bench under which the light is mounted is ideal for this purpose. The rebate for the perspex should be generously applied with waterproof mastic or bedding compound to prevent accidental splashes of liquid reaching the light source.

Stock solutions can be further reduced if the reducing action is found to be too rapid.

INDEX